ALSO BY THOMAS HINE

THE GREAT FUNK

THE GREAT FUNK

FALLING APART AND COMING TOGETHER (ON A SHAG RUG) IN THE SEVENTIES

THOMAS HINE

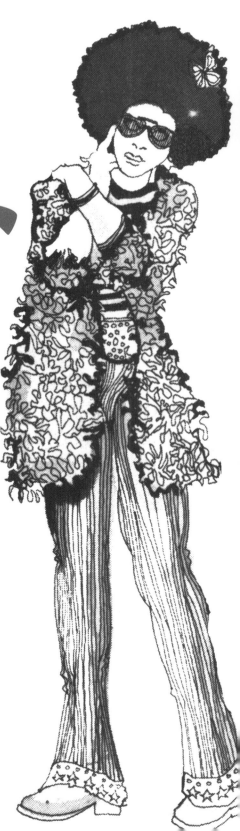

SARAH CRICHTON BOOKS
FARRAR, STRAUS AND GIROUX NEW YORK

Sarah Crichton Books

Farrar, Straus and Giroux

19 Union Square West, New York 10003

Copyright © 2007 by Thomas Hine

All rights reserved

Distributed in Canada by Douglas & McIntyre Ltd.

Printed in the United States of America

First edition, 2007

Illustration credits appear on pages 239–41.

Designed by Iris Weinstein

www.fsgbooks.com

10 9 8 7 6 5 4 3 2 1

Library of Congress Cataloging-in-Publication Data

Hine, Thomas, 1947–

The great funk : falling apart and coming together
(on a shag rug) in the seventies / Thomas Hine.
— 1st hardcover ed.

p. cm.

"Sarah Crichton books."

Includes index.

ISBN-13: 978-0-374-14839-3 (hardcover : alk. paper)

ISBN-10: 0-374-14839-2 (hardcover : alk. paper)

1. Arts, American—20th century. 2. Popular
culture—United States—History—20th
century. 3. United States—Civilization—20th
century. I. Title.

NX504.H56 2007

973.924—dc22

 2006030632

For James

We met at the end of the Great Funk—and just in the nick of time

CONTENTS

THE GREAT FUNK

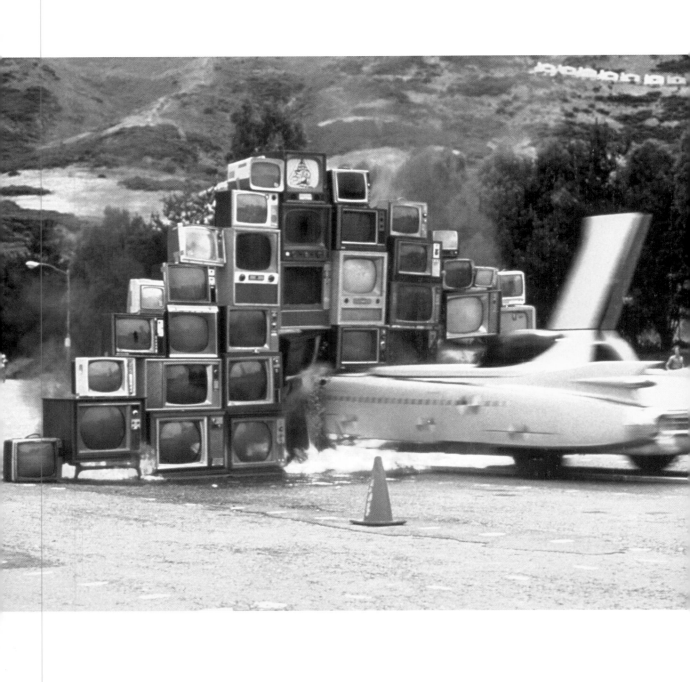

RUNNING ON EMPTY

If you wanted a world that was orderly, where progress was guaranteed, the seventies were a terrible time to be alive. Cars were running out of gas. The country was running out of promise. A president was run out of office. And American troops were running out of Vietnam.

Only a decade before, as the nation anticipated the conquest of space, the defeat of poverty, an end to racism, and a society where people moved faster and felt better than they ever had before, it seemed that there was nothing America couldn't do. Even the protestors of the sixties objected that America was using its immense wealth and power to do the wrong things, not that it did things wrong. Yet during the seventies it seemed that the United States couldn't do anything right. The country had fallen into the Great Funk.

America even fumbled the celebration of its birthday. In 1975, the United States began a multiyear observance of the two-hundredth anniversary of the American Revolution. Fifteen years earlier, such a celebration would have engaged America, but by the mid-seventies, everything seemed to be falling apart. Four years of pageantry, featuring musket-wielding guys in tricorn hats, didn't feel like a solution for the country's malaise. At many of the commemorations, Gerald Ford, that unelected, unexpected president, said some little-noted words. Ford presided over bicentennial America like a substitute teacher, trying to calm a chaos he had no hand in making and seemed scarcely to understand.

The bicentennial celebration left few memories, few images or events that have resonated through the decades since. "Media Burn," staged on

An Eldorado hits the Zeniths as part of Ant Farm's "Media Burn," an unofficial bicentennial pageant that dramatized the seventies' smashed expectations. Gerald Ford, an unexpected president, watched over the nation's birthday in the wake of the sordid revelations of Watergate.

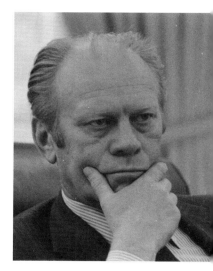

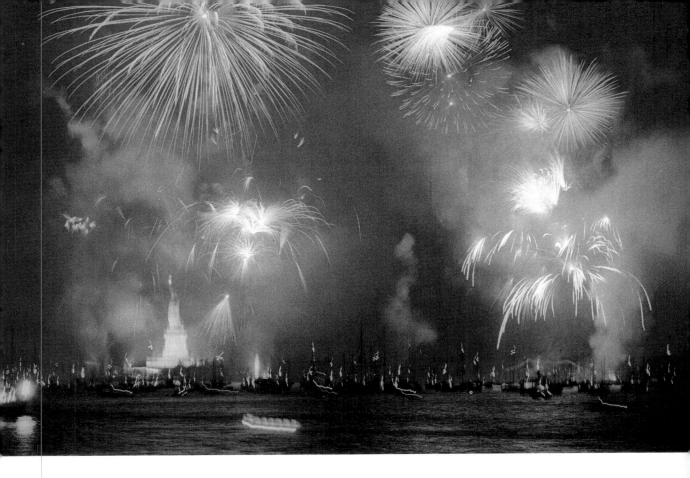

The thrilling bicentennial fireworks display in New York City was a bright spot in a decade when bankruptcy threatened and the city appeared to be crumbling.

July 4, 1975, at San Francisco's Cow Palace, is an exception. It was not an official commemoration but rather a project of Ant Farm, an art and architecture collaborative. President Ford was not in attendance as he was at most of the bicen's big moments. Instead, the presiding figure was an imitator of the late President John F. Kennedy, who was remembered at the time as the last *real* president, or at least the last who didn't leave office in disgrace. "Haven't you ever wanted to put your foot through your television?" the ersatz Kennedy asked. In the climactic moment of the event, a specially modified and apparently driverless 1959 Cadillac Eldorado convertible crashed through a wall of vintage television sets. In fact, there was a driver hidden inside the car. And the crash was documented by a camera housed in an additional tail fin, constructed for the purpose.

"Media Burn" was a quintessential event of the seventies—bleak, funny, transgressive, and intensely satisfying in a way that was either juvenile or profound. Though it lacked the Betsy Ross impersonators and flag-waving oratory that marked official bicentennial events, it was nevertheless a historical pageant: Kennedy and the Cadillac Eldorado, icons of success in the immediate past, represented an America that was past and seemingly irrecoverable. Only a decade and a half earlier, every part of American culture—from its leaders to its cars and even its linoleum—seemed to promise expansiveness and progress. Americans had watched those television sets and seen the future, but nothing had turned out as advertised.

By 1975, the future had turned from a promise to a shock. Following the first Arab oil embargo of 1973, the Eldorado and the dream of freedom and luxury it embodied had come to appear grotesque, a true road to ruin. Overnight, Americans went from a world where abundance was assured to one in which scarcity was an ever-looming threat, and they didn't handle it well. Mysterious rumors of shortages of everything from toilet paper to raisins led to runs on supermarkets and hoarding as the everyday necessities of life seemed no longer to be guaranteed. What was, in essence, only a commodity shortage quickly became, for many,

The bicentennial was an excuse to wave the flag and feel patriotic, even after the American failure in Vietnam. It was a time for patriotic tableaux, dress-up, and firing antique guns. The family celebration, *below*, was held on July 4, 1976, but the observances dragged on for a long time, and by the time of the Philadelphia celebration, *below left*, America had endured nearly four years of its bicentennial.

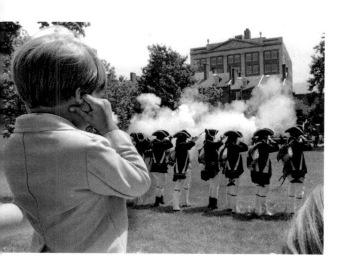

"I think you would have to conclude," declared Richard Nixon on his visit to China in 1972, "that this is a great wall." Career anti-Communist Nixon amazed the world by breaking with two decades of American policy and acknowledging the existence of the world's most populous nation. Nixon and his wife, Pat, both liked to bowl, and in 1970 he had a lane constructed at the White House.

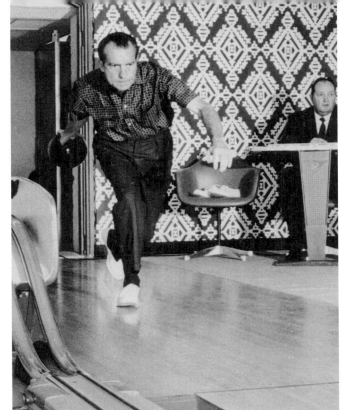

an intimation of apocalypse. In the early sixties, people brainstormed about when all human problems would be solved; in the seventies, the talk was about when and how civilization would end.

Just days before "Media Burn," the Vietnam War had come to an ignominious end, with diplomats escaping by helicopter from the roof of the embassy in Saigon. Earlier, Richard Nixon, too, had left in a helicopter, after resigning the presidency in the wake of a bungled burglary and a cover-up that revealed a personality even more diabolical and self-destructively insecure than even his many enemies had imagined. For nearly two years, Americans had seen the intellectually brilliant, sometimes visionary president they had reelected in a landslide ever so slowly revealed as a foul-mouthed conspirator, condemned by his own words on his own secret tapes. ("NIXON BUGGED HIMSELF" screamed the *New York Post* headline.) Spiro T. Agnew, Nixon's vice president, had resigned as well, in the wake of a tax-evasion scandal.

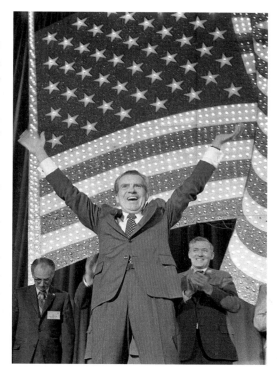

Nixon struck this characteristic full-body victory pose at a 1973 Realtors' convention, just as his administration was starting to sink under scandal.

And then there was the economy, producing very little actual growth, while prices were rising at a double-digit pace. This was something that elementary economics textbooks said could not happen, and yet it did. This so-called stagflation so traumatized politicians and policy makers that for the rest of the century, their central goal was to assure that it would not happen again. "Things can't get any worse," was the expert consensus in 1970, after the booming economy of the sixties started to sputter in 1968 and inflation persisted the following year. The experts, it turned out, had no idea. You could get eight loaves of bread for a dollar at the supermarket in 1970. The next year, that dollar bought five; in 1973, four; and by the end of the decade, one and part of a second. In 1974, following the imposition of wage and price controls that had only made matters worse, President Ford was encouraging Americans to wear little buttons that said "WIN—Whip Inflation Now," even as prices rose 13.9 percent in that one year. The seventies began with worries over home mortgage rates approaching 7 percent and ended with them at 13 percent, on the way to a high of 18 percent in 1981.

Many more Americans were feeling like losers as the economy entered unfamiliar territory. Ever since World War II, Americans had come to expect ever higher living standards and greater economic opportunities. During the seventies, income equality decreased, and lad-

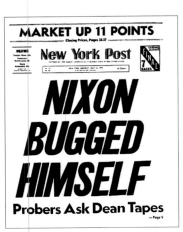

ders of advancement disappeared. After dominating the world economy for more than three decades, the United States saw its balance of trade with the rest of the world begin to slip into the red during the early 1970s, and stay there permanently after 1976. Americans had turned from a nation of producers to one of consumers. American workers, who had long been able

The White House–authorized burglars who broke into the Democratic party headquarters at the Watergate communicated with one another by speaking into the Chap Stick. Nixon's practice of surreptitiously taping all Oval Office conversations provided the evidence that brought him down.

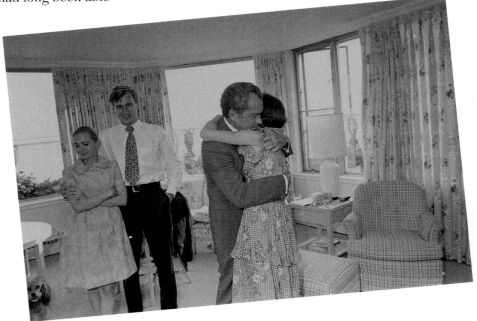

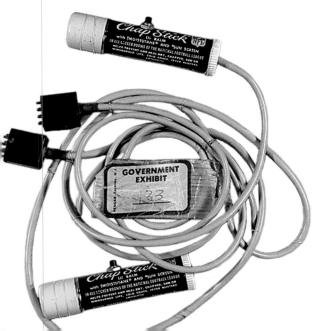

to ignore the rest of the world, had to worry about competition from overseas.

Nearly all American cities experienced a dramatic increase in crime during the decade, and some truly bizarre crimes made headlines. In 1973 and 1974 in San Francisco, a band of black supremacists known as the Death Angels killed fourteen and injured seven in what became known as the Zebra murders. The first of what became known as the Son of Sam murders took place in New York in the summer of 1976, and twelve more attacks, resulting in five more murders, happened during the next year. The killer claimed that he had been ordered to commit the crimes by his neighbor's Labrador retriever. In San Francisco in 1978,

a member of the city's board of supervisors shot the city's mayor and another supervisor, then won clemency because, his lawyers argued, his judgment was impaired by eating too many Twinkies and other sugary foods. Call it the Decade of Poor Excuses.

Perhaps the most horrible revelation was at Love Canal, near Niagara Falls, New York. There, a chemical company had buried barrels of extremely toxic chemicals atop which a public elementary school and more than one hundred houses were built. For more than twenty-five years, these chemicals leaked, causing such grotesqueries as babies born with two rows of teeth on their lower jaw and skulls that failed to fuse together, while adults had extremely high incidences of rare ailments. Its revelation, the result of an activist mother putting all the pieces together and demanding a school transfer for her child, was more than just a horrible litany of human suffering. It was like an outpouring of long-suppressed evil that had been denied during sunnier times but was now inescapable.

THE WHITE HOUSE
WASHINGTON

August 9, 1974

Dear Mr. Secretary:

I hereby resign the Office of President of the United States.

Sincerely,

Richard Nixon

11.35 AM

The Honorable Henry A. Kissinger
The Secretary of State
Washington, D. C. 20520

HK

To whom does a president send his resignation? That was a legal question as Watergate wore down, but it didn't matter because everyone was willing to accept it. A day later, after some hugs at the White House, Nixon was gone.

Overseas, the revolution in Iran in 1979 led to yet another gasoline crisis in the United States. Following the revolutionary students' seizure of the embassy in Tehran in October, fifty-two Americans spent 444 days as hostages. An attempt to rescue them in April 1980 proved a disaster and contributed to President Jimmy Carter's defeat in the 1980 elections.

Even parts of the world that didn't suffer through America's traumas of Watergate and Vietnam suffered from the same economic stagnation, fear of scarcity, and trepidation about the future. In Europe, terrorism was becoming a fact of life. Terrorists disrupted the 1972 Olympics, killing eleven athletes and a dream of peaceful competition. In Britain and Ireland, street-corner bombings became routine, and in Italy a prime minister was kidnapped.

In space, an increase in solar radiation doomed Skylab, the first U.S. orbiting space station, which fell out of the sky on June 11, 1979, just about a decade after the first moon landing. The sky *was falling*, if only on Australia.

The contemporary consensus is clear. The seventies were awful. The important things were awful, and the trivial things were awful. The politicians were awful. The economy was awful. Those insipid harvest gold and avocado kitchens were awful. Those polyester clothes that looked like tailored sponges were awful. The gas lines were awful. The pudgy AMC Pacer automobile was awful. As for Earth shoes, whose raised toe and lowered heel turned every walk into an uphill climb, they were awful too. And don't even mention disco! Call it a slum of a decade, and people will smile and nod knowingly. Even in an era like ours that seems nostalgic for everything, seventies style sounds like an oxymoron, an aesthetic whose allure seems mysterious even, or especially, to those who once embraced it.

Still, after the litany of disasters and the inventory of embarrassments have been recited, many who lived through this supposed nightmare of an era recall good times, and not just hedonistic ones. The seventies were a time when many people felt free to invent or reinvent themselves, or to feel good about who they were. In civic life, the confrontations of the sixties gave way to improvisation and cooperation. The routines of everyday life—eating, staying comfortable, taking out the trash—could be meaningful, both personally and globally.

Some of the old promises of progress had proved to be empty or unwise, but new possibilities were emerging. Indeed, the very phenomenon of "Media Burn," in which a bunch of people get together and decide to drive a Cadillac into a wall of televisions just because it would be, you know, cool, suggests a defiance of the lousy circumstances and even a certain confidence that shattering old beliefs is the beginning of making something new. The world Americans had been promised might have broken down, but when that ziggy, chrome-encrusted Caddy smashed into the wall of Zeniths and Motorolas and Magnavoxes, it showed that a break*down* does not preclude a break*through*.

There is something deeply liberating about discovering that you don't live in a perfect world. When what you have always been taught has

been shown to be untrue, that opens the opportunity of finding new truths on your own. When things fall apart, you can put them together in new ways. When the center cannot hold, well, that's good for those out on the edge. When the forces of order are revealed to be a malign conspiracy, it's a good time for a party.

The disappearance of a universally accepted American Way of Life opened the door to celebration of a number of different ways of life. Even *Life*, the magazine that once presumed to define America's national purpose, ceased publication. It was replaced shortly afterward by *People*, a shift in emphasis that suggests, as people would have said back in the seventies, a change of consciousness.

You can't help living in the present. Thus, when you look back at a time that is relatively recent, though in many ways remote from contemporary experience, it's difficult not to pay the most attention to those phenomena and attitudes whose impact is obvious now.

The Great Funk grows from a different feeling—the one you have when you look at an old photograph of yourself. You see yourself—but not quite yourself—in weird clothes and with a look on your face that you only dimly recognize. It is a past self who might have done all sorts of things you never quite accomplished, a self that didn't know all the things life had in store. "What was I thinking?" you exclaim, and it's a question that's worth trying to answer. Also, "What was I feeling?" and "How did I become the person in this picture?" If you lived through the seventies, you probably have a bunch of different pictures in which it seems like you were several different people, thinking and feeling a lot of different things. That was the nature of the time: Finding your identity was extremely important, but theatricality and artifice were seen as ways of finding—or making—yourself.

The great question of Watergate, asked by Senator Howard Baker, was, "What did the president know and when did he know it?" *The Great Funk* is about what people *thought* they knew, how they felt, what they did. It will try to get into the heads of these figures from recent history—in many cases ourselves—by getting into their shoes, scrutinizing

Low-heeled, high-toed Earth shoes quite literally gave people a new stance, one well-suited to a time when everything else seemed to be going downhill.

their homes, feeling the rhythm of their music, and scanning the advertisements that attempted to incite their desires.

One of the things we learned in the seventies is that people's experiences, both as individuals and as members of groups and communities, are astonishingly diverse, and different people remember and value very disparate things. Still, many phenomena will be ignored here, not out of malice but simply because that's a danger of writing a short book on a big subject. Feel free to disagree, send angry e-mails, or even write your own book, which would be a seventies kind of response. I lived through the period and had a furry sofa (though I never accumulated a closetful of polyester shirts). Still, *The Great Funk* isn't a memoir; it's an attempt

The one thing everyone had in common at this 1979 street fair is that their mothers didn't like their hair.

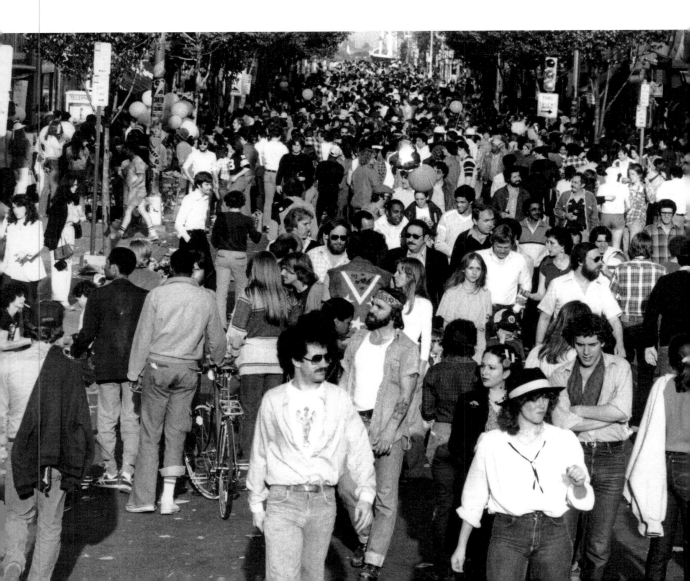

to evoke an era by looking at the ideas, feelings, textures, shapes, gestures, colors, catchphrases, demographic forces, artistic expressions, and all the other things that shaped people's lives at the time. It's not a place to look for accounts of Watergate, the Iran hostage crisis, global warming, or other major issues that have generated whole libraries' worth of reporting, analysis, and polemic. Rather, it is about living in the shadow of these matters. It is about the way that knowledge of corruption, or forecasts of impending doom changed the texture of life and shaped how people thought about themselves, how they dressed, and behaved, and decorated.

While *The Great Funk* doesn't attempt to look back from the twenty-first century to find the origins of the present, it does, in the tradition of

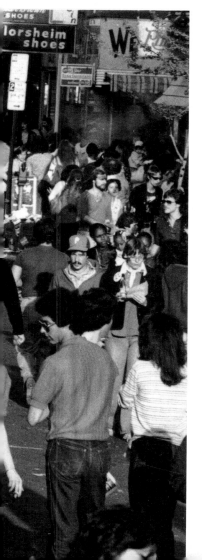

"Media Burn," join the people of the seventies as they look back at a recent period that was radically different from their own. This is the post–World War II era, part of which was the subject of my book *Populuxe*, which dealt with American life in the decade from 1954 to 1964.

Near the end of that earlier book, I wrote, "The Populuxe era confidently projected the American family—Mom, Dad, Junior and Sis—unchanged, centuries into the future, spinning through the galaxies in starbound station wagons. And today, Mom and Dad are divorced, the factory where Dad worked has moved to Taiwan, Sis is a corporate vice president, Junior is gay and Mom's a Moonie. The American Way of Life has shattered into a bewildering array of 'lifestyles,' which offer greater freedom but not the security that one is doing the normal thing."

The decade when everything shattered was the seventies. And although one can see what happened in the seventies as a fall from grace, most of us would not wish to return to the seeming certainties of the Populuxe era even if we could. The seventies undid the fifties, and to a great extent the fifties deserved to be undone. The eras of Populuxe and of the Great Funk represent two extreme versions of American life. Neither was normal, neither could go on

forever. But the way we understand and misunderstand these times colors the way we view the present.

I coined the word "Populuxe," a proudly artificial term that evokes the smoothness and speed of a society that looked forward to sharing an ever more opulent future. It's obvious that a term for the seventies couldn't be so slick. As I tried to come up with one, I found myself returning to an old English word, "funk," one with many meanings, most of which are relevant to the period I am describing. One kind of funk is a panic or depression; the seventies had plenty of panic, and economically, the years of the Great Funk were the worst since the Great Depression of the 1930s. An even older meaning of "funk," stretching back four centuries, is that it's an unpleasant smell, redolent of old cheese and crevices of the body. This kind of funk became a term in African-American music during the 1930s, to describe music that was rough, rhythmic, sexy, and real. Funk music, which emerged at the end of the sixties, was unruly, repetitive, conceptually simple, improvisatory, and often self-indulgently long-winded. Funk was probably the most important genre of the seventies: It expressed the era's lust for authenticity even as it underlay other genres, such as disco, with which it superficially had little in common. The funky furnishings and clothes that people found in flea markets and thrift stores were prized as a fusion of mildew, authenticity, and anarchy. The importance of funk in seventies life reflected a conviction that reality sometimes stinks, but it's better than being fooled by a perfumed delusion.

The oldest meaning of "funk," one that I didn't know until I started looking it up, is spark. (It seems to be related to "punk," a connection that opens even more seventies pathways.) I like this mostly forgotten meaning because this difficult decade sparked quite a few new insights and lasting changes in people's lives. The Great Funk speaks then of panic and stink, but also of ebullience and improvisation. It is an ambiguous term to describe a paradoxical era, one in which society was coming together even as it was falling apart.

There is one more question I'd better answer before I disappear behind the curtain of authorial omniscience, and that is: When were the seventies? The answer isn't quite as obvious as it might seem, because human experience is rarely neatly organized into ten-year segments. When the seventies were depends, to some degree, on what you find interesting or what you are trying to prove. I have opted

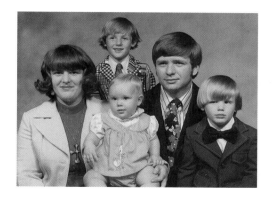

In this formal family portrait from 1976, each family member dressed to express. The bow tie was big that year.

for a longish seventies, beginning in midsummer 1969. The Woodstock music festival and the riots at the Stonewall bar in New York City's Greenwich Village, both of which happened that summer, are often seen as quintessentially sixties events. But they really represent a transition from issue-based protest to the politics of identity and generational solidarity that characterize the seventies. And the draft lottery of December 1969 allowed draft-age young men to plan their lives, thus taking some of the urgency out of antiwar protest and setting the stage for the next phase. The end came in January 1981, when the Iran hostages were released and Reagan took the oath of office a few minutes later. Some of the economic gloom of the seventies carried over into the eighties, as the harsh inflation-killing policies of Federal Reserve chairman Paul Volcker, a Carter appointee, continued under Reagan. But from the beginning, Reagan reassured the public that we were back in more normal times, times more like the fifties.

When Janis Joplin's recording of "Me and Bobby McGee" became a number one hit in 1971, the notoriously hard-living, drug-abusing singer had recently died. Thus, the song's refrain, "Freedom's just another word for nothin' left to lose," was heard as a kind of epitaph. Still, that line, self-pitying though it is, nevertheless expresses something important about the time. Americans clearly hadn't lost everything in the seventies, but the obvious failure of so much they had counted on provided an opportunity. There was room to experiment, room for you and like-minded friends to try to do things that might make a difference.

WANTED BY THE FBI

Patricia Campbell Hearst

FBI No.: 325,805 L10
Alias: Tania
Age: 20, born February 20, 1954, San Francisco, California
Height: 5'3" **Eyes:** Brown
Weight: 110 pounds **Complexion:** Fair
Build: Small **Race:** White
Hair: Light brown **Nationality:** American
Scars and Marks: Mole on lower right corner of mouth, scar near right ankle
Remarks: Hair naturally light brown, straight and worn about three inches below shoulders in length, however, may wear wigs, including Afro style, dark brown of medium length; was last seen wearing black sweater, plaid slacks, brown hiking boots and carrying a knife in her belt

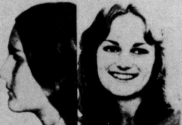

Jan., 1971 Feb., 1972 Dec., 1973 April, 1974

THE ABOVE INDIVIDUALS ARE SELF-PROCLAIMED MEMBERS OF THE SYMBIONESE LIBERATION ARMY AND REPORTEDLY HAVE BEEN IN POSSESSION OF NUMEROUS FIREARMS INCLUDING AUTOMATIC WEAPONS. WILLIAM HARRIS AND PATRICIA HEARST ALLEGEDLY HAVE USED GUNS TO AVOID ARREST. ALL THREE SHOULD BE CONSIDERED ARMED AND VERY DANGEROUS.

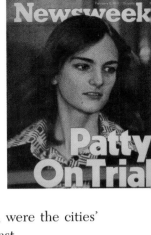

Authority had broken down. Everywhere, there was a growing, and ever more justified, skepticism about experts and their ability to deal with the challenges of the time. In the sixties, the establishment fought back against the protestors, but in the seventies, it seemed simply to have walked away and left the rebels to cope with the fusillade of crises.

"If you're not part of the solution, you're part of the problem," said the sixties slogan, but in the seventies, it became clear that the solution often becomes the problem. In 1973, the Pruitt-Igoe public housing towers in St. Louis, which had won praise and awards only two decades before, were blown up by the agency that had originally built them. The image of the imploding high-rises quickly became the symbol of a failed idea and of the bankruptcy of the whole concept of large-scale urban renewal. Busybodies keeping their eyes on the street, not heroic architects and planners, were the cities' future as well as their past.

Meanwhile, school busing, the technocrats' solution to segregation, was despised by whites and

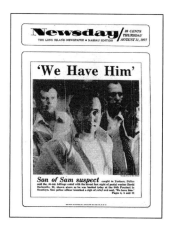

Newsday

THE LONG ISLAND NEWSPAPER • NASSAU EDITION
20 CENTS
THURSDAY
AUGUST 11, 1977

'We Have Him'

Son of Sam suspect caught in Yonkers. Police said the 24-col. killings ended with the arrest last night of postal worker David Berkowitz, 24, shown above as he was booked today at the 84th Precinct in Brooklyn. One police officer breathed a sigh of relief and said, 'We have him.'
—Pages 4, 5 and 15

I SAY GOODBYE AND
GOODNIGHT.
POLICE: LET ME
HAUNT YOU WITH THESE
WORDS;
I'LL BE BACK!
I'LL BE BACK!
TO BE INTERRPRETED
AS — BANG BANG, BANG
BANK, BANG — UGH!!
YOURS IN
MURDER
MR. MONSTER.

blacks alike, and it unleashed a sometimes violent resistance movement. Economists who had promised to "fine-tune" the economy as if it were a fancy stereo system became subjects of ridicule. The Vietnam War was not the only ill-conceived venture for which "the best and the brightest" were blamed.

All sorts of people came together during this time in order to try many different approaches to life. Some people removed themselves from the society and went to live as families or communities in remote places unconnected to the technological network. Women came together to raise one another's consciousness, to try to understand their lives as women and to change them. Charismatic Christians came together to reconnect with those ecstatic days after the Pentecost, when Christ's apostles spoke in tongues and emotion was translated immediately into action. Young professionals—they weren't called yuppies yet—came together in deteriorating big-city neighborhoods to try to re-create modes of urban living that had been given up for dead. Gays came together, to dance or to march, but mostly to affirm that what they felt was not unnatural, not wrong. Young computer enthusiasts came together to figure out how to make it possible for individuals to partake of the power of information technology. Neighbors came together to recycle their trash, a pursuit that elicited surprising fervor, perhaps a reconnection with ancient practices of making sacrifices to justify consumption. Political conservatives came together to create new institutions to claim some of the

Crimes of the times: San Francisco heiress Patty Hearst was kidnapped by radicals and then shocked the world by joining them. The New York serial killer known as Son of Sam claimed to take orders from his neighbor's Labrador. Dan White, the politician who assassinated San Francisco's Mayor George Moscone and Supervisor Harvey Milk, claimed that eating too many Twinkies made him do it.

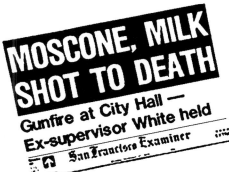

MOSCONE, MILK SHOT TO DEATH
Gunfire at City Hall —
Ex-supervisor White held
San Francisco Examiner

intellectual ground and political power left empty by the failure of vaguely liberal mainstream institutions.

While many of the groups that emerged during the seventies had a political program, or at the very least represented a challenge to what had been a political consensus, they spoke not of ideology but of identity. Feminists reveled in the power of sisterhood, gays liberated themselves from the closet, survivalists established self-sufficient settlements in the wilderness to embody better ways of living, and settlers in city neighborhoods styled themselves urban pioneers. And even though they were part of a different generation, the rapid proliferation in Florida, Arizona, and elsewhere of communities made up entirely of old people mirrored their grandchildren's inclination to dispense with the family and traditional multigenerational ties and hang out with people who listened to the same music and shared the same tastes and concerns.

Writing in 1976, Tom Wolfe memorably christened the seventies "the Me Decade," but perhaps the pioneering gay politician Harvey Milk was

closer to the mark when he spoke of an emerging coalition, "the us-es." These were, he said, "not only gays but those blacks and the Asians and the disabled and the seniors—the us-es, the us-es—without hope, the us-es give up." It's important to note that Milk did not speak of these groups as victims, any more than Maggie Kuhn, the founder of the Gray Panthers, would label the old people for whom she spoke as passive or pitiful. Both were seeking to lead people who had long been marginal or forgotten, but their rhetoric had more to do with unleashing power than with bewailing past injustice.

There were, however, more "us-es" than Milk or Kuhn or others on the left realized. Indeed, Wolfe's key point about the decade was that it was "the third Great Awakening," a time of seeking an intensely personal savior. He was prescient in identifying those seeking a religious revival based on personal faith uncompromised either by reason or the necessity for a social consensus as the most important of the countercultures that arose during the period. This antiestablishment religiosity has since become ever more potent and has pushed back against the growing power of some of the "us-es" with whom Milk identified.

Like the newly adult boomers who gave the era its character, the seventies were at once hedonistic and moralistic. Much of the hedonism sprang from the zone of freedom created by the failure of the old values of the Populuxe era. Some was a result of demographics: Never before had so many people reached sexual maturity at the same time. And some of it, of course, was the drugs. In *Harold and Maude*, the 1971 cult movie hit, the seventy-nine-year-old sensualist heroine spoke for the seventies when she introduced her college-age paramour to the pleasures of marijuana. "It's organic!" she said. Even so, many in the seventies were willing to imbibe wholly artificial substances in their quest for more intense experiences.

For many, the moral basis for behavior came from awareness of the limits of Earth's natural resources and the belief that humans were irreversibly polluting the air, the oceans, the aquifers, and thus jeopardizing the lives of future generations. Such an awareness of material limits could give moral force to everyday behavior. Building your house so that it takes full advantage of the sun and the prevailing breezes provided a more satisfying basis for design than mere style or status. Cooking yogurt and barley soup from the recipe in *Diet for a Small Planet*, even

though it didn't taste great, made the most fundamental act of consumption into an act of generosity toward your fellow creatures and toward the future. It was also a way to defy the chemical-agribusiness complex, and also to rebel against the boomers' moms' embrace of artificiality and convenience. Later in the decade, the movement toward healthy and local food gave rise—through the efforts of Berkeley's Alice Waters and many others—to a tasty and sensuous indigenous American cuisine. Being able to have something that is moral and pleasurable at the same time was truly a seventies sort of nirvana.

Falling apart and coming together—whether for the planet, for sex, for peace, for freedom, or for God—was the common experience of the era. And even if we fear to repeat the seventies, it is nevertheless an important place to revisit, to see an America that was very different from the present, one that contained many seeds of the present and suggested countless other possibilities that remain unexplored.

This 1975 Houston Best Products store, disguised as a ruin, embodied the seventies taste for texture, and even decay. The work of New York architect James Wines, it was an architectural icon of the era. Its artful rubble has since been stripped away.

Baby boomers had grown up with a cheap toy called the Magic Slate. A child could draw on it with a stylus and her drawing or writing would show. One needed, however, to pull up the plastic that covered it to make everything disappear so that you could start anew. During the post–World War II era, the entire society seemed to view itself as the embodiment of the Magic Slate. Progress would keep coming; it would supplant everything that had come before. Images of the future never contained any old buildings. They had been erased repeatedly by the magic slate.

The shocks of the seventies killed this myth of inevitable progress. They showed that some marks are permanent, and they can't be erased with a flick of the wrist. Americans started to notice all the places, people, and things that are left over after progress. Decaying, crime-ridden cities showed that the previous decades' rhetoric of ceaseless

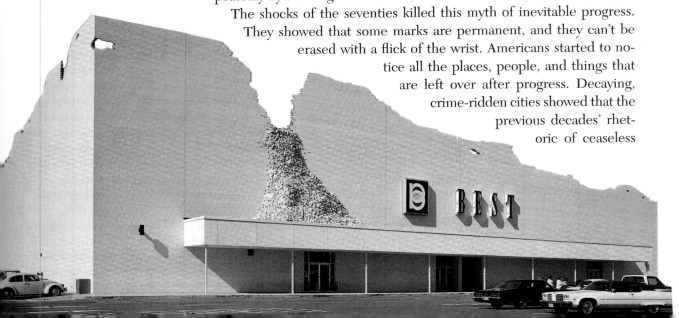

improvement had been a sham. But they were also filled with neglected treasures: not just grand buildings and generous parks but also finely crafted details, such as granite curbs, statues of forgotten leaders, and elaborate architectural moldings. These expressions of permanence and seriousness showed an alternative to the throwaway culture of the post–World War II era. The Great Funk aesthetic begins not with a blank slate but with a landscape filled with ruins—the ruins of communities and buildings, and the ruins of failed old ideas. It is based not simply on looking forward but rather on looking all around, to see what was available, to find new uses for what had been left behind. It was an aesthetic of salvage and of juxtaposition. Recycling was becoming an environmental imperative, and it became a cultural one too, as people sought to rediscover and renew what had long gone unnoticed and neglected. Creators of Great Funk style roamed the city streets on garbage night, finding the Mission oak tables, the moderne kitchen sets, the disheveled remnants of old avant-gardes. They were on the lookout for space, big spaces in unexpected places such as abandoned warehouse districts, which became artist studios, performing spaces, places to dance, places to live. They prowled through attics and discovered old fabrics and fashions that could be aggressively mismatched and made into something new.

The Great Funk aesthetic rejected the hard and the shiny, whose connotations of speed and progress felt wrong for those who saw the society going in bad directions. Instead, it embraced texture and layering, distressed surfaces and exposed brick. Some of the textures were artifi-

Exposed brick embodied the seventies ideals of being both truthful and textured. *Below*: Was this wall in Chicago urban squalor or artistic expression? Either way, it was authentic.

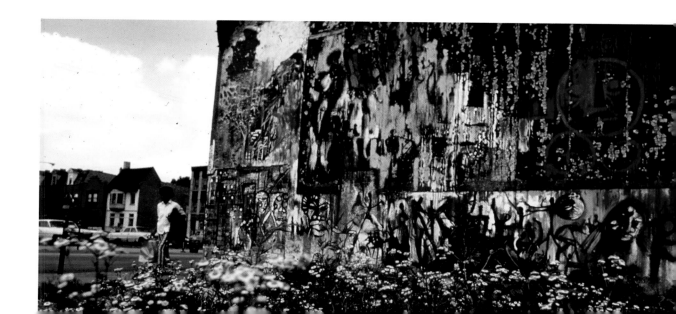

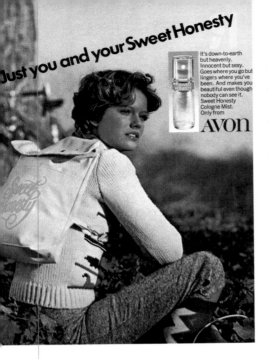

cial and downright unpleasant; there were squishy suits and slimy sport shirts.

People in the seventies took pleasure in setting their tables with mismatched chinaware. Those around the table were probably mismatched too. At least they weren't trying so hard to assimilate. Some were rediscovering ethnic roots that their parents and grandparents had sought to escape. Some were engaged in spiritual explorations, or expressing a newfound sexual identity, or throwing themselves into a craft, like carpentry or cooking, that made their parents wonder what good college had done them. They may have been wearing polyester, but they were homespun in their hearts.

Tolerance and acceptance were core values of the time, which meant that some dangerous, or at least stupid, behavior and beliefs were not only tolerated but encouraged. The smiley button—the yellow circle that bids everyone to have a nice day—was a badge of openness and universal cheerfulness. For many, it has become the very symbol of the vapidity of the seventies, even though the first version of it began to appear in the sixties. Unquestionably, many wore the little buttons because they honestly wanted to wish everybody well, which may be naïve but not cause for censure. Almost as soon as the button became popular, however, some people began wearing it ironically, as an accent in a punk wardrobe of rejection, provocation, and screaming fury. The smiley, which has subsequently become enshrined as an Internet emoticon, was an assertion of bland acceptance, but it was one part of a far from bland time.

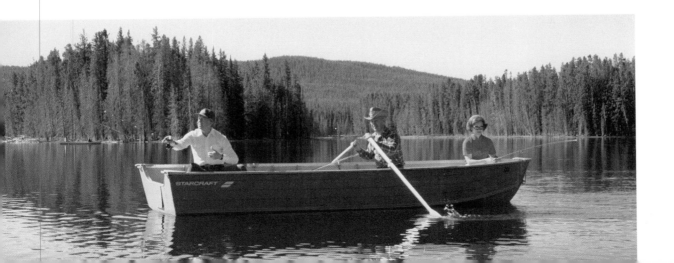

Indeed, the Great Funk was far more memorable for its extremes of ebullience and despair; mere cheerfulness scarcely enters the equation. One can feel this emotional intensity in one of the era's pop masterpieces, Stevie Wonder's two-LP album *Songs in the Key of Life* (1976). Its overall tone is joyous and celebratory, but it is hardly a smiley button. Wonder sings of his elation at the birth of his daughter in "Isn't She Lovely" but only after bemoaning the fate of poor children with sores on their hands playing in broken cars in "Village Ghetto Land." He celebrates Duke Ellington, one of his greatest predecessors, in "Sir Duke" but condemns those who want to live in a "Pastime Paradise"—or a future paradise. In between these bits of social criticism are dance numbers, love songs, and laments in a seeming attempt to include every feeling, emotion, and situation. That was a dream of the seventies, to live in the present, to love everyone and everything, and to miss nothing. *Songs in the Key of Life* epitomized seventies acceptance of complexity and love of layering. Wonder celebrated life in all its glorious contradictions, all of which could—and should—be experienced with the same heartfelt intensity.

A good way to feel the crosscurrents of Great Funk culture was watching the most compromised and allegedly brain-rotting medium, television. In the fifties, the society's tensions were largely invisible on television, while more recently, they have been dumbed down, polarized, and packaged into screaming ideological smackdowns. During the seventies, television recognized change and conflict in the society, and, capitalizing on its position of strength in the center of the household, showed how those tensions were coming home. The wisdom of the Vietnam War (thinly disguised as the Korean War) was being ridiculed on *M*A*S*H*. Several shows, including *Sanford and Son*, *The Jeffersons*, and *All in the Family*, found humor in class conflict and racial unrest. On *Saturday Night Live*, Gerald Ford was laughed at more for his clumsiness than for his policies. Still, calling attention to the president's literal stumbles focused attention on an administration that wasn't exactly sure-footed. The

In the aftermath of Watergate's mendacity, cosmetics promised Sweet Honesty, and cigarettes affirmed they were real. President Jimmy Carter and his wife, Rosalynn, sought simple, honest pursuits like fishing, as in this photo of a 1978 trip to Wyoming, *opposite, below.* But even simple pleasures could be fraught: When a "killer rabbit" tried to climb into Carter's boat in 1979, the president had to beat it off with a paddle, an incident that recast the leader of the free world as Elmer Fudd.

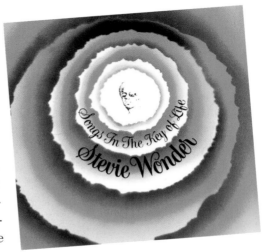

issues raised by feminism, and the grievances that brought it about, were aired in different ways on *Maude*, on which the title character had an abortion; *Alice*, which dealt with a single mother who had no choice but to work; and *Mary Tyler Moore. Soap* found comedy in frontiers of family dysfunction that few had even imagined.

For many, the 1973 public television series *An American Family* ranked among the shocks of the decade, right up there with the oil embargo and Watergate. In twelve one-hour programs, film-makers chronicled the real lives of Bill Loud, a prosperous Santa Barbara, California, builder; his wife, Pat; and their five children, Lance, Kevin, Grant, Delilah, and Michelle. They were, by and large, the kind of people you expect to see on television: attractive, healthy, living in a large, comfortable house. What was unexpected was that this nuclear family exploded right before the viewers' eyes. Pat, feeling the need to be something more than just a housewife, announced that she was leaving Bill, who was shown to be unfaithful to her. Lance, the eldest son, moved to New York, established himself at the fringes of the Andy Warhol scene, and announced that he was gay. The other members of the family were given plenty of screen time to show themselves wounded, angry, selfish, and shallow. ("Television ate my family," Lance Loud later reflected.) The celebrated anthropologist Margaret Mead pronounced the series "as significant as the invention of drama or the novel—a new way in which people can learn to look at life." *An American Family* was certainly unlike anything television had ever done before, boasting as it did the first real-time marital breakup, not to mention the first in-your-face homosexual. It was seen by only ten million people, not a large number in those pre-cable years, but certainly enough to get people talking. Some even believe it helped accelerate an already rising divorce rate. It was, nevertheless, great television that spoke directly to families.

The tensions of the time were even more visible in the movies, though often less literally expressed than they were on television. Indeed, the early seventies are widely acknowledged as a golden age of American film, which is just about the only art form of the period that gets any respect. *The Godfather* (1972) and *The Godfather Part II* (1974) bracketed the Watergate era, and by the time the sequel reached theaters, the values and behavior of the murderous gangsters the film

The Louds were the family that imploded on public television. With cameras watching, father Bill philandered, mother Pat walked out, son Lance emerged flamboyantly from the closet, and the other children were selfish and shallow. It was a long way from *Father Knows Best*.

depicted seemed almost noble compared with the conduct of some public officials. (The two summers' worth of congressional hearings about Watergate were transfixing television.) *Chinatown* (1974) was an immensely entertaining film that argued that the very basis of Southern California life—its drinking water—fed a conspiracy that was primordially sinister. *Shampoo* (1975), set on the night of Nixon's election in 1968, starred Warren Beatty as a hairdresser—Don Juan with a blow dryer—who motorcycles through the Hollywood Hills bedding the wife, mistress, and daughter of a wealthy pro-Nixon businessman. Clips of Nixon promising to bring the country together are juxtaposed with the behavior of people who seem to have no principles, only desires.

"The American people are turning sullen," proclaimed the ruthless television executive played by Faye Dunaway in the 1976 film *Network*. "They've been clobbered on all sides by Vietnam, Watergate, the inflation, the depression; they've turned off, shot up, and they've fucked themselves limp, and nothing helps . . . The American people want somebody to articulate their rage for them." *Network*, the story of a TV anchorman who is fired, then goes crazy on the air, then threatens to kill himself and becomes a big hit, was—the porno boom of the time notwithstanding—the most naked movie of the decade. It was funny and cynical, romantic and cathartic. And when the anchorman told his audience to go to their windows, open them, and shout, "I'm mad as hell, and I'm not going to take it anymore," he provided a cry for the age.

Even *Jaws* (1975), a summer blockbuster that some critics cite as the beginning of the end of serious American films, has a story based on a plot by officials to cover up the existence of a deadly menace. In seventies America, the killer shark was a reality that could be denied no longer.

Jaws was a post-Watergate thriller: Covering up the existence of a giant, hungry shark didn't make the monster go away.

During the Great Funk, people weren't precisely nostalgic for the Populuxe period. Many, if not most, were pleased to be free of the sexual stereotypes and other repressive elements of Populuxe culture. As *Shampoo* suggested, even those who disapproved of the licentiousness of the time indulged in some of the pleasures.

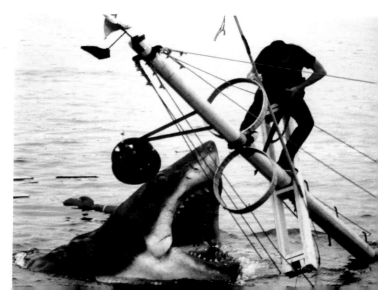

Still, Americans had been led, for a very long time, to believe that the two decades after World War II represented normal times. That's why the contrast between those times, so often described as innocent, and the far more confusing present was such a strong theme of seventies culture.

One of the most poignant and popular films of the era was 1973's *American Graffiti*, which depicted the world of eleven years before as if it were a distant and lost civilization. A film with very little plot, it follows the activities of several young people, most of them recently out of high school, on the last night of summer vacation. They drive around, flirt, and listen to the radio, in a world where nothing seems to matter but themselves. Its only overt political point comes at the end of the movie, before the closing credits, where a text panel tells what has happened to these fictional characters. One is a draft evader living in Canada; another died in Vietnam. Audiences couldn't help but reflect on what had happened to them in those few short years and how everyone's expectations had been remade.

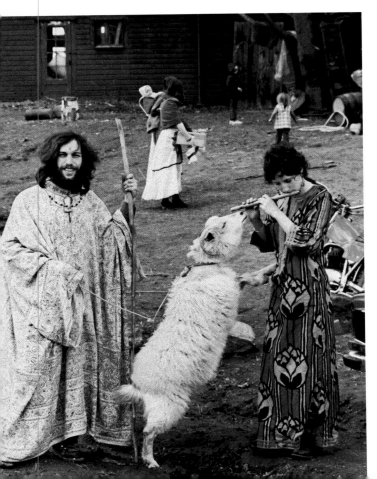

One of the main things the Populuxe era and the Great Funk had in common is that many find the artifacts of both decades—the tail fins of the former, the polyester leisure suits of the latter—to be aesthetically offensive. That may be because both periods were dominated by popular rather than elite taste. In the post–World War II era, most Americans were becoming wealthier, and they relied on big companies like General Motors to provide them with products that would enable them to assert and celebrate their good fortune. In the seventies, incomes were shrinking. People rushed to the warm, the fuzzy, the cheap. And in a time of perceived scarcity, people cluttered their homes as they hadn't done since Victorian times, creating places full of bold patterns, rough textures, salvaged junk, and domestic jungles of spider plants and ferns to serve as refuges from the world outside.

In the Populuxe era, however, there was only a narrow range of acceptable

clothing and hairstyles. A businessman who wanted to be wild on the weekend might indulge in a madras plaid sport coat, but that was about it. Women's wardrobes were more varied, but they were, for the most part, clothes designed to be appropriate for specific circumstances, in which most others would be wearing similar outfits. By contrast, many objects—including automobiles, appliances, and furniture—were quite expressive. Through color, form, and a set of dynamic, future-evoking ornamentation, their cars, refrigerators, barware, patio furniture, and other possessions embodied the joy of having things and the confidence that there would always be more. During the Great Funk, this shared nouveau riche optimism was long gone, but it had been replaced with a sense of personal freedom. Appliances and cars were no longer very sexy, but dress and behavior more than compensated. People sought to express their individuality, especially through their bodies. Much of what people wore in the seventies might appear, in retrospect, to be a misjudgment. But the clothes, the hairstyles, the dances, and the attitudes were very positive gestures, affirmations that people could feel good about themselves regardless of whatever else was happening in the world. They didn't use machinery to live out their dreams, as in Populuxe times. They used their bodies instead.

The key symbolic object of the Populuxe era was the jet fighter plane, whose acute angles and parabolic curves created "a new shape of motion" that was tremendously faster than the streamlined shapes that had come before. The fighter plane projected a vector of progress, powerful, relentless, unstoppable. By the seventies, people had lost their faith in progress, or at least in the common vision of progress that seemed to have crashed and burned. The energies within society were more diffuse, pushing in many different directions.

One candidate to be the characteristic object of the age is the disco ball, which, as it revolved, reflected light by breaking it into discrete beams shooting in unexpected directions. And as those tiny points of light shined upon them, each dancer on the floor could feel like a star. The disco ball is an instrument of disorienta-

In *Shampoo*, Warren Beatty was a hair stylist who often bedded his customers. The sin in *Shampoo*, though, wasn't sex; it was hypocrisy. *Opposite*: A flute, a sheep, and great clothes added up to counterculture Arcadia.

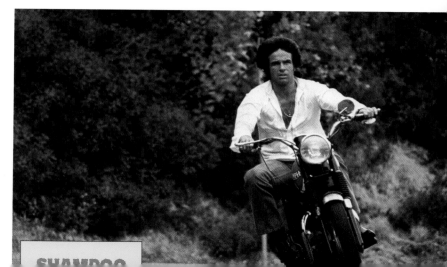

tion, which makes it an appropriate symbol for the seventies, an era whose allure lay in the belief that old ways were dead ends, and that new paths might lead in any direction.

But there is another spherical object that might be an even stronger candidate: Earth itself. "Fly Me to the Moon," Americans had crooned throughout the sixties. During that decade, the song was recorded by acts ranging from Frank Sinatra to Dion and the Belmonts. In 1969, we finally got there, and it turned out to be a dead end. In 1961, astronaut Alan B. Shepard made history as the first American in space, and his short sojourn outside Earth's atmosphere seemed little short of heroic. By 1971, Shepard was on the moon, hitting golf balls, and the Apollo mission had come to seem a cosmic irrelevancy.

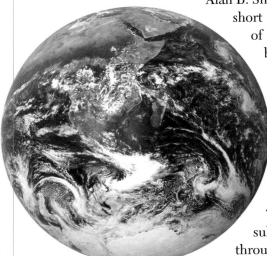

Fortunately, though, the astronauts took some snapshots along the way, and the best ones were taken when they looked back toward home. Earth sparkled in the heavens, a shining sphere of blue ocean, orange earth, and swirling white clouds. It was beautiful—and finite. It provided an unforgettable reminder that we live on what Buckminster Fuller, in 1963, termed "spaceship earth." Like the astronauts in the *Apollo* capsule, the inhabitants of the planet were seen to be floating through space aboard a vessel that had very limited resources.

That view of Earth from space galvanized efforts to conserve these resources and stop, or at least slow, the despoiling of the planet. Though we tend to associate the environmental consciousness of the seventies with oil shortages, the first and most widely observed Earth Day was observed in April 1970, more than three years before the first oil embargo. Concern about pollution had been building for many years, but the astronauts' view of Earth from space provided the image that people rallied around.

The icon of the Great Funk era was the blue-green Earth, shining in space, shimmering and finite, whose survival was in human hands . . .

Both of these spherical icons—the disco ball and the glowing Earth—seem to represent contradictory visions. The fragmented brilliance of the disco ball embodies the differences that seemed so suddenly to have emerged in the culture, and it evokes the hedonism and theatricality that were so much a part of seventies life. The glowing Earth in space represents an awareness of limits and an emerging sense of responsibility for future generations and all the other life on the planet. Earth consciousness also helped give us earth tones, the oranges, browns, greens, and tans that were the background colors of life during

the Great Funk. Glitter doesn't seem to go with mud, but both were big in the seventies.

Yet they are linked both ecologically and emotionally. The science of ecology demonstrates that a diversity of life-forms is a sign of health in an environment. Monocultures are prone to sudden collapse in biological systems, and it's not difficult to extend this insight to social, political, and economic systems as well. Postwar America seemed to aspire to monoculture, and in the seventies it seemed in danger of collapse. The country was clearly going in the new direction; it was time to break up and try a lot of new paths.

Beyond this rationalization, though, there were just too many pent-up urges. Many people had feelings and desires that were suppressed by the society's expectations. The roles people could play were few and limited. And when the system weakened, the oddballs and malcontents found an opening. It became possible to try out identities and find solidarity with other rare birds like yourself. Awareness of a world with limits allowed people to impose fewer limits on themselves and to explore frontiers within themselves.

Thus these twin spherical icons express different but not contradictory ways of seeing and being. The dazzling disco ball symbolizes the many different directions in which people were taking their lives, or permitting themselves to be led. Earth is a reminder of profound commonality. Yet, as Buckminster Fuller noted in 1970, "none of the perpendiculars to our spherical earth's surface are parallel to one another; they go in an infinity of directions." That tells us that each person standing has a direction of his or her own, but we should also understand that we're all in the same boat. This seems obvious, but it became so only in the seventies.

. . . or was it the disco ball, a tool of disorientation, an enabler of abandon? Or—this was an inclusive time, after all—was it both?

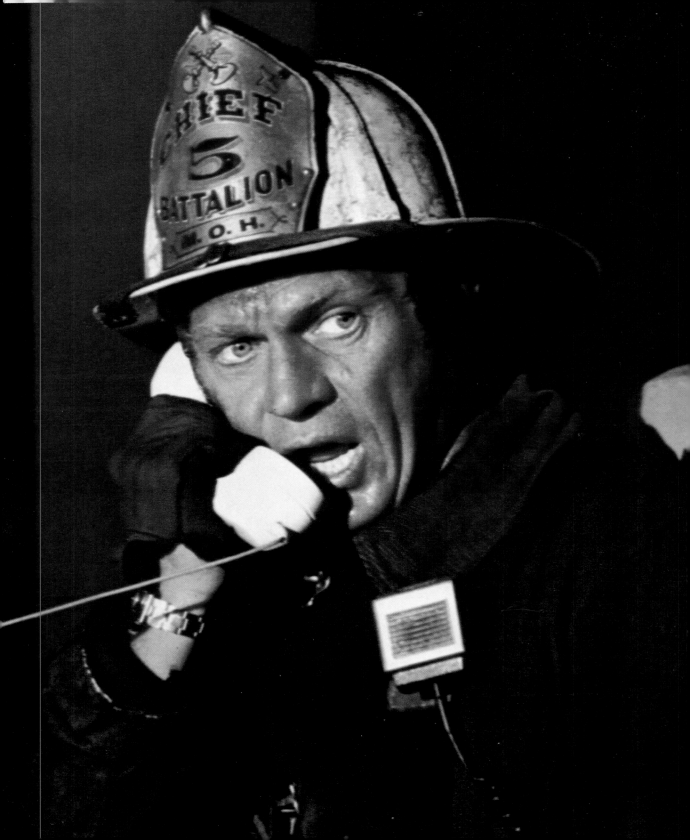

Too Late, Baby

There are some songs that have a bit of phrase and melody—what music pros call a hook—that insinuates itself in your consciousness and pulses in the background of everyday life. In 1971, the hook that burrowed into many minds went, "It's too late, baby, now it's too late," the chorus from the hit song from Carole King's *Tapestry* album. The song itself was about the end of an affair, though the feel of the tune was more triumphant than melancholy. King sang that she was going to stop faking her love, and although she mourned that something inside had died, there was an infectious, affirmative quality to the melody that overpowered any inclination toward self-pity or depression.

And like many bits of pop genius, the hook from this song serendipitously summed up a more general mood in the culture. It was too late, baby, for so many things. Many felt it was too late to do anything right in Vietnam, except give up. Environmentalists warned that it was too late to do anything about global warming, even as some others warned that a new ice age was on the way and nothing could be done about it. Population theorists warned that the planet could not sustain rising human numbers, and that it might already be too late to avoid global catastrophe. It was too late to find enough oil, or enough copper, or to grow enough food so that most of the people in the world could live healthy, productive lives.

In a spate of disaster films, including *The Towering Inferno*, overconfidence sparked disaster, and aging actors took the hit. It was up to honest working guys like Steve McQueen to ensure that at least a few members of their all-star casts survived.

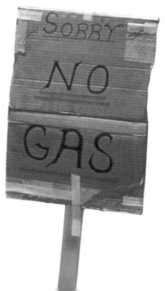

It was too late, others warned, to stop a slide of educational and social standards. Underachievement and criminality begin at home, and by the time children get to school it's too late to do anything about it. Others complained that universities and other once-elite institutions had surrendered their standards and would never be able to restore them.

And for a different group, the end of the world as we know it appeared increasingly imminent and they were looking forward to it. These were Christians who, looking at the dangerous conflicts in the Middle East and resource shortages around the world, saw the hand of God. The establishment of Israel and the tensions that resulted were, these people concluded, proof that the end-time that had been predicted in the Book of Revelation were already under way. It was too late to stop them, not that any human could, though you could look to yourself and see whether you might be saved when the day of Rapture arrives.

A Populuxe sign offers a Great Funk message.

If all the real problems of the moment weren't enough, Hollywood served up fantastic doses of too-lateness in the form of lavish, star-studded disaster films. The movies' plots are so similar that they run together in memory, largely because they dramatized a widely shared perception of their time. The films opened in an atmosphere of smug opulence. Something wonderful was being celebrated—the largest and most luxurious ocean liner the world had ever seen in *The Poseidon Adventure* (1972) or the tallest and most amazing skyscraper in *The Towering Inferno* (1974). Slightly over-the-hill movie stars come out in droves to celebrate this wonder, but a few are worried. Corners have been cut, worries have been dismissed, corruption has compromised the grand achievement. Before you know it, the liner has capsized, or the skyscraper's cheap wiring has shorted out, and the world has turned upside down. The glamorous celebrants must crawl and slither and climb and tear their way to safety. Some will reveal themselves as heroes, others as villains, and some won't survive. Indeed, one of the unspoken pleasures of these films is that there were so many stars that they were expendable. You never knew which one might be the next to be crushed or incinerated. When, for example, Charlton Heston, who as Moses

parted the Red Sea in *The Ten Commandments* (1956), got washed down a storm sewer in *Earthquake* (1974), audiences knew that nobody was safe anymore. The authority figures—developers, contractors, captains of industry—are unmasked as frauds and humbled, while the guys who just do their job, such as *The Towering Inferno*'s fire chief, played by Steve McQueen, and security guard, played by O. J. Simpson, turn out to be the real saviors.

Each of these disaster films ends in reform, as the survivors realize the magnitude of the dangers they have so narrowly escaped and resolve to build their buildings and their relationships on sounder footings. A little catastrophe, the movies tell us, can be good for the soul.

Thus, as the insouciant melody of King's song implied, the too-lateness of the times could have positive results. James Reston opined in *The New York Times* that the seemingly endless string of setbacks would help build the nation's character. For others—including minority, feminist, and gay advocates—disaster offered opportunities for liberation. And for some, it brought the hope of redemption.

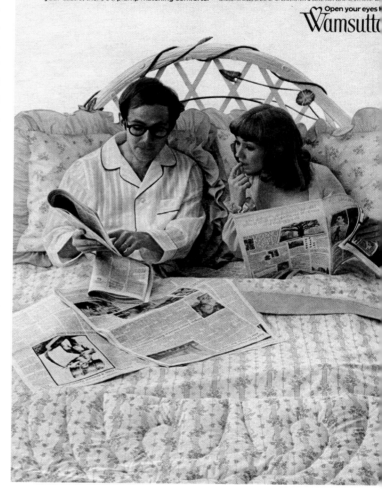

In many ways, the story of the seventies is about how people dealt with issues that were first raised during the late sixties. Still, looking back, we see that those two eras were very different. The sixties were about struggle, the seventies about acceptance. In the sixties, the prophets of apocalypse were protest singers, hippies, and a handful of writers and artists. By the seventies, even despite a slight easing of the Cold War confrontation that had brought the world to the brink of nuclear war in 1962, the idea that a cataclysm of some kind was coming was simply a commonplace. Doomsayers weren't only zealots, picketers, and preachers. Some were schmoozing on Johnny Carson's sofa.

Sometimes it seemed the only way to cope with a flood of bad news was to just stay in bed.

Is your license number odd or even? This became a big issue as the 1973 gasoline crisis brought alternate-day regulations. The unintended effect was that lines grew longer and motorists more desperate because they didn't dare miss filling up on their designated day.

Although it was too late to do much about the great issues, you could still live your life in a less harmful way. You could cease pretending to believe in things that had already failed—whether that belief was in an old boyfriend, an old policy, an old technology, or an old religion—and live your life in an honest way, doing what you could to keep things from getting worse. It may have been too late, baby, but people still had to eat, to work, to live. You did what you could, even though that probably wouldn't be enough.

Starting in 1972, America seemed to be running out of everything. All sorts of essential supplies, from beef and gasoline to baling wire and raisins, became suddenly scarce, setting off waves of panic buying and hoarding. The reasons for each of these shortages were different, although many were the result of government mandated price freezes and rationing. Inflation played a role, as did rising commodities prices. Indeed, some people started hoarding their pennies once they heard that the copper they contained was worth more than a cent. Whatever their cause, though, each contributed to an overall sense that life was somehow changing for the worse, and one couldn't really depend on anything.

While the oil crisis that followed the Yom Kippur War between Israel and Egypt and Syria in 1973 was by far the most serious and memorable

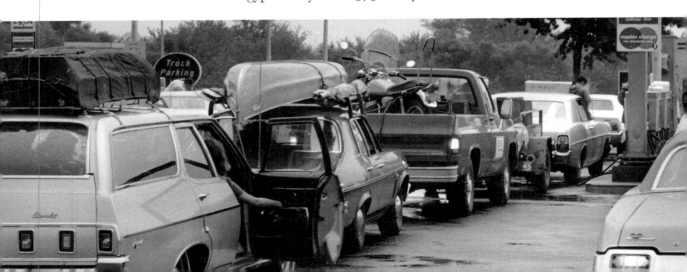

such crisis, it was not the first. Earlier that year, Americans were up in arms over a shortage of beef. This was a panic caused by a chain of events that began with the failure of the Soviet wheat crop. Our Cold War adversary entered the American grain market in a big way, and the demand for bread in Russia increased the price of feed for cattle raisers in the United States. Meanwhile, as part of its inflation-fighting efforts, the U.S. government imposed a price freeze, and Americans stampeded their supermarkets, bought up every cut, and stuck the meat in their home freezers. One unexpected result, according to the University of Arizona archaeologists who excavate land-fills, was that abnormally high amounts of meat were thrown away uneaten. The reason, as the archaeologists confirmed in studying the sugar shortage of 1975, is that when people panic over shortages, they buy cuts of meat or kinds of products with which they are unfamiliar. They don't know how to use the products, or how to store them, and as a result, things are wasted.

In October 1973, Saudi Arabia and other Middle East oil producers restricted oil exports in order to pressure the United States to lessen its support for Israel. The price of crude oil quadrupled. Many feared that gasoline would simply become unavailable at any price. By winter, most states had initiated a rationing system that allowed people to fill their tanks every other day, depending on whether their license plates ended with an odd or an even number. This policy was a disaster, one that caused endless lines at gas stations that included many who didn't need gasoline at the time but thought it prudent to top off their tanks. Drivers did not wait patiently. The lines, which sometimes ran to a hundred cars or more, backed up highways and even freeways, causing more anger and frustration. Untold amounts of gasoline were wasted as motorists repeatedly started their cars so they could crawl a few feet closer to the pumps. The lines also produced more than their share of fender benders, as motorists made sure that they would maintain, or even improve, their place in line. In one San Jose, California, incident, a gas station attendant fended off several people who were trying to push to the head of the line by spraying them with gasoline.

PAIN AT THE PUMP
Regular gas per gallon

	
1970	36 cents
1971	36
1972	36
1973	39
1974	53
1975	57
1976	59
1977	62
1978	63
1979	86
1980	91

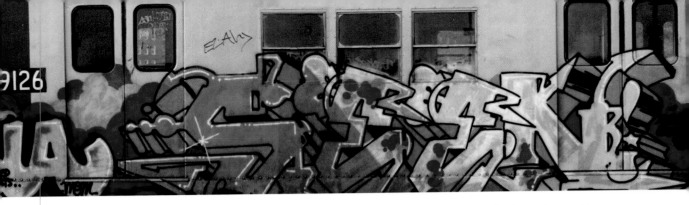

In December 1973, Johnny Carson made a joke based on a Wisconsin congressman's statement that the government would face a shortage of toilet paper. ("I hope we don't have to ration toilet paper," U.S. Representative Harold Froehlich said. "A toilet paper shortage is a problem that could touch every American.") The next day, supermarkets were cleared of toilet paper as viewers rushed out to stock up. The following night, Carson said that it was a joke and there was no shortage, but by the time he said that, he was wrong. There *was* a shortage because people believed there was one. Scott Paper ran advertisements showing the mills turning out vast quantities of the product, but it didn't matter as people bought and hoarded. For three weeks, stores found it difficult to keep rolls on their shelves.

This mania wasn't limited to consumers. Many businesses became involved, the Federal Reserve Bank reported in 1974. They were buying and hoarding everything from plastic resins and paper to oil-drilling equipment and steel. The Fed also found that black markets were springing up for many basic commodities.

The period of outright panic didn't last very long. The oil embargo was lifted in March 1974, and most of the rationing systems were gone soon after. Nevertheless, some effects remained for a very long time.

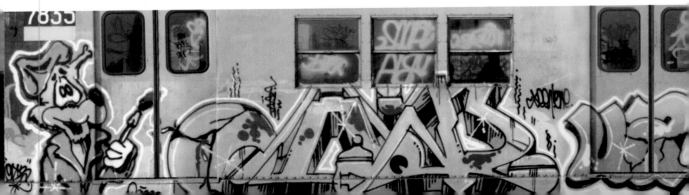

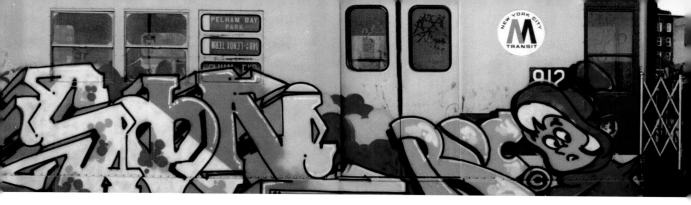

For example, in many cities, building owners were required, or shamed into, turning off exterior lighting on tall buildings. The lights on many civic buildings were extinguished in order to set a good example to citizens who were being exhorted to cut down on their own use of electricity. In most major cities, advertising signs were allowed to go back on once it became clear that gloom was bad for business, but the big skyscraper and civic lights stayed off for years.

The dark skylines seemed indicative of an atmosphere of urban abandonment, as major American cities continued to lose middle-class population and became increasingly dangerous and run-down. In 1971, someone erected a billboard that requested "Will the Last Person Leaving SEATTLE—Turn Out the Lights," and similar billboards and bumper stickers appeared elsewhere. In 1977, all the lights went out in New York City, and unlike a similar incident twelve years before, this blackout brought significant looting and arson.

When a new oil embargo was imposed in 1979, Americans were even more desperate than they had been six years earlier. In June, a truckers' protest over the high cost of diesel fuel at a Levittown, Pennsylvania, intersection where there were six gasoline stations grew into two days of rioting in which more than one hundred people were injured. Unrest had reached suburbia.

While people's behavior was far from consistent throughout the decade, the fear of scarcity never completely disappeared. The fifty-five-mile-per-hour speed limit, the unreliable cars that had been recon-

In cities throughout the country, graffiti filled the walls. Sometimes, as on this New York subway train, it was energizing and artistic. Usually, it was a dispiriting sign of neglect.

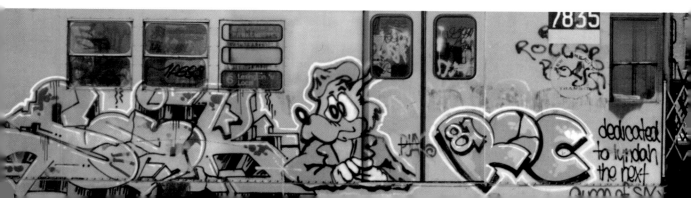

figured to meet fuel efficiency standards, the constant reminders not to be "fuelish" served as reminders that one of America's oldest freedoms—the freedom to waste—had been severely curtailed. "We have learned that more is not necessarily better," Jimmy Carter said in his inaugural address in 1977. "Even our great nation has recognized limits."

H it me and we blow up together." This admonition, which began to appear on the bumpers of Ford Pintos in the mid-seventies, was not an apocalyptic warning but rather a fatalistic acknowledgment of a real flaw in the vehicle. The design of the Pinto, with its nearly useless bumpers and bolts that penetrated the gas tank in rear-end collisions, greatly increased the danger that a rear-end collision would cause a fire. As if this weren't bad enough, documents that emerged in 1974 during one of several lawsuits that followed Pinto fires suggested that Ford could have fixed the problem for $11 per vehicle. It had not done so because a cost-benefit analysis had determined that it would be cheaper to settle the lawsuits than make a safer car. In 1978, a jury awarded $124 million in punitive damages to one plaintiff, and not long after, Ford discontinued the Pinto. While later commentators have argued that the Pinto wasn't significantly more dangerous than other cars, at the time the scandal confirmed widespread suspicions of Detroit's contempt for their customers. Everyone knew that American automakers were offering very few exciting cars. Dull and dangerous is a terrible combination.

American automobile companies have never liked to sell small cars because profit margins are greater for larger vehicles. The U.S. producers have always viewed small cars as loss leaders; each one sold is a lost opportunity to sell something bigger. Contrary to what many people remember, however, American car manufacturers had experience making small cars. There were several

attempts to interest Americans in small cars after World War II, most dramatically in the early 1960s when Detroit introduced whole lines of small cars, including the Chevrolet Corvair and Ford Falcon. But small cars tend to grow year by year, and in the early seventies, Detroit launched a new generation of small cars in response to competition from Japan. The Pinto, for example, was introduced in 1971. Until the oil crisis, however, the most popular American cars were long, low, and luxurious, powered by large V-8 engines, while small American cars, like the Pinto, were nasty, brutish, short, and not very popular.

Expensive gas changed everything. In 1974, the average fuel economy for all new American cars, including the compacts, was below fourteen miles per gallon. Many cars barely managed ten miles per gallon, and rising prices at the pump made these seem to be white elephants. During the panic stage of the energy crisis, drivers sold their muscle cars and luxury cruisers for a fraction of what they had cost and replaced them with smaller, fuel-efficient vehicles. Detroit hastened to meet the increased demand for more economical cars. In some cases, they attempted to modify the engines of their gas-guzzlers to get better mileage, which made them liable to stall at inopportune times. American automakers curtailed their premarket testing and instead rushed untried technologies into the dealerships. The result was that American cars were increasingly perceived as unreliable. And worst of all for Detroit's automakers, they were left with large inventories of small cars, which buyers rejected once gas prices stabilized.

The seventies gave the auto industry a case of whiplash from which it never fully recovered. Automobiles no longer provided the basis for peo-

Ford's compact hatch-back Pinto, *center,* had an explosive rear end that cast doubt on the competence and morality of the U.S. auto industry. In the wake of gasoline shortages, automakers tried to convince buyers that the big, soft behemoths they sold, such as the Gran Torino, *bottom left and right*, were actually responsible choices.

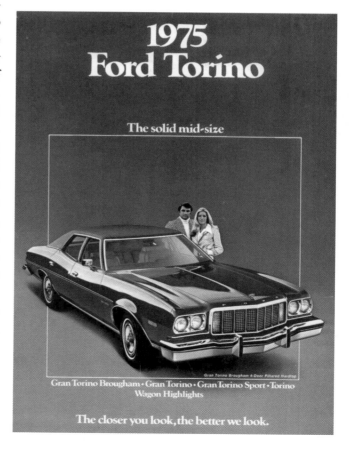

1975 Ford Torino

The solid mid-size

Gran Torino Brougham · Gran Torino · Gran Torino Sport · Torino Wagon Highlights

The closer you look, the better we look.

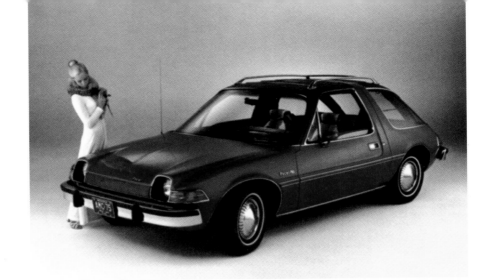

The AMC Pacer, *above*, was fat and funny, and its big windows made it a greenhouse on wheels. Still, it was interesting, and there was nothing else like it. The powerful, sexy Datsun 240Z, *below*, was the first Japanese car that American buyers really wanted. Once in the showroom, they discovered the practical, compact 510 sedan, *opposite*, which was a pretty good car too.

ple's fantasies of progress and power. Indeed, as gas prices rose and wages stagnated, they were perceived to be part of the problem.

The 1975 Ford Torino, for example, was promoted as "the solid mid-size." The word "solid" sounds a bit defensive; this is the company that brought us the Pinto. But you hear the word "mid-size" and look at the car, with its immense front end and relatively cramped, though swanky, passenger compartment. If this eighteen-foot-long car was mid, what was big? That would be the nineteen-foot LTD, if you wanted a Ford. (Cadillacs were on average an inch or two longer than that.) Still, the Torino was far from the worst of seventies cars, and it was the kind of car that proved popular after the first oil shock wore off and before the second one arrived in 1979.

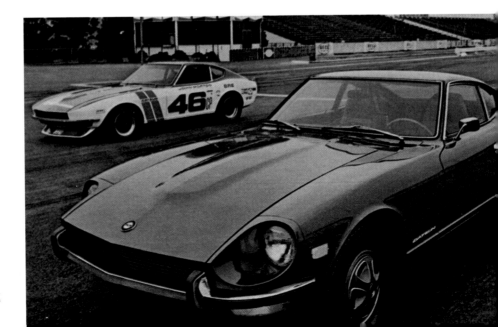

American cars from the early seventies are remembered far more often for their power than for their styling, and by the late seventies, even most of the power was gone. Throughout the decade, the character of cars became blurred. Buicks looked a lot like Chryslers, which looked a lot like Chevrolets and Mercurys. Many sported "luxury" features, such as landau roofs that were partly covered in vinyl to suggest a convertible top, or so-called opera windows, which provided limited views and no ventilation to the backseat.

Only a handful of cars had real personalities, and many of those came from the smallest U.S. producer, American Motors. The company's chief designer, Richard A. Teague, had worked for such legendary

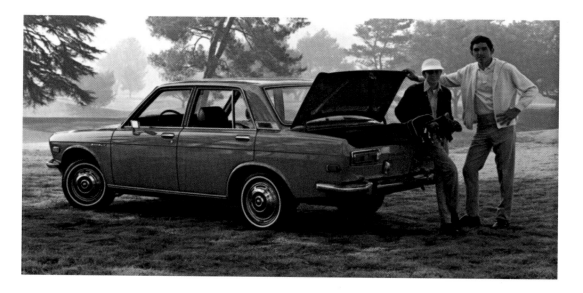

sculptors of sheet metal as Harley Earl, the father of automotive styling; Virgil Exner, the architect of Chrysler's "Forward Look"; and William Mitchell, creator of the Corvette Stingray and Buick Riviera. Compared with these, such vehicles as the AMC Gremlin, which was introduced in 1970 and was America's first subcompact, and the roly-poly AMC Pacer, introduced in 1975, might seem anticlimactic. Nevertheless, these two cars embody a sense of artful desperation that made them stand out from the crowd and epitomize at once the best and worst of the seventies.

Teague had little money to work with, and many of his designs reconfigured existing parts in new ways. He later recalled that he sketched out the Gremlin on the back of a Northwest Airlines airsickness bag. Essen-

tially, it was an existing AMC model whose tail had been cut off with a diagonal stroke. This so-called Kammback shape had been found to be more aerodynamically efficient than shapes that strike the eye as streamlined. The car was a pioneering hatchback, although one that inspired people to ask, "Where's the rest of it?" The Pacer offered unprecedented visibility; the curved windows all around made the passenger compartment into a hothouse, which put a heavy burden on its air conditioner, an added-cost—but essential—option.

The two most important cars in America during the seventies weren't American cars. They were Japanese.

The first was the Datsun 240Z, a two-seat sports car that delivered speed, glamour, and even reliability at a very reasonable price. This car, which was actually introduced in late 1969, endured as an object of automotive lust throughout the early seventies. Its importance was not in the number of units sold, or in the impact of its European-inspired styling. Rather, it was what is now known as a "halo car," a fantasy model that increases the desirability of other, more practical cars. Usually, a halo car helps the manufacturer's other models; the 240Z helped elevate the status of all Japanese cars.

Japanese cars had been exported to the United States as early as 1958, and they started to catch on, particularly on the West Coast, during the late sixties. But they were seen not as real cars but as low-priced substitutes for cars. They were dull and boxy looking, with styling somewhat below the level of European cars like Renault and Fiat, which Americans viewed as second-rate. During the immediate post–World War II decades, Japan

The Honda Accord wasn't a vast improvement over earlier Japanese models, but after the 1979 oil crisis, Americans embraced it as a family car for uncertain times.

was the origin of vast numbers of cheap manufactured goods. It made great tin toy cars. As for real cars, Americans were skeptical of Japanese products. They needed something exciting to shake their preconceptions.

And that's exactly what the 240Z did. It was the first Japanese car that appealed to the emotions, the first Japanese car that Americans really wanted. In many cases, those who went to the showroom to look at the 240Z drove away in another car, the Datsun 510. This was a far more responsible car, a four-door sedan whose styling was anything but memorable. Still, it cost less than a Volkswagen Beetle but had a lot more passenger room and horsepower. Unlike the Volkswagen, it had a functioning heater, optional fully automatic transmission, and optional air-conditioning. When you drove it, it inspired a lot more confidence than Detroit's halfhearted stabs at small cars. The 510 driver had to endure sneers from garage mechanics and auto worker relatives about the stupidity and disloyalty of buying cheap Japanese junk. Gradually, though, the sense emerged that the Japanese car makers were serious about what they were doing. Their cars offered the economy of European cars, but with greater attention to comfort and quality. Detroit was adrift, trying to deal with an economy of expensive oil and physical limits, just the kind of society for which the Toyotas, Datsuns, Mazdas, and Subarus had been created. Japanese cars suddenly made a whole lot of sense.

Think tank reports, such as the Club of Rome's *Limits to Growth,* were the intellectuals' answer to disaster flicks. Their computer models produced graphs that showed that too many people and too few resources were steering the world toward a catastrophic crash.

The second of the most important cars of the seventies brought this reality home. This was the Honda Accord, introduced in 1976, with a four-door sedan introduced in 1979. Even though it was far smaller than the aircraft-carrier-like sedans that were still coming out of Detroit, and its horsepower was actually lower than that of the Datsun 510, the sedan was successfully sold as a family car. It's true that families were getting smaller, which helped. More important, it boasted an enormously efficient engine, one that didn't need expensive and balky catalytic converters to comply with U.S. air quality regulations. That promised a car with fewer headaches than most. Not everyone loved the car; *Forbes* picked the 1978 hatchback model as one of the worst cars of all time. But it was a perfect car for its moment. It seemed designed from the inside out. Its interior was comfortable but not showy. Its exterior was modest but not cheap looking. It delivered on the premise of the 510 that small cars are not a compromise but rather a sensible choice that can express positive values.

Americans had then, as they have now, little choice but to drive. But how can you justify an activity that uses up a finite, dwindling resource and pollutes the planet besides? The Honda Accord promised to do the least harm and be comfortable too.

The battle to feed all of humanity is over," Paul Ehrlich wrote in his influential 1968 book, *The Population Bomb.* He was *not* declaring victory. He continued: "In the 1970s, the world will undergo famines—hundreds of millions of people are going to starve to death in spite of any crash programs embarked upon now. At this date, nothing can prevent a substantial increase in the world's death rate . . ." Ehrlich compared overpopulation to cancer and argued, by analogy, that one shouldn't feed the cancer by such methods as food aid but by a tough-minded policy that would allow the population to drop to a level Earth could support. He said that there were many things that could be done about the threat that too many people posed to the planet's carrying capacity, but he counseled a cold global view rather than a warm personal

one. Such exercises of human creativity as more productive grains, the keystone of the so-called green revolution, would only delay the day of reckoning, Erlich argued. In 1970, Norman Borlaug, the agricultural scientist most identified with this effort, was awarded the Nobel Peace Prize. But Ehrlich viewed such achievements as distractions from the real problem. He didn't hope, as some did, for more Norman Borlaugs. For him, the only solution was fewer of everybody.

When it was published, this dense tract by a Stanford population sciences professor drew little attention. It grew into a major social phenomenon, however, and Ehrlich became one of the country's most visible prognosticators during the seventies. He was such a charming and articulate guest that Johnny Carson let him talk for more than forty-five minutes during his first appearance on *The Tonight Show* and invited him back more than two dozen times. Thus Ehrlich's bleak predictions came into not only the homes of nonreaders but also into their beds. And that was right where he wanted to be, telling them that they shouldn't do anything that would increase the number of mouths the world would have to feed. Ehrlich made the best of his invitations to

In *Silent Running*, *opposite*, the last surviving plants were exiled to space under the care of Bruce Dern and a couple of robots. *Logan's Run*, *below*, showed a near-future society in which those over thirty are allowed to survive only if they can keep themselves from being spun off a diabolical merry-go-round, a portent of the impending disco era.

preach the message, if not the mechanics, of population control to the heartland. He did advise, however, that parents encourage their children to take birth control devices to school for show-and-tell, as part of an effort at cultural transformation.

In 1972 another book, *The Limits to Growth*, issued by an international think tank called the Club of Rome, was believed to echo Ehrlich's hypothesis, and when the oil shock came in 1973, it became a sensation, selling a reported twelve million copies. It's difficult to believe that many of them were read, because the thing that made the study innovative—its use of a computer simulation called World III, which was somehow seen as more reliable than the opinion of mere experts—made for a very dry text, filled with difficult-to-decipher charts. Its theme was that accelerating economic growth could not continue indefinitely, although, unlike Ehrlich, it said that civilization had about a century to apply the brakes, before humans crashed into the world's limits. The book's message was, however, more often viewed not as a basis for new policies but as a reason to panic.

It all seemed pretty simple. Earth is finite. There were ever more people demanding ever more things. People were experiencing air pollution and traffic congestion and materials shortages, which seemed to suggest that humanity's fat and happy days were at an end.

While there is no doubt that technology had proved its ability to make people and resources more productive over time, there was no reason to trust blindly. "We'll think of something!" seems a policy better suited to farce than to managing an exploding planet. Environmentalism had been building as a grassroots bipartisan political movement throughout the sixties—several strong new environmental laws were passed during that decade—and the Environmental Protection Agency began operating in 1970. But people began losing trust in government because of the Vietnam War, the 1971 publication of the Pentagon Papers, which revealed failed policy making, and later Watergate and the oil shocks. It was far from unbelievable that bureaucrats and politicians weren't

up to coping with a global crisis. Corporations were even worse because they were causing the problem.

The 1971 movie *Silent Running* was a memorable pop-culture take on ecopanic. It's set in the year 2008, and all the plants on Earth have been destroyed. The only remnant of Earth's greenery is contained in a sort of terrarium spaceship—a vast interstellar fern bar—maintained by a robe-clad hippie ecologist and three endearing robots. When the order comes that the plants must be destroyed because the ship is to become a freighter, the ecologist finally rebels. In *Soylent Green*, released two years later but set fourteen years farther into the future, New York City is teeming with forty million mad, starving people and a handful of rich fat cats. The only food choice is an artificial food of mysterious provenance. The memorable thing about that movie was the advertising campaign for this mystery food, delivered in precisely the tone of all-knowing, benevolent authority that Americans of the time were learning to mistrust. "Soylent Green is people," was the slogan, and it was truth in advertising. The movie's not-so-shocking revelation was that Soylent Green

AND FABIAN WAS 500TH

Most popular boys' names of the seventies:

	number
Michael	706,714
Christopher	475,752
Jason	462,263
David	445,367
James	444,458
John	402,205
Robert	396,982
Brian	322,397
William	283,209
Matthew	277,441

was people, ground up, processed, and, mysteriously, not missed. The overpopulation horror genre also produced *Logan's Run* (1976), whose premise was that people would be allowed to live a hedonistic life until age thirty, then would be either routinely exterminated or hunted down. That film even became an appropriately short-lived weekly television series the next year.

Though all these movies were set in an American future, Ehrlich bemoaned that Americans viewed the population explosion as a problem of poor places such as China, India, and Africa. It was unquestionably true that these were the most precarious places, and only a few years before Ehrlich's book, China had suffered a series of famines believed to have killed somewhere between ten million and forty million people. This recent dying off, the worst in history, made Ehrlich's dire predictions credible. Still, in terms of resources, Ehrlich argued, each additional

MAX TOTH AND GREG NIELSEN

PYRAMID POWER

The Secret Energy of the ancients revealed
the world's greatest mystery!

Pyramid power could keep your mind and your razors sharp. And it could do wonders for hamburgers.

American put a greater burden on Earth than several more Chinese. The organization Ehrlich founded, Zero Population Growth, devoted most of its attention to developed countries. It called on the affluent to stop reproducing, and they did. Birthrates plummeted in North America, and especially in Europe and Japan, during the seventies, though it is difficult to determine whether Ehrlich's book or his bedtime sermons to Johnny Carson had anything to do with it. A bit later, China began to institute draconian programs of birth control, one feature of which was to empower busybodies and informers to police pregnancies. World population grew from about 3.6 billion people when Ehrlich's book was published to an estimated 6.75 billion forty years later. This is an enormous increase, though not as dramatic as Ehrlich predicted, and there have been horrific famines during that time, though nothing as dire as the hundreds of millions of deaths he anticipated.

In one respect, Ehrlich and the prophets of planetary collapse who followed him were in an odd position: People in affluent countries, who were their primary audience, actually followed their advice. (More recently, the birthrate has been in decline worldwide.) But with disaster apparently averted, or at least postponed far longer than they thought possible, the prophets of environmental collapse ran into the familiar dilemma of doomsayers on the morning after the world doesn't end. People are relieved, of course, but they also feel that they have panicked needlessly. That makes them less inclined to take subsequent warnings seriously.

The other strain of apocalyptic thought that emerged during the Great Funk was based not in science but in religion. Hal Lindsey's 1970 book, *The Late Great Planet Earth*, which sold twenty-eight million copies, revived an unorthodox early-nineteenth-century interpretation of the Christian Bible's final book. What made it a phenomenon, though, was the way that Lindsey fused his obscure theological interpretation with an account of current events. He saw the creation of the state of Israel in 1947 as a strong precursor to the end of the world and the Second Coming of Jesus, an argument that could claim some support in the biblical text. In addition, Lindsey surveyed just about everything that was happening at the time.

"Look for the present sociological problems such as crime, riots, lack of employment, poverty, illiteracy, mental illness, illegitimacy, etc., to increase as the population explosion begins to multiply geometrically in

the late '70s," Lindsey wrote, with a distinct echo of Ehrlich. "Look for the beginning of the widest spread famines in the history of the world." Lindsey also told his readers that they should look for drug addiction, a loss of support for the military, a greater interest in Eastern religions, and many other phenomena they wouldn't have much trouble finding. Prophecy is inevitably about the present; its predictions are typically about what will happen if the prophet's wisdom is ignored. Lindsey often seemed to be predicting the present, which made him far more likely to appear correct. Lindsey, like Ehrlich, sought to scare his readers into new patterns of belief and behavior. His edge was his ability to convince people that the day's discouraging headlines were not only anticipated by Scripture but were an expression of God's will.

Lindsey tapped into a lively market for prophecy during that time; books about extraterrestrial saviors, the rebirth of Atlantis, and other unlikely prospects were also phenomenally popular. In 1973, a television program, *In Search of Ancient Astronauts*, based on Erich von Däniken's 1968 book, *Chariots of the Gods*, helped popularize the idea that all Earth's civilizations were started by advanced creatures from outer space. According to von Däniken, a Swiss hotel manager, these aliens visited Earth repeatedly, mated with human women, and taught people all that they needed to know. This claim was buttressed by the existence of archaeological artifacts of which, it was asserted, early humans could not have been capable. For example, he argued that the great pyramid of Khufu in Egypt would have taken 684 years for humans to have built without extraterrestrial help.

(Von Däniken helped revive a minor cult of pyramids, in fact. Some people began building tiny pyramids in which to store their razor blades to keep them sharp. Others built pyramidal canopies over their beds to sharpen their minds or increase their sexual potency.)

It's likely, though, that the scientific (or pseudoscientific) basis for such New Age beliefs was less important than their adherents' hunger to ascertain some deep, hidden meaning in the cosmos. In von Däniken's case, the presence of creatures from the sky, gods and angels, in so many

of the world's religious traditions gave his ideas credibility. He was able to quote chapter and verse in the Bible to make his point.

But Lindsey told his readers to look out for such arguments, which he said were a distortion of the Bible and were the work of the Antichrist. Lindsey and his followers were looking hard for the Antichrist because, evil as he would be, his presence was a necessary precursor to the Rapture and all the events that would follow. Much of the appeal of Lindsey's book was that it was scary; everything that was happening fit together like so many puzzle pieces that spelled out the message that the end was near. Nevertheless, the message was also reassuring because it revealed that apparent chaos was, in fact, divinely ordained. Indeed, believers should welcome this apparent falling apart because the Second Coming of Christ was an event that many had awaited for nearly two thousand years.

Lindsey's base in Christianity gave him an edge of respectability that other New Age enthusiasts lacked. Still, his theological stance, known as premillenarian dispensationalism, was not embraced by mainstream churches. Lindsey countered that the church is simply a group of people gathered together by God and that the established churches were not true churches. Thus, while his ideas claimed the authority of the Bible, Lindsey was in tune with the antiauthoritarian mood of the time. Like other New Age beliefs, this form of doom-obsessed Christianity answered chaotic times with the almost comforting thought that the whole universe makes sense—but in a way that you would never imagine. The truth was visible for all to see, the argument went, but those in authority don't want us to see it. The entire cosmos was a kind of conspiracy, and for the most part, a benevolent one, but it was hidden by another conspiracy of men who didn't want us to see the truth.

This paranoid view of life was part of the culture in the United States, Europe, and most of the developed world long before the break-in at Watergate and the revelation of the criminal conspiracy in the White House. Perhaps one of President Nixon's greatest mistakes was in his timing. Only a few years before, it would have been close to unimaginable that the leading figures of the most powerful country on Earth were engaged in the kind of spying, crimes, and skullduggery revealed by Watergate. In fact, most news organizations were slow to give credence to the information that Bob Woodward and Carl Bernstein were revealing bit by bit in *The Washington Post* in 1972. That November, the nation's

voters rewarded Nixon with an electoral landslide. Throughout 1973, as ever more incriminating news emerged about the conduct of Nixon and his staff, particularly his secret taping system, Nixon's position was weakened. On October 20, 1973, Nixon took the drastic step of firing Archibald Cox, who had been appointed to investigate Watergate, and prompted, in turn, the resignation of Attorney General Elliot L. Richardson and Deputy Attorney General William D. Ruckelshaus, an event that became known as the Saturday Night Massacre. The news was announced at 8:25 p.m., preempting the closing moments of *All in the Family*, the most-watched television program, and *M*A*S*H*, the popular antiwar military comedy. Cox, said White House press secretary Ron Ziegler, had "defied" the president's instructions "at a time of serious world crisis" and made it "necessary" for the president to discharge him. Many viewers, settling in to watch the greatest lineup of comedy shows ever to appear on American television—*Mary Tyler Moore, Newhart*, and *Carol Burnett* were scheduled to follow—saw instead something that felt like a coup d'état from one of the political conspiracy films of the previous decade. With Nixon, more than with most successful politicians, a dark side had always lurked near the surface, which made him vulnerable to doubts about his conduct. Still, if he had done his deeds at a time when people felt greater trust in institutions and weren't suspecting conspiracies everywhere, the Watergate crimes might not have had the same impact.

Energy and materials shortages engendered plenty of gloom, but also optimism that a wiser use of resources would create a better world for future generations.

There's little doubt, though, that the revelations of Watergate gave greater credibility to all who claimed that truths were being covered up. Was the 1973 oil crisis the work of a conspiracy? Yes, it was, at least to the extent that it was orchestrated by the Organization of Petroleum Exporting Countries, an international cartel that was, by definition, a kind of conspiracy. Was the moon landing simulated in a television studio? The evidence suggests not, but that depends on what evidence you choose to trust. There was renewed interest in the event that got the conspiracy business going: the 1963 assassination of John F. Kennedy. And some suggested the possibility that what had been revealed in the Watergate investigations was just a cover story, while the real, deeper conspiracy had yet to be discovered. Sometimes it seemed that rational thought had ventured into the Bermuda Triangle, that area in the Atlantic where, it was believed, boats and airplanes disappeared without a trace. (Some people began looking for the remains of Atlantis in that vicinity, as well.) Still, you didn't have to be too paranoid to see that

there were enemies, liars, and all sorts of important stuff you didn't know.

The biggest difference between the end-time-obsessed Christians and other New Agers is that while pyramid power and alien civilizers still have their adherents—they appear nightly on cable television—the millennial Christians have become a mighty force.

The old mainline Protestant churches have been so weakened that these apocalyptic believers have become the loudest Christian voice in American culture and politics. At least two presidents have made remarks hinting that they are looking forward to the Rapture and end-time, something that disquiets nonbelievers since U.S. presidents have the power to help Armageddon happen. It seems a paradox that one of the most powerfully enduring legacies of an infamously libertine decade turns out to be the religious right. Yet, like their contemporaries, they rejected the established authorities and found their faith for themselves.

The prospect of too much trash and too few materials prompted some to try garbage as a building material—including an insulated wall made from beverage cans, and this New Mexico house by architect Michael Reynolds, which took inspiration from the Navaho hogan and Central Asian yurt, but was made from old tires.

"We have arrived in a rush at history's watershed only to find that the dam is about to burst," wrote journalist and conspiracy investigator Jim Hougan in his 1975 book, *Decadence: Radical Nostalgia, Narcissism, and Decline in the Seventies.* Only a few years earlier, Hougan said, Americans had seen themselves as Atlas, holding the world on their shoulders. In the seventies, in the face of deluge, that feeling had given way to what he called "the Noah fetish," the belief that the best one could do is survive.

Noah was not a heroic figure, but, however reluctantly and uncertainly, he got the job done. In the seventies, there were many Noahs, getting out the hammer and nails and trying to cobble out a way to survive.

The hero of many seventies Noahs was the engineer, philosopher,

inventor, mathematician, and freestyle blowhard R. Buckminster Fuller. Fuller had been around for decades, and before the seventies was best known for such inventions as the geodesic dome. In the post–World War II era, the dome served as a symbol of American technology, housing as it did a number of trade exhibitions and, most famously, the U.S. pavilion at Expo 67 in Montreal. During the sixties, geodesic domes made out of such found materials as old automobile bodies became the preferred structure of youth-culture utopianism. In the seventies, though, as

Fuller himself liked to point out, he was esteemed less as an inventor than as a thinker. The young and not so young attended his lectures by the hundreds and the thousands to hear the great man's often convoluted and jargon-laden but intermittently profound pronouncements. It often seemed to be the same lecture, and even when he finished several hours of speaking, one sensed afterward that he was silently continuing a perpetual lecture to an audience of himself. On one occasion, for example, his announced topic was Society Hill, the Philadelphia neighborhood in which he was then living. "Before you can understand Society Hill," he began, "you must understand the universe . . ." The discussion of the universe that followed never made it back to Earth, let alone Society Hill.

You can see why the seventies became Fuller's moment, given that two of the biggest concerns of that time were shortages of petroleum and other basic materials and pollution of the environment. For Fuller, the coincidence of these problems was proof that there was no problem at all. Pollution, he said, was nothing more or less than valuable materials in the wrong place. Pollution is an indication of material plenty. Figuring out how to use the materials in a way that is not wasteful and doesn't threaten Earth's ecosystem is the kind of problem human beings exist to solve. Fuller believed that people have an exalted role: to be a counterforce to entropy, the increasing disorder of the universe. Just as humans learned to sail against the wind, he said, we can find ways to do more with less, create order, and apply intelligence to the physical world. There was something a little bit crazy about this idea, but

Buckminster Fuller had made hexagons virtuous, and this Zome house in New Mexico was one result. It was heated by blackened, water-filled 55-gallon drums that were warmed by the sun during the day and released heat at night. Fuller domes sprouted up in all sorts of places and seemed destined to be a vernacular building form, as American as a tarpaper shack.

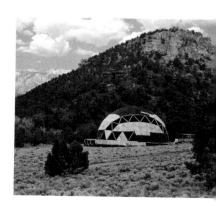

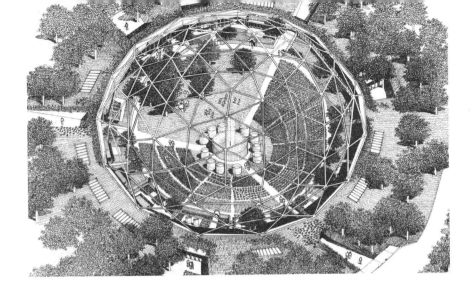

The space-age image of technology was bankrupt, and people sought new ways of understanding. The New Alchemy Institute on Cape Cod projected an image that was both medieval and forward-looking.

something thrilling too. Fuller's ideas were the reverse of von Däniken's. We humans would be the astronauts who spread thought throughout the cosmos. First, though, Fuller said, it would be necessary to put our own house in order, stop behaving like babies who have no idea about what keeps them alive, and become adults who take responsibility for themselves and for future generations.

Another hero for would-be Noahs was the British economist E. F. Schumacher, whose book *Small Is Beautiful*, a title that became a mantra of the times, was published in 1973. In contrast with Fuller, a big-idea man whose thought was sometimes too grandiose to grasp, Schumacher was radically modest. His point, essentially, was that there are appropriate scales at which to carry out any activity, and that while some things are too complex to be done by a few people, there are many activities that are carried out most successfully at a small scale. As an apostate economist, he criticized the concept of economic expansion as the only real growth, and he argued that many activities that truly improve people's situation are not counted as growth, while destructive acts often are.

In their styles of thought, Fuller and Schumacher couldn't be further apart, yet what people took away from the arguments was very similar: It was essential to do more with less. It was important to use tools and techniques appropriate to the task at hand without expending too much energy or creating too much bureaucracy. And people ought to be able to feel that what they do has meaning.

As marine biologist John Todd, who as founder of the New Alchemy Institute was one of the most influential of the Noahs, explained, "Science not practiced out of a context of sacredness or responsibility

was a devil's bargain." He attributed this thought to Taoist teachings, and Todd and his cohorts shared New Agers' impatience with the establishment technocratic culture. But they looked to ancient places and systems not for evidence of astronauts but for lessons about building an advanced civilization with less energy and waste. "We had degrees and boatloads of academic credentials amongst us," Todd recalled in speaking of the group's effort to help a community in California, near the Mexican border, become self-reliant. "And we stared at this land and realized that we'd been tricked. That our knowledge was abstract. That none of us could make a piece of the world work."

When Todd, with his wife, Nancy Jack Todd, and colleague Bill McLarney, left the university and set up the institute in Falmouth, Massachusetts, on Cape Cod, the first structures they built were geodesic domes. There was also one large windmill and several smaller ones, so it had an improvised, hippie look about it. Its goal was to create a highly productive ecological system on a small piece of land, through fish farming, recycling of biological wastes as nutrients, and high-density agriculture. Fish tanks doubled as solar collectors. Wastes from the fish in the tanks were used to fertilize the crops, and wastes from the crops could feed the fish. It was essentially an experimental station and demonstration project, and with the usual trial and error, it worked. "The basic concept of . . . ecological design, as being a powerful tool, perhaps one of the most powerful tools of this century, had been pretty much proven by the late 1970s," Todd said. That may have been true, though the follow-up was modest in the years of cheap energy that have followed. The most lasting influence of the New Alchemists may have been fish farming; before they began raising tilapia few had ever heard of this obscure tropical fish. But later fish farmers have not sought to exploit the fishes' waste, and aquaculture has become an environmental problem of its own.

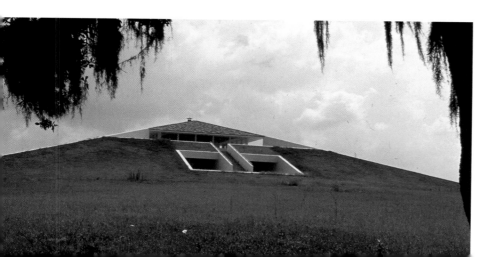

At the Hilltop House in Brooksville, Florida, the architect William Morgan created a pyramidal house that was largely beneath the earth, yet had sweeping views and possibly kept your knives sharp.

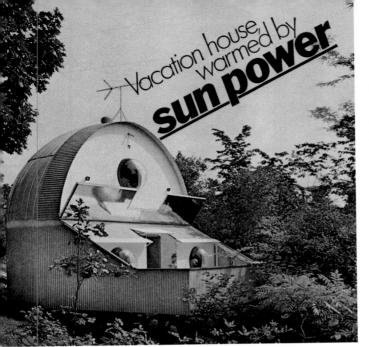

Vacation house warmed by **sun power**

The New Alchemists were not typical of their time, any more than David Bowie or Woodward and Bernstein were. Many more people were spectators to the emergence of what became known as appropriate technology, as they were of glitter rock and investigative reporting. Nevertheless, people like Todd, who tried to find practical ways to make everyday life less wasteful and free people less dependent on distant food and energy sources, had an impact on how many others felt. Moreover, during the second half of the decade, as the federal government began to fund research into energy conservation, renewable energy, and alternative technologies, such people were welcomed into the mainstream. Indeed, at the time, these approaches to technology—rather than the personal computer movement that sprang from similar ideas about democratizing technology—seemed to represent the future.

Passive solar houses needed active owners. Structures like this weekend house in Illinois, and the Douglas Kelbaugh house, in Princeton, New Jersey, *opposite, top*, demanded that their occupants watch the sun and open and close doors and curtains to make them work. But solar energy could be fun, too, as with this hot tub, *opposite, bottom*, also designed by Kelbaugh.

Architects, who make shelters for a living, may be more inclined to play Noah than the rest of us. The years immediately following the 1973 energy crisis seemed full of potential for architects. There was an opportunity to be at the forefront of solving one of society's major problems. Moreover, in solving that problem, architects had the opportunity to develop new kinds of expression that would allow them to escape the tired conventions of modernism. Architecture could do more than simply cloak developers' formulas; it could speak as it had for thousands of years, of earth, sun, sky, and spirit. Buildings could take advantage of the sun that's shining right now, rather than deplete the ancient remains of sunshine found in oil, coal, and other fossil fuels. They could catch the wind for ventilation, and offices could make better use of daylight and free workers from fluorescent flicker. By the direction buildings faced, the way they welcomed or staved off the sun, and rain, and wind, they would once again be part of the landscape rather than intrusions upon it. Even in the city, one could acknowledge with sunscreens and other devices that the building was part of the natural world and taking some responsibility for its demands on the environment.

Devices to turn solar rays directly into electricity had already been developed by NASA for use on space flights. They were, at the outset, very expensive. There were also solar collector units typically placed on roofs and well suited for water heating. (President Jimmy Carter installed such a unit at the White House in 1977, and Congress passed a tax break the following year for others who did so.) But for the Noahs of the world, the real action was in passive solar design, the kind that uses the building itself rather than add-on devices to make the difference in saving energy. Passive design had the advantage of being permanent. It had few moving parts to break down. It encouraged the use of old-fashioned massive materials, such as adobe, rammed earth, or stone, to absorb heat from the sun during the day and slowly radiate it during the night. And for architects, passive solar design provided the opportunity to create buildings that directly expressed their relationship to the environment and their concern for its health.

"One of the most important things about this house is that you can

understand it," said the architect Douglas Kelbaugh in 1977 about a house he had built two years before for his family in Princeton, New Jersey. "It's not some kind of technology over which people feel that they have no control." Kelbaugh's house made use of a Trombe wall—a massive heat-absorbing black concrete wall behind a south-facing glass wall. It also had a greenhouse extension with water-filled black barrels that fulfilled much the same function. Another important part of the design was a big tree that shaded the house in summer.

In fact, most passive solar houses had one very important, albeit non-mechanical, moving part: the home-

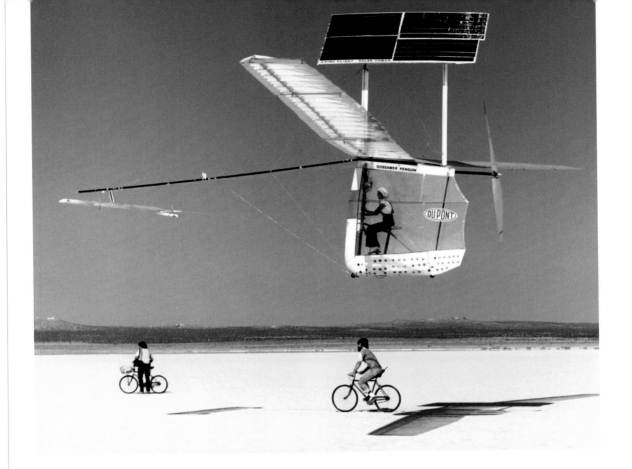

Doing more with less could be a path to beauty. For many, the proof of this was the work of Paul MacCready, whose ultralightweight human-powered *Gossamer Albatross* was pedaled across the English Channel in 1979. This plane, the *Gossamer Penguin*, was solar-powered, and it first flew in 1980.

owner. He was constantly opening shutters, closing blinds, and opening or closing dampers. Some used a bead wall: small pieces of acrylic insulation that were blown between the two panes of double-glazed window each day at sundown and vacuumed out after dawn. In October 1975, *House and Garden* published an article about a cutely cartoonish, futuristic-appearing, solar-heated vacation home in Illinois. "The straightforward solar system works like this: On winter days, reflective Mylar-lined panels direct sun through transparent roof sections into heat storage tanks beneath the bubble windows. After sundown, the tanks are closed, then later opened to reflect their accumulated heat—and the roof panels closed to reflect heat back into the house. In summer, roof panels are closed during the day, opened at night to let interior heat radiate out." All that opening and closing, which the magazine made sound so automatic, was, of course, done by the house's occupants, vacationers as Noah, saving their money and the planet at the same time.

Another way to save energy in buildings is to place them under-

ground. Burying a building eliminates much of the cost of both heating and air-conditioning, because the subsurface temperature is constant. But for many, the greatest advantage is that it increases the growing surface of Earth. As the architect Malcolm Wells put it, "1. People can't draw energy directly from sunlight. 2. Plants can. 3. Plants can't live underground. 4. We can. It's as simple as that."

One surprising thing about earth-sheltered buildings is that it is possible for them to have plenty of windows, and even a view, without compromising their environmental advantages. Indeed, compared with solar homes that had concrete walls behind their windows, some of the buried buildings of the time seemed open and airy. The Florida architect William Morgan even applied such principles to a number of public buildings, including a state museum, a police headquarters, and a state office building. Still, his two most striking designs are residential ones: the Dune Houses, a pair of condos built in Atlantic Beach, Florida, and the Hilltop House in Brooksville, Florida. The latter transforms the top of the hill into a pyramid, though this aggressively passive design seems more landform than building, even though it does boast cross ventilation and the possibility that your razors will stay sharp.

Americans did not move en masse into either passive solar houses or subterranean dwellings. Yet average household energy use declined nearly 20 percent from 1973 to 1991, and the drop in the amount of energy needed to produce each dollar of gross domestic product fell even faster. Nowadays, this amazing achievement in making homes and businesses more efficient tends to be denigrated. People remember seeing Jimmy Carter wearing a cardigan and urging them to turn their thermostats down. But the sweater, while largely symbolic, was part of the solution. An even bigger part was adding insulation, using weather stripping, installing double-glazed windows, buying more efficient appliances. Businesses found ways to provide better lighting while burning less electricity. New buildings incorporated more efficient mechanical systems. Motorists began driving cars that used significantly less gasoline.

It turned out that American life didn't really have to be transformed, just thoughtfully tweaked. The heroes weren't visionary architects but mechanical engineers, who found a way to make everything work just a little bit more efficiently. The good news emerged very slowly. It took a decade before people realized that it might not be too late. Just about the time they became really worn out from worrying, they realized that they didn't have to worry quite so much.

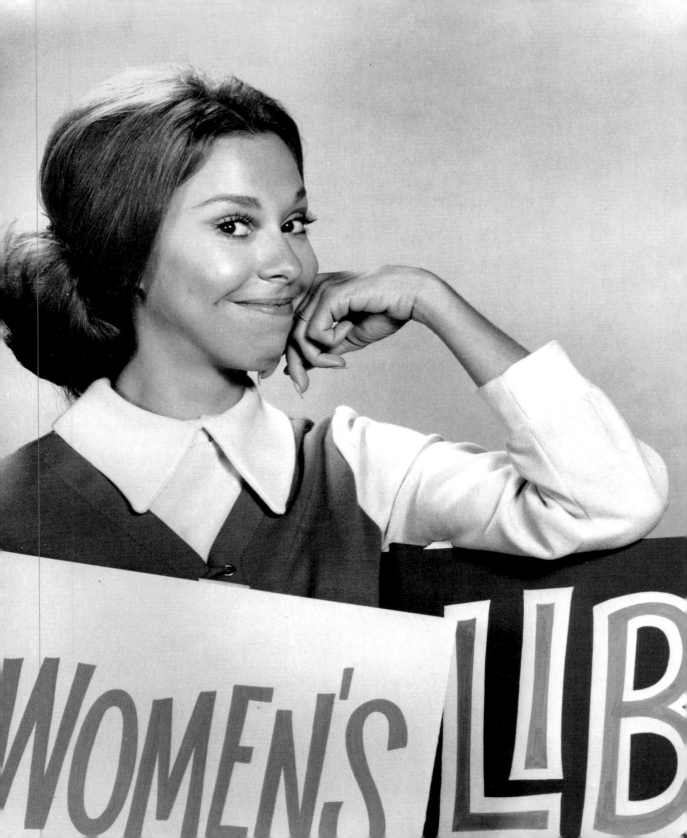

RAISING CONSCIOUSNESS

With a tenth of a second to avoid the youngster, Fletcher Lynd Seagull snapped hard to the left, at something over two hundred miles per hour, into a cliff of solid granite.

It was, for him, as though the rock were a giant hard door into another world. A burst of fear and shock and black as he hit, and then he was adrift in a strange strange sky, forgetting, remembering, forgetting; afraid and sad and sorry, terribly sorry.

—RICHARD BACH,
JONATHAN LIVINGSTON SEAGULL (1970)

"You must begin by knowing that you have already arrived."
—*Jonathan Livingston Seagull*

Splat! went the high-flying young seagull into the stone wall. He should have been dead, but he wasn't. It was the seventies, after all. He had reached a higher level of consciousness.

Still dazed from the collision, he hears some advice. "You can stay here and learn at this level—which is quite a bit higher than the one you left, by the way," the messianic Jonathan Livingston Seagull tells the crash-dazed Fletcher, "or you can go back and keep working with the Flock."

For the millions who read *Jonathan Livingston Seagull*, there was no choice at all. Who would forgo a state of higher consciousness to go back to a flock that saw flying simply as a means to a meal, and not, like Jonathan, as a drive toward infinite self-realization? "Don't believe what your eyes are telling you," Jonathan tells Fletcher. "All they show is limitation. Look with your understanding, find out what you already know,

The aerobatic Zen of *Jonathan Livingston Seagull* became so popular that the character served as frontbird for a line of knitting yarn.

and you'll see the way to fly."
Many spent the seventies, in
their different ways, seeking
to find out what they knew
and trying, one way or an-
other, to take flight.

Heightened consciousness
was the seventies grail, the
goal of countless quests that
were solitary and collect-
ive, philosophical and drug-
induced, utopian and career-
ist. The reward of higher
consciousness was new ways
of living and being, and new
kinds of power, both tempo-
ral and spiritual.

*Jonathan Livingston Sea-
gull* is, like polyester leisure
suits, one of those embarrass-
ments of the era. It is a little
book that those who lived
through the era remember
everyone else reading but

rarely admit to having read. And if you're the sort of person who worries
about intellectual coherence—or who wonders exactly *how* seagulls
smile—the book will drive you crazy. It's a muddle, perhaps, but one
that tells much about its times.

It's obvious that going back to the flock would be a big mistake. That's
not just because it represents coercion and conformity. Its real sin, to
the seventies reader, was that the flock was willing to settle for shared
prosperity, but at a cost of stifling the potential of each of its members.
Such a tradeoff had served America well in the post–World War II era,
but by the early seventies it was increasingly suspect. Its rewards
came at the expense of a degraded environment, limited opportunities
for women, closeted lives for gays, and the rejection of ways of think-
ing that deviated from a straight-and-narrow path. Besides, the rewards
of this way of living—endless material progress—no longer seemed so
sure. Many sought to free themselves, both as individuals and within

groups they formed, from what they saw as the stultifying controls and expectations of an outmoded social, economic, and spiritual vision. Minds were really changing. New kinds of consciousness were struggling to be born. Seventies culture was, above all, about learning to live without the flock, and perhaps finding or, like Jonathan, founding a flock of one's own.

A preoccupation with consciousness was one of the defining characteristics of the seventies. It sprang from the failure of a shared vision of progress through technology and endless material expansion. That failure opened the door to a new kind of subjectivity, a recognition that different people see and feel life differently. "Reality" wasn't universal and immutable. It might be a shared delusion, or even a conspiracy against the weak. Having a worldview different from the one you learned in school or from the television did not necessarily make you an oddball. You might even be a visionary who could change the world simply by understanding it differently.

But while consciousness was subjective, different sorts of consciousness were believed to be widely shared. The experience of growing up as a woman in a male-dominated society, for example, affected more than half of the population. And once women realized how they had been harmed, they would see the world with a common consciousness. The same applied to homosexuals, whose desires had been branded as sin or sickness, and for whom there had been no place in the consensus culture of post–World War II America. Progress came not from making things bigger or faster but rather by allowing people to live the kinds of lives that felt right for them.

IN THE SHELTER OF HIS ARMS

Jimmy Swaggart and His Golden Gospel Piano

JIM
THE GOLDEN SOUND
LP-103

What had been outsider forms of religious expression drew more adherents and attention because of the consciousness revolution. Jimmy Swaggart made fundamentalist Christianity entertaining. *Opposite*: a 1974 Nation of Islam gathering in Chicago.

Consciousness could come from firm religious convictions or from spiritual yearnings that caused many to spend the decade shopping for a faith. With the decline of the consensus future, many people found new ways of thinking by looking at the past, either in their ethnic roots or in buildings and towns made by earlier generations of Americans. Consciousness could be shaped by place. In the South, a region that had long been defined as outside of the mainstream, there arose a new consciousness based not on ancient defeat but on the region's rising economic, political, and cultural power. In the old cities of the rust belt, a new consciousness arose from those who chose to live among the ruins of a declining industrial civilization.

Some people at the time were torn between the claims of different kinds of consciousness. Women's liberation and sexual liberation sometimes conflicted, because the latter involved sleeping with the enemy. Lesbians felt forced to choose between women's liberation and gay liberation (though most chose solidarity with women rather than with male homosexuals). Still, some other forms of consciousness—Southern pride and evangelical Christianity—proved to be mutually reinforcing for many and helped create an enduring political force.

What all these communities of consciousness had in common was that they believed deeply that their ways of understanding the world and acting in it were valid. They would not be ignored, closeted, condescended to, or discriminated against. And they were not going to go away.

The seventies fascination with consciousness had its origins in Marxism and marijuana. The Marxist concept of "false consciousness," actually formulated by Friedrich Engels, describes the oppressed classes' mistaken understanding of society. They see their situation as the inevitable result of forces they cannot hope to fight. Such acquiescence benefits the rich and powerful, who do their best to maintain the false consciousness. Most baby boomers, who were attending

college in higher numbers than earlier generations, encountered at least a Cliffs Notes version of the class struggle. Faced with Vietnam, political corruption, and an ailing economy, the old promise of unending technological and material progress seemed like a classic case of false consciousness.

Still, Marx and Engels wouldn't have been happy with what the seventies made of their idea. Fascination with consciousness actually accompanied a decrease in political activism. People weren't thinking about the class struggle; they were thinking about themselves and about how they could reshape their own consciousness to change their lives. The use of marijuana and other mind-altering substances certainly encouraged this process. They offered another way of looking at life. They

pulled people off center and encouraged them to see the commonplace as strange, ridiculous, or wonderful. And while the use of such drugs during the sixties was largely confined to only a part of the youth culture, during the seventies, marijuana use became far more widespread, and multigenerational besides.

The bestselling series of books by the anthropologist Carlos Castaneda about his training by two Mexican sorcerers made the connection between drugs and consciousness quite explicit. The chief teacher, Don Juan, gives Castaneda drugs as a way to shock him out of his everyday expectations and to perceive a wholly different reality. Don Juan eventually tells him the drugs aren't necessary, though not until the third book. But for a technologically dependent, relentlessly rational person like Castaneda—and probably the reader—the drugs are a necessary first step.

The climactic moment in the Castaneda books came in *Tales of Power* (1974) when Castaneda, having learned to escape ordinary reality without drugs, makes a leap off a cliff. "I had the sensations of being tossed, spinning, and falling down at a tremendous speed," he wrote. "Then I exploded. I disintegrated . . . There was no longer the sweet unity I call 'me . . .' I was a myriad of selves which were all me."

Consciousness is a slippery idea, and those who pursued it followed many divergent paths. Even without being trained as a sorcerer, most individuals understand they have more than one dimension, more than one way to see themselves and the world. Yet, despite his awareness of myriad selves, Castaneda can also find the "me," "the un-

bending solidarity of my countless awarenesses."

You can see something like that when you look at the society as a whole. Fragmentation was part of its politics and its aesthetics, its religion and its music. Yet the essence of the Great Funk is being fragmented without finally falling apart. People redefined themselves and their relationships with one another in many exciting, innovative new ways. The exploration and development of consciousness is a theme that runs through it all.

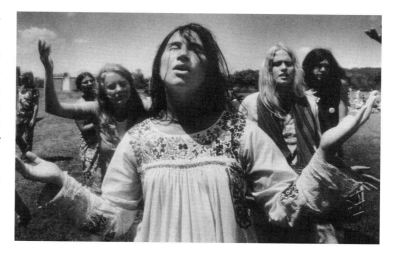

For nearly all, developing consciousness was energizing. Its promise of hidden personal potential led not merely to vague spiritual yearnings but also to very real career ambitions. Some of the doors of perception that were opened revealed hallucinations, but others revealed artistic and architectural treasures that had been devalued by a compulsory belief in progress. And while some explorers of consciousness were antirational and antitechnological, others tried to link reason and technology to individual empowerment.

At the time, critics ridiculed the belief that an internal change of consciousness—rather than, for example, political activism—could change the world. Yet those who sought to change consciousness, from women's liberationists to born-again Christians, were those who made the biggest difference. The history of the seventies is dominated by the rise of groups of like-minded but hitherto marginal individuals asserting the validity of their ways of seeing and doing things. Not all these ways of thinking were ultimately liberating. Nevertheless, finding that there were others who thought and felt as you did was liberating in itself. Thus political conservatives, who became a potent force during the seventies, shared an experience of joyous self-discovery and solidarity

For some, expanded consciousness could be raised at home, in the form of fast-growing marijuana plants. Ram Dass, *below*, first gained notoriety as a pioneer and advocate of hallucinogenic drugs, but during the seventies he incorporated them into an Indian-inspired approach to spirituality. Still, many felt spirituality supplied its own high and no drugs were needed.

that was similar to that experienced by gays, computer enthusiasts, or retirees newly decamped to Florida and Arizona.

In retrospect, it is possible to see what seemed to be an explosion of new kinds of consciousness as the shattering of a broad, if imperfect, social and political consensus and its replacement by what Christopher Lasch, in 1979, termed "a culture of narcissism." In this view, the pieces have never been put back together, and the result has been decades of political and economic dysfunction. But while one might mourn this loss intellectually, few would want to return to the limited choices offered by post–World War II American culture, even if it could be made to work. We've all left the flock by now and flown off in different directions.

S

ome things you miss because they are so tiny you overlook them," Robert M. Pirsig, the narrator of *Zen and the Art of Motorcycle Maintenance* (1974), muses about his tensions with his traveling companion. "But some things you don't see because they're so *huge*. We were both looking at the same thing, talking about the same thing, thinking about the same thing, except that he was looking, seeing, talking and thinking from a completely different *dimension*."

Living in close quarters with others whose brains might as well be on another planet gave rise to one of the recurrent themes of Great Funk culture, the comedy of consciousness. The odd couples (and quartets and crowds) weren't people with incompatible quirks but rather those with utterly divergent ways of seeing and being.

Pirsig's book, which is essentially a philosophical meditation, is not particularly funny. But there is something wonderfully ridiculous about the narrator's motorcycling companion who becomes silently enraged by a dripping faucet but who, nevertheless, refuses to fix it. To do so, the narrator observes, would involve him in technology, and to master technology would be to implicate himself in the System that dehumanizes and oppresses. The narrator, by contrast, feels that the Buddha lurks in the faucet as well as in the flower, and that knowing how to use a wrench is a humane act. You can see that these two guys don't have much common basis on which to converse—at least about plumbing.

In the pioneering consciousness-in-conflict movie *Easy Rider* (1969), the cultural conflicts between the drug-dealing, drug-using hippies on motorcycles, played by Peter Fonda and the film's director, Dennis Hopper, and the Southerners they encounter are taken very seriously.

Apocalypse looms, and nothing less than the American dream is at stake. But the character played by the actor whom the movie made a star, Jack Nicholson, was funny and compelling because he was caught between two kinds of consciousness. And all it takes is some good marijuana to enable him to find his freedom. The next year, in *Five Easy Pieces*, directed by Bob Rafelson, Nicholson made audiences roar in a scene where his character encounters a waitress whose mind is wholly limited by the restaurant's menu. "I don't make the rules," she says, refusing to serve him toast with his omelet.

In response, he asks for an omelet with a chicken salad sandwich, with no butter, no mayonnaise, and no lettuce. And, he adds, "Now all you have to do is hold the chicken, bring me the toast, give me a check for the chicken salad sandwich, and you haven't broken any rules."

"You want me to hold the chicken, huh?" the waitress replies.

"I want you to hold it between your knees," he answers, then trashes the table. Seen more than three decades later, this scene seems snobbish and mean-spirited. At the time, though, it seemed like an incisive commentary on those who were so rule-bound and limited in their consciousness that they would never understand anything.

By contrast, the films of Robert Altman, especially *Nashville* (1975), juxtaposed people with very different goals and attitudes, none of them wholly wrong, or wholly right, either. *Nashville* followed twenty-four main characters, each with a distinctly different consciousness. They pass like ships in the night but come together for a shared disaster and achieve mindless harmony by singing a song called "It Don't Worry Me." With its noise and overlapping dialogue, the movie feels overheard, a perfect evocation of the disorientation of the era.

The most widely viewed comedy of consciousness, however, was undoubtedly the television show *All in the Family* (1971–83), which for several years was watched by sixty million people every Saturday night. It was set in a two-generation household, presided over by the bigot patriarch Archie Bunker, portrayed by Carroll O'Connor. He was nostalgic

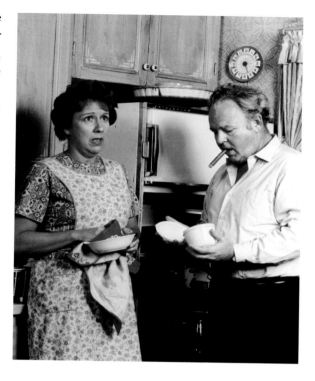

Archie Bunker, an entertaining bigot, and Edith, his sometimes befuddled but well-intentioned wife, dealt with racism, affirmative action, Vietnam, and even wife-swapping on *All in the Family*, the decade's most popular television program.

for a more settled time, when, as the theme song had it, "goils were goils and men were men." He was in constant conflict with his son-in-law, Mike Stivic, a longish-haired sociology student and knee-jerk liberal. Week after week, the family from Queens grappled with the big issues of the day—affirmative action, gay pride, women's rights. "I'm white, I'm male, I'm Protestant," Archie once declared. "Where's there a law to protect me?"

The show was a bit of a setup because its producers, Norman Lear and Bud Yorkin, were liberals, and while the scripts let Archie rail about "spics" and "fags," he invariably got his comeuppance. "I think that if God had meant for us to be together, he'd have put us together," Archie once told the African-American entertainer Sammy Davis Jr., who had been a passenger in his cab. "But look what he done. He put you over in Africa, and put the rest of us in all the white countries." "Well," Davis replied, "he must've told you where we were, because somebody came and got us."

Yet even though he didn't usually get the last laugh, Archie got most of the rest of them. He was simply more fun and more interesting than the people who were right. Archie may have been intended as a punching bag for liberals, but he was, paradoxically, a powerful spokesman for those President Richard M. Nixon had termed "the silent majority." Not only did his show have a longer run than Nixon's presidency, his railing at elites has become a leitmotif of American politics ever since. It's likely that more people were laughing with Archie than at him; no character can last so long on television without being likable. At a time when tolerance was expected, Archie provided a lot of closet bigots with a vicarious thrill. Still, the reason *All in the Family* was compelling is that many parents had discovered that there were aliens in their midst, creatures whose thought and behavior were inexplicable and ridiculous. And they were our own parents, our own children.

Consciousness . . . is not a set of opinions, information, or values," wrote Charles Reich in *The Greening of America* (1970), "but a total configuration in any given individual, which makes up his whole perception of reality, his whole world view." He argued that most Americans were walking around with either of two kinds of outdated consciousness: one shaped by the frontier and another shaped by the industrial world of mass production. New times, though, demanded a new

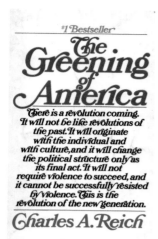

"We think of ourselves as an incredibly rich country, but we are beginning to realize that we are also a desperately poor country—poor in most of the things that throughout the history of mankind have been cherished as riches."

"The more you look the more you see. Instead of selecting one truth from a multitude, *you are increasing the multitude.*"

"Do you know that at this very moment you are surrounded by eternity? And do you know that you can use that eternity, if you so desire?"

consciousness, he argued, and fortunately one was emerging among the young.

Reich's book was a sensation from the moment it was first serialized, at epic length, in *The New Yorker*, and it is probably responsible for most of the consciousness rhetoric of the seventies. It appeared during the transition from the chaotic sixties into a decade that many hoped would make more sense than the one before. Reich was a brilliant man, a Yale law professor, former Supreme Court clerk, and author of a

deeply influential legal analysis of property. He had the stature and forum to explain America to itself. He had a historical analysis that appeared to explain the present, and he had a hopeful message of salvation by baby boomers.

"The great question of these times," he wrote, "is how to live in a technological society; what mind and what way of life can preserve man's humanity and his very existence against the domination of the forces he has created." Reich looked out of Yale's collegiate Gothic windows and saw the future right out on High Street, the long-haired, bell-bottomed, blue-jeaned, love-beaded, pot-smoking young. (George W. Bush was there, too, but presumably neither Reich nor Bush noticed.) They were, he argued, pioneers of a new kind of thinking, which he called Consciousness III, that stood in contrast to the American traditions of rugged individualism (Consciousness I), and of conformity, hierarchy, and often coercive corporate liberalism (Consciousness II). Consciousness III was a sort of pragmatic transcendentalism, rooted in respect for oneself and others, generosity of spirit, sensuality, and skepticism about societal expectations or institutional imperatives.

"Consciousness III does not believe in the antagonistic or competitive doctrine of life," he wrote. "They do not measure others, they do not see others as something to struggle against. People are brothers, the world is ample for all . . . A boy who was odd in some way used to suffer derision all through his school days. Today there would be no persecution; one might even hear one boy speak, with affection, of 'my freaky friend.' Instead of insisting that everyone be measured by given standards, the new generation values what is unique and different in each self."

Today, it can be a bit embarrassing to read *The Greening of America*, largely because, despite its world-historical framework, Reich's own consciousness is so nakedly on display. That odd boy who suffered through his youth is clearly Reich himself, who was still gawky and awkward as an adult. In a later, little-read book, *The Sorcerer of Bolinas Reef*, Reich described how, in the aftermath of *Greening*, he realized he was gay and, with the help of male prostitutes, was able to accept himself in the way he argued Consciousness III people do. (Gay liberation was a phenomenon *Greening* didn't address directly, though his descriptions of long-haired boys in blue jeans had an undeniable erotic charge.)

While others looked at the long-haired young and saw dirty hair, bad hygiene, promiscuity, drug use, idleness, and encroaching chaos, Reich saw the promise of life itself. "The extraordinary thing about this new

consciousness is that it has emerged out of the wasteland of the Corporate State, like flowers pushing up through a concrete pavement," he wrote. "Whatever it touches, it beautifies and renews: a freeway entrance is festooned with happy hitchhikers, the sidewalk is decorated with street people, the humorless steps of an official building are given warmth by a group of musicians."

Reich's mistake was to interpret minor, transient phenomena as bellwethers of permanent, positive change. Bell-bottoms were, he said, a way of expressing personal freedom, the delight and beauty of movement, and a rather comic attitude toward life. He wasn't wrong about that, but he seemed to think that people would be wearing bell-bottoms forever. He wanted to believe that Consciousness III saw through the false promises of fashion. He was too linear in his thinking (too Consciousness II) to understand that people can *use* fashion for their own purposes and that dressing can be a form of creativity. And despite his thesis that consciousness has to keep catching up to the circumstances of the world in which we live, he presents Consciousness III as a permanent solution—paradise now.

Yet the book does not deserve the derision with which it is often remembered. Though much of his evidence for a cultural revolution proved to be fleeting, Reich nevertheless identified some important and lasting changes in the society. He saw that what emerged in America during the late sixties was not, as many believed, a political movement, but a social and cultural one. It espoused values—earlier enunciated by such figures as Ralph Waldo Emerson, Walt Whitman, and Mark Twain, among others—that had long been an important though not dominant strain in American civilization. He was correct that many young people, not all of whom were hippies, were finding their own families to replace the biological families they felt had failed them. They were looking for ways to be themselves, while still supporting and being supported by others. And it was true that some young people were early to see that some fundamental aspects of American life weren't working well and that their improvisatory spirit could prove useful during times of crisis. The openness to experience and respect for differences that Reich observed became so much a part of the American ethos that, today, it's obligatory to say you share such values, even if you don't.

"For one who was almost convinced that it was necessary to accept ugliness and evil," Reich wrote on the book's final page, "[Consciousness III] is an invitation to cry or laugh. For one who thought the world was irretrievably encased in metal and plastic and sterile stone, it seems

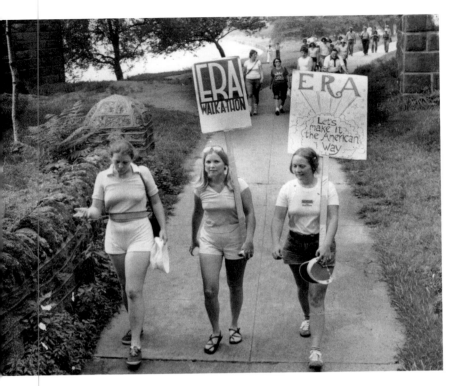

a veritable greening of America." Reich was what the nation hungered for at the start of the seventies: an intellectual with good news.

Yet though Reich was right about many things, he was wrong about one big thing. The widespread rejection of the consensus liberalism of Consciousness II was not leading inevitably to a new, widely shared Consciousness III. Rather, there were many kinds of consciousness emerging, all of which were disgusted with Consciousness II but which set off in very different directions, both radical and reactionary. Reich's belief in inevitable progress was heartening to some, but it was really old-style thinking, a remnant of Consciousness II.

Early in the decade, passing the Equal Rights Amendment seemed as if it would be as easy as a walk in the park. *Center:* **Half a century before, some women smoked to challenge old rules of decorum. But not until the seventies did tobacco companies, looking for new niches for deadly products, introduce feminist cigarettes.**

While Reich unquestionably got America talking about consciousness during the early seventies, it was the women's movement, through its focus on consciousness-raising, that used the idea to bring about profound social transformation. Consciousness-raising involved intimate conversation in organized groups, whose members shared their experiences, hurts, anger, and aspirations. The goal was to help women understand that society and its institutions gave women fewer opportunities and fewer rewards than were available to men and to show them how this situation could be changed.

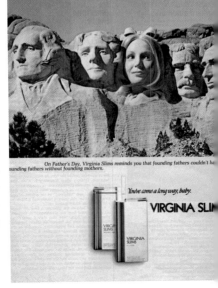

On Father's Day, Virginia Slims reminds you that founding fathers couldn't have founding fathers without founding mothers.

You've come a long way, baby.

VIRGINIA SLIMS

The term "consciousness-raising" entered seventies culture by way of northeastern Brazil. There, during the early sixties, Paulo Freire, a leftist educator, developed a program to teach reading and writing that would also give people a framework for understanding and changing the immediate circumstances of their lives. Freire called his effort *conscientização*, whose literal translation is "making conscious." When the word was translated from Portuguese to English as "consciousness-raising," its meaning changed in subtle ways. The original term suggested that the students were utterly oblivious. The English translation carried a hint of self-improvement, and of snobbishness toward those of lower consciousness, that may well account for the phenomenal success of the movement it spawned, as well as the persistence of the term in American speech.

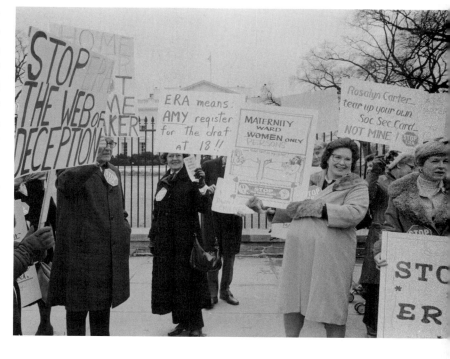

While the consciousness-raising movement took its inspiration from Brazilian leftists, and from the Maoist "speaking bitterness" women's groups that were organized in China during the 1940s, American women transformed the practice from political indoctrination into something far more personal and open-ended.

Feminist consciousness-raising began with a clear program: to help women understand how a patriarchal society abused women, marginalized them, stunted their personal growth, and limited their lives. The National Organization for Women (NOW), the largest and most mainstream

Opponents of the Equal Rights Amendment saw the constitutional change as a trap that would force women to fight in the army, deny widows their husbands' Social Security pensions, and force everyone to use the same bathroom. The amendment had wide support and seemed destined to pass early in the decade. Ultimately, though, it was defeated.

"Hear me roar," sang Helen Reddy in "I Am Woman," the 1972 pop song that became an anthem of feminism, and a top-seller besides.

feminist organization, had made consciousness-raising its largest program by 1972, claiming it involved one hundred thousand women that year. NOW and other groups drew up agendas that attempted to direct discussions toward political organizing and confronting the system. "Every Tuesday night," wrote Anita Shreve in a 1986 article about one New York City group, "they divulged their thoughts, feelings and fears about issues prescribed by NOW as being pertinent to consciousness-raising: body image, first sexual encounters, marriage, sexism in the work place, aging, abortion, to name a few . . . A topic from the prepared list was selected for each meeting; topics were also introduced by the women themselves. Each woman was allowed 'free space' to talk for as long as she liked, without interruption."

Ultimately, each consciousness-raising group was a dozen women in a room, discussing issues that were very personal and very volatile. There was no way to keep them under control, and while this made some groups completely dysfunctional, it was also their strength. Information gleaned from these meetings about the incidence of family abuse, rape, job discrimination, and countless other matters vital to women provided some of the first real data about a range of issues that had gone unstudied by social scientists. Consciousness-raising was never intended to be an end in itself. It was supposed to help mobilize women to work toward passing legislation—preeminently the Equal Rights Amendment to the U.S. Constitution. Consciousness-raising groups were intended to make women angry and committed so that they would organize politically, lobby for legislation, and fight for their rights in court and through regulatory agencies and unions. For many, such political action was the serious work of the women's movement, while consciousness-raising was merely an organizing tactic.

If the women's movement was triumphant during the seventies, though, the reason was consciousness-raising. Though the original intent of the process was to spread a doctrinaire analysis of women's oppression, in the apartments and houses where the groups met, a subtle shift was under way. While critics of feminism fixated on the Marxist and Maoist origins of the consciousness-raising movement, the women

themselves subverted it into something deeply American, a way to explore and express their own talents and powers.

"We found that we had all made similar *assumptions* about our limitations and about what was expected of us," wrote Joan Kennedy Taylor, a historian of feminism, about her own experience in a consciousness-raising group in western Massachusetts in 1972. "In other words, although some of us might have experienced discrimination or sexism, far more pervasive and disturbing was the way in which we had internalized what society expected of us." Taylor cites the case of a woman who had dropped out of theology school, only months short of graduation, when she found she was pregnant. She told the group she couldn't remember why she had done so, even though her husband had encouraged her to finish. "No one besides her husband, however, no teacher, no advisor, no relative, gave her similar encouragement. They all said, 'You mustn't miss a moment of this glorious experience of having a baby,' and she had listened to them." The group, Taylor says, helped this woman, and many others, to change their expectations of themselves. Consciousness-raising often served as a transition back to school, back to work, and as a spur to pursue other agendas that had been put aside years earlier. When women dropped out of the group to pursue other goals, Taylor says, most of the other women viewed that as evidence of success.

"I am woman, hear me roar," sang Helen Reddy in the anthem she cowrote that briefly, in 1972, became the bestselling record in the United States. Consciousness-raising had begun as a method of making women aware of how badly they were being treated. But it proved a lot more liberating to make people feel, as Reddy sang, that they were strong, that they were invincible, than to tell them they were victims.

Reddy's song was only one of many expressions of what was known as women's lib in popular culture. Indeed, sitcoms and the occasional sports spectacle challenged and changed perceptions about women's lives among those who had never attended a consciousness-raising session.

For example, Mary Richards, the central character of *The Mary Tyler Moore Show*, which ran for seven years beginning in 1970, was no militant, easily intimidated as she was by her gruff but lovable boss. Nevertheless, she was probably the best-known and best-loved face of the emerging feminist consciousness.

The character Mary Richards was a young woman who had moved to Minneapolis to take a job in a television newsroom after ending a live-in relationship with a man she helped put through medical school. She wasn't chasing after marriage. Despite her fears, she became a success in the glamorous world of television, at a station whose only other female employee did a show called *The Happy Homemaker*. Mary had an apartment in an interesting old Victorian building, but most of the show happened in her office, where she was resolute and energetic as she pursued her career and her independence as a woman. The audience could assume she was sexually active, though the issue was never made entirely explicit. Instead, it played off Moore's wholesome

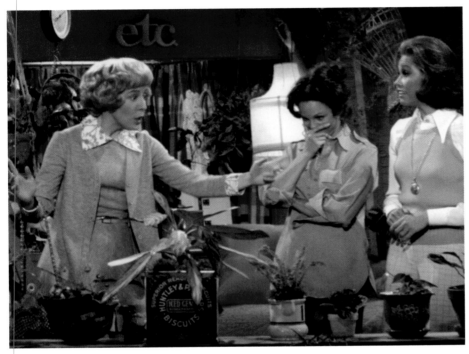

Mary Tyler Moore (right) played the seventies liberated daughter. On her television program, she was a single girl finding both a career and a life without marriage. She lived in a plant-filled apartment in a quirky Victorian building, and she and her friends wore multilayered outfits.

persona. ("Living on a budget is like making love in a straitjacket," Mary's landlady, Phyllis, complains. "Don't knock it if you haven't tried it," replies Mary, with just the merest hint of a smirk.)

The actress Mary Tyler Moore was well-known to the audience. Indeed, she had played Laura, the smart, sexy, beautiful, funny wife of the lead character on *The Dick Van Dyke Show*, one of the most popular sitcoms of the sixties. Laura was an endearing character who happened to be the perfect modern wife. To see the character on her own required a bit of adjustment for the audience. Indeed, the original concept called for Mary Richards to be divorced, but Moore has said the idea was vetoed because network executives feared audiences would be distraught if it were suggested that Laura had ended her perfect marriage.

The awkwardness of Mary's character was an acknowledgment of the audience's nervousness about a woman living her life without husband

or family. The program was admittedly only a sitcom, and it surely suggested that being successful in the workplace was easier than it really was for such women. Nevertheless, both Mary and her program succeeded. "How will you make it on your own?" asked the theme song during the first season. In later seasons, the lyric was changed to affirm, "You're going to make it after all."

Mary Richards became a kind of women's hero even though she wasn't a feminist paragon simply because she

Tennis hustler Bobby Riggs challenged women's champion Billie Jean King to a match that became known as the Battle of the Sexes. It was a circuslike event, complete with scantily clad models and muscle men carrying the players in sedan chairs. Still, King's easy victory was a breakthrough for women in sports.

seemed so normal. That doesn't seem like such a big thing; she did represent a dramatically rising demographic trend. Still, many people—men and women alike—found the concept of women's liberation frightening. Spending a half hour on Saturday night with Mary, a woman one could imagine as your own daughter, could be consciousness-changing in itself.

A very different popular performance that helped force recognition of another dimension of women's potential was the much-hyped "Battle of the Sexes" tennis match, between Bobby Riggs and Billie Jean King, on September 20, 1973. Riggs, a self-proclaimed "male chauvinist pig," was a fifty-five-year-old former Wimbledon champion who was making his living as a hustler, betting on himself to win tennis matches. Earlier that year, he had defeated Margaret Court, thirty, a top female player, in a match he said proved the innate superiority of men. His outrageously antifeminist remarks were understood at the time to be part of his hustle, but he successfully turned anxiety into an entertainment.

Billie Jean King took up his challenge, and unlike Court, she studied Riggs's game and prepared for the match, even as Riggs drummed up interest by discoursing endlessly on the physical inferiority of women. The event, held in the Houston Astrodome, was an incredible show; King entered in a sedan chair borne by musclemen, and Riggs followed in a rickshaw drawn by minimally costumed female models. Before a full arena, and forty million watching on television in the United States and audiences in thirty-six other countries, King won decisively in straight sets. It proved to be a turning point, as women's sports won steadily more attention from news media, tournament sponsors, and the public

at large. Being a woman athlete came to seem a natural thing.

While Riggs and King dramatized women' physical abilities to a mass audience, a relatively obscure piece of legislation that had been passed the year before—Title IX of the Education Amendments of 1972—actually encouraged women to be athletes. This law requires all educational institutions that receive federal money to offer the same programs for women as for men. The biggest area in which schools lacked programs for females was sports, an arena in which extreme sex-role stereotyping had long held sway. That men play sports and women cheer them on seemed a primordial fact of human nature, and the low level of female participation in sports—only one in four-

Phyllis Schlafly galvanized a latent conservative consciousness and single-handedly made the ERA controversial.

teen high school girls in 1972—seemed to prove the point. Critics of the law argued that Congress couldn't possibly have meant to require that schools offer costly programs to a population that wasn't interested. But young women *were* interested. In the two decades after the law was passed, female participation in high school sports increased to 40 percent. Being a female athlete was viewed as normal, and having an athletic daughter became a cause for parental pride, not worry. The change reshaped fashions, spawned athletic clubs, and, over time, has changed Americans' bodies.

But even as King won the Battle of the Sexes, Mary Tyler Moore charmed on Saturday nights, and powerful, confident women became increasingly visible in every sphere of life, political feminists failed to achieve their key political goal—adoption of the Equal Rights Amendment. This proposed amendment to the Constitution, which stated, "Equality of Rights under the law shall not be denied or abridged by the United States or any state on account of sex," seemed, in 1972,

to be unstoppable. It passed the Senate by an overwhelming 84–8 vote, after passing the House by a similarly lopsided margin. As state after state followed with ratification, its passage seemed assured. Yet it fell three short of the thirty-eight states required.

Its nemesis was a strong woman, Phyllis Schlafly, who made her own shrewd appeal to seventies mistrust of the system. Why, she asked, should government, which doesn't work very well in any case, be forced to interfere in areas where it doesn't belong? If the amendment were adopted, she argued, courts and legislatures would start drawing all sorts of unwelcome conclusions, voiding laws that protect women from dangerous work, drafting them into the army to fight against men, and perhaps even requiring the recognition of same-sex marriage. NOW denounced such issues as scare tactics, though even without the Equal Rights Amendment, much of what Schlafly predicted has come to pass. Republicans had long been supporters of the ERA; Schlafly was able to get the party to reverse its position, which proved an important milestone in the GOP's adoption of a culturally conservative agenda. Schlafly and other architects of the conservative uprising transformed the Republican party by aggres-

Dolly Parton celebrated female sexuality, inspired male lust, and helped make country music mainstream. She was an embodiment of the rise of the South.

sively interpreting the world in a way that reflected the mistrust and antiestablishment spirit of the time. They gave the Republicans a new consciousness.

Schlafly provided a rude awakening for those who believed that rejection of the post–World War II political and economic consensus would inevitably push people to the left. That consensus had been an essentially liberal one. Once that was gone, the way was clear for conservatives, fundamentalists, libertarians, and many others to emerge from the margins.

Much of this change came from the region of the country that was becoming known as the sun belt, which includes the Old South, the Southwest, and California. While the shift of power into this region is often explained by the advent of air-conditioning, the success of the civil rights movement had made the once-backward Southern states much more like the rest of the country. In the seventies, they emerged as the center of industrial expansion, the preferred location for foreign investment, and, increasingly, the place where the country's future was taking shape. The new cultural power of the sun belt came at the expense of Northern cities, home to the elites that traditionally dominated the national conversation, and to the unionized industrial workers who were beneficiaries of the country's postwar prosperity.

Though she was very different in style from Mary Tyler Moore or Phyllis Schlafly, Dolly Parton was an equally potent avatar of the changing demographics and attitudes of the seventies. At first glance, she seemed to fit a stereotype, the dumb blonde, but her independent style, her skill as a songwriter, and her wit showed her to be a powerful woman. Like Mae West before her, she used trashy femininity as a way to assert her freedom. But while West was an anomaly, Parton embodied a larger trend: The South had risen again, as a new kind of place, sexier, bolder, but still rooted in tradition.

Parton personified the seventies paradox of affirming her authenticity by flaunting artificiality. "I'm not offended by all of the dumb-blonde jokes," she once said, "because I know I'm not dumb—and I'm also not blonde." She grew up very poor with eleven brothers and sisters in a tiny shack in the Smoky Mountains, and the opulence and ebullience of her costumes celebrate her success, but according to the values and fantasies of the culture from which she came. "It takes a lot of money to look this cheap," she once remarked.

Although she had been a successful country performer from the time she was a teenager in the sixties, Parton really achieved stardom in the mid-seventies and superstardom in 1977 with the song "Here You Come Again." By the time that song broke out of the country music ghetto and made her a nationwide hit, another Southerner, Jimmy Carter, had already been inaugurated as president. Southern culture, long seen as marginal and low-class, was becoming mainstream. As rock music had become louder and more adolescent, country music was telling adult stories about difficult lives, filled with uncertainty, love, betrayal, drunkenness, and faith. As the sophistication and authority of the East and West coasts became suspect in the wake of political scandal and economic failure, the music that came from Nashville emerged as America's real popular music. Parton didn't look like a protestor or a dissident, but her rich-hooker wardrobe and no-nonsense attitude were surely anti-establishment.

While older country music was often dominated by messages of despondency and resignation, that of Parton and her cohorts had a certain feistiness, a determination to prevail no matter how difficult the circumstances. The dramas described in the songs played out not in rural areas but in suburbs, albeit suburbs with no seeming connection to any city. In this, they reflected the great long-running demographic phenomena: the spread of exurban sprawl and the rapidly increasing population of the Southern states. The South was increasingly important in politics and the economy; it had always been important to American music. Thus it's not surprising that its songs told stories that tried to reconcile new circumstances and old values. The music reveled in the character of its region, all the while asserting that songs of the sprawling South expressed the real soul of America.

This Southern consciousness was tied, in turn, to a Christian consciousness that was very different from the liberal Christianity that had become the consensus during the post–World War II era. While President Carter was politically liberal in most respects, he was also, famously, born again. He referred frequently to his faith. His speeches often contained biblical phrases or, more often, echoes of biblical language. When he confessed (in *Playboy*) that he had lusted in his heart, he provoked giggles from some, but he also connected with a very large segment of the population that knew the Bible and saw it as the

chief guidepost of their lives. Once the Southern churches stopped bearing the burden of upholding segregation, they were free to devote themselves to restoring the nation's moral compass, along more fundamentalist lines. During the seventies, the churches remained apolitical. Nevertheless, the shattering loss of the consensus that sustained the so-called mainline Protestant churches opened the door for some new and proud versions of old-time religion, along with a host of novel religious expressions.

Many different kinds of spiritual consciousness called for attention, often in public places. The Hare Krishna kids, with their saffron robes and shaved topknotted heads, never amounted to more than a few thousand followers, but they were relentlessly visible. They clustered in

Hazel Gordy (left), the daughter of Motown Records founder Berry Gordy (center), celebrates her seventeenth birthday in 1971, with her aunt Gwen Fuqua. The party was opulent but the style was peasant.

the arrival areas of airports and rail and bus stations, officially begging but, more important, making their presence known. In 1971, *The New Yorker*'s fashion columnist Kennedy Fraser wrote an essay about how people dressed on Fifth Avenue on a fine spring day, and after recounting a litany of awkward outfits, she declared Krishna Consciousness devotees to be among the few people sighted whose outfits showed "dignity, simplicity and taste."

The proliferation of religious groups, many of which required a surrender of personal choice, money, and freedom, provoked panic among many parents of young people who were attracted to them. The phenomenon even generated a new service industry, the deprogrammer, whose promise was to ambush the cult member's consciousness and return it back to something approaching normal. Some of the deprogrammers turned out to be as scary and abusive as the cult leaders them-

selves. But it was clear that there were dangers in consciousness exploration, and on November 18, 1978, the worst happened. Some 913 persons, including 270 children, who were associated with the People's Temple, a San Francisco–area cult, were ordered by their leader, Jim Jones, to drink cyanide-laced purple Kool-Aid at a camp in Guyana. This mass suicide effectively ended the enthusiasm for alternative religions, although many that were part of this explosion have remained highly visible.

Ethnicity was fashionable, and when it came to clothes, it didn't even have to be your ethnicity. Garments that appeared to have been embroidered by old-world grandmothers conferred authenticity.

Ethnic consciousness, like the various forms of spiritual and regional consciousness, recast old values in a new way. It sought to reassert the claims of family, tradition, and old-fashioned values that, while never absent, had diminished in importance amid the unifying forces, first of war and then of general prosperity. As the unifying forces of culture disappeared, white Americans with non-English surnames and immigrant traditions were said to be opting out of the mainstream and becoming what sociologist Michael Novak termed "unmeltable ethnics." In contrast with the bureaucratic and often metaphorical patriarchy denounced by feminists, upholders of ethnic pride often advocated a kind of patriarchy in which real fathers had real authority.

Yet this phenomenon was not exactly the return to tribalism that some of its advocates suggested it was. Indeed, "ethnics" was a sociological term that didn't make a lot of sense to the Italian Americans, Polish

Many Americans became curious about their African ancestors and the lives they left behind, a trend that climaxed in *Roots,* which became one of the most watched television programs of all time.

Americans, Irish Americans, and other groups to whom the term was applied. Many of them were Catholic; few saw themselves as ethnics.

A 1972 William Hamilton *New Yorker* cartoon showed a prosperous family sitting around a well-set table. "Are we ethnic?" asked the little girl. It was funny because the family looked just about as WASP as it's possible to be. Yet there's no question that a family in privileged circumstances with mainstream tastes could, in 1972, have traced its descent from Italy, Eastern Europe, or any of the other fatherlands of those conventionally characterized as ethnic. The deeper joke is that success in finance, law, academia, and other professions has the effect of turning everyone into WASPs. Yet the persistent image of the ethnic was that of an urban working-class man like Archie Bunker who was fed up with pointy-headed intellectuals, women's libbers, tree huggers, and other elitists intent on messing up a way of life that was working pretty well.

In fact, some of the best-known exponents of ethnic consciousness, such as Novak, were intellectuals themselves, though of a politically conservative bent. Their celebrations of ethnic consciousness were, at least in part, a political ploy. Members of the working class—especially union members—were important members of the coalition formed by Franklin D. Roosevelt in the thirties that had provided the base of the Democratic party ever since. Civil rights legislation during the sixties had alienated many white Southerners, another major portion of the Democratic base. The alienation of Northern workers from the parts of the party that had embraced the politics of liberation provided another opportunity to weaken the Democratic base. The success of this strategy was confirmed with the emergence of Republican-voting "Reagan Democrats" in the presidential election of 1980. These were, by and large, the ethnic-pride forces of the decade before.

Yet if ethnic consciousness were entirely a political ploy it would not also have emerged as an important factor in fashion around the same

time. Wearing ethnic dress, though not necessarily clothing that reflects your own background, was a way of affirming a quest for authenticity. Handmade garments with bright colors and cheap materials, along with brightly colored tiles and handwoven rugs and textiles in the home, were a way of opposing an increasingly artificial environment and embracing something real. Similarly, celebrating your ethnic roots was a way to reconnect with something that seemed real and felt real, even when it was artificial.

By 1977, nobody went to the moon anymore, and the blockbuster film *Star Wars* placed space travel in the distant past.

One of the most dramatic expressions of this enthusiasm was the tele-vision miniseries *Roots.* This historical drama of the lives of the African slaves that writer Alex Haley claimed as his ancestors was first broadcast for eight consecutive nights in 1977, and it quickly became a national sensation. Its final episode seems likely to retain the distinction of being the third most watched program in the history of American television. It traced the family history, starting with Kunta Kinte, who was born about 1750 in what is now Gambia, in West Africa, and who was captured and brought, after a harrowing journey, to Virginia, where he became a plan-tation slave.

The popularity of this series, and of its 1979 sequel, indicated that its appeal reached far beyond the African-American community that might be expected to be its most important audience. Rather, as its title sug-gested, the series spoke to a wider desire by all sorts of people to know about the circumstances and experiences of their forebears and to con-nect with their traditions. *Roots,* by telling such a rich story about slaves, for which the historical and genealogical record was presumed to be sparse, encouraged others whose ancestors didn't arrive on the *May-flower* to look for evidence of these humbler lives. Libraries and ge-nealogical collections found themselves swamped with inquiries from people of all ethnicities after the series aired.

Americans don't generally consider people of African descent to be "ethnics." Members of ethnic groups have the choice about whether to

assert their ethnicity, which is a choice most black Americans don't have. Moreover, white resentment over affirmative action and other policies intended to help African Americans helped spur the rise of ethnic consciousness. Yet the success of *Roots* suggests that racism and anger were not the only things animating ethnic consciousness. One of the achievements of the series was that it made the slave experience something with which everyone could identify, and in the process made African Americans seem more like other American ethnic groups. Slavery remains a historical horror that makes the African-American experience different in kind from that of all other immigrant groups. Still, *Roots* helped give black Americans a heritage—with its panoply of costumes, holidays, and historical figures—that had been unknown to most blacks and whites alike.

This seventies inclination to look back in order to look forward was strikingly and definitively expressed in the text that introduced the original *Star Wars* in 1977. "Long ago, in a galaxy far away . . ." the movie began, thus shifting space flight—the mid–twentieth century's most potent and pervasive symbol of future progress—into a mythical, storybook past. These few words summed up the seventies understanding that time is not a vector pointing toward infinite progress but rather is a circle, in which the rise and decline of peoples and nations are inevitable. *Star Wars* opened in a world of failure and abandonment, and hope springs not from advanced technology but from powers that the characters find within. It is a battle for consciousness.

In *Star Wars*, even some of the spaceships, especially the *Millennium Falcon*, the beat-up ship piloted by Han Solo (played by Harrison Ford), were old and dilapidated, and had to be coaxed to run. The soulless corporate space exploration depicted in the 1968 film *2001: A Space Odyssey*, itself a story about the inevitable progress of consciousness, had given way to the more traditional tale of saving mankind with daring, character, imagination, and luck. In the wake of *Star Wars*, the darkest, most opaque and alienating office tower in each city became known as the "Darth Vader building," referring to the film's villain who had gone over to "the dark side." What had only a few years ago seemed cool and modern now looked absolutely evil.

Belief in the inevitability of progress through technology and speed was a major part of the shared consciousness of the post–World War II era. With the shattering of that consciousness, a new one emerged that

was concerned with history but not necessarily historical. It was more like that of Billy Pilgrim, the narrator of Kurt Vonnegut's 1969 novel *Slaughterhouse Five*, which was made into a movie in 1972. Billy, a witness to the Allied fire-bombing of Dresden during World War II, has become "unstuck in time." His consciousness seems to consist of shards of eventfulness, experienced very intensely but outside of chronology.

Just like Billy Pilgrim or *Star Wars'* Luke Skywalker, who are trying to make lives amid the ruins of war, many young people in big cities found themselves living amid derelict landscapes. Changing industry, and the movement of manufacturing to the South and overseas, had left large areas of cities as empty shells, and the traditional cures for urban ills had come to seem worse than the disease.

In many cities, and especially in New York's SoHo, artists and musicians began to live and work in neighborhoods filled with former warehouse structures. Such lofts were originally attractive because they were cheap and offered high ceilings and unfettered spaces. Indeed, these old buildings provided the opportunity for the sort of flowing, modernist space that new buildings somehow couldn't deliver. Visual artists moved in first, looking for large quantities of cheap space. They often lived where they worked, even when the laws didn't permit it. Their presence generated galleries and, perhaps more important, events within the lofts themselves. The musician Philip Glass, for instance, gave con-

Beginners can be choosers.

certs in his loft that only a few got to hear but many more talked about. One of the pioneering New York discotheques, The Loft, was on an upper floor of what appeared to be a derelict relic. Before long, though, developers not just in SoHo but also in the largely abandoned warehousing and manufacturing districts of many cities were renting loftettes to young people who wanted the flavor of a way of living that was both stylish and authentic.

The rediscovery and renewal of old residential neighborhoods was even more widespread and dramatic. Streets full of close-packed houses, with stoops or front porches, had long seemed obsolete, but they were now hailed as repositories of urban wisdom, and of-

ten fine craftsmanship besides. There quickly emerged an ecology of urban pioneering: The artists came first. The next wave was gay men, most of whom were unconcerned with such practical matters as bad public schools and many of whom made their living creating, defining, or communicating style. They were followed by young married couples who actually viewed themselves as pioneers. They were looking for things that felt real—real, though often troubled, neighborhoods, real plaster cornices and carved oak woodwork, and often real profits once the neighborhood turned around. They also provoked a backlash from those who decried gentrification, the process of making neighborhoods too expensive for their original residents.

For people who no longer believed in progress, funky finds at flea markets or yard sales, and brand-new old-fashioned-looking phones, were things to covet. The movie *Butch Cassidy and the Sundance Kid* (1969) showed the Old West as Victorian. Even Kleenex took on a "heritage" look.

The enthusiasm for the old also reshaped the new. The frightening yet exhilarating sense of being adrift in space and time gave designers license to go backward as well as forward. The enormous surge of inter-

The impulse to salvage, along with bicentennial patriotism, brought an interest in historic preservation. Boston's Faneuil Hall became the center of a retail development, while the Egyptian façade of a Philadelphia building, *right*, became part of a high-rise corporate headquarters.

est in antique buildings, antique furniture, vintage clothing, and all things old has been described, both at the time and more recently, as evidence of nostalgia. Certainly, amid the upheavals of the time, there was some desire to go back to a simpler time. It is more accurate, though, to see this preservationist consciousness as evidence of a willingness to live with greater complexity. There is no one path of progress, this thinking goes. It makes sense to judge what has survived from the past in terms of its usefulness for the present and future. This was a time of oil crises and resource shortages. It simply seemed to make sense to reuse and recycle the old rather than to throw it away and start anew. Besides, many were pessimistic that anything that would be done in their own time would make life better.

Americans' rising respect for the past was enshrined in one of the nation's sincerest expressions of values, the federal tax code. Before 1976, it gave a clear preference to those who constructed new buildings, thus

making most attempts to preserve buildings uncompetitive financially. In 1976, the preference was reversed, and those who preserved buildings according to government guidelines were treated more favorably than those who built new.

The United States was celebrating the bicentennial of its revolution during the mid-seventies, and this encouraged a lot of media exposure for history. CBS ran a series of Bicentennial Minutes that seemed to go on forever. Every community had celebrations, and many had projects to restore a significant local landmark. For the most part, though, the bicentennial celebration fell flat; Americans weren't in a flag-waving mood. People weren't preserving the past because they were patriotic. They were, like Fletcher Lynd Seagull, dazed from hitting the cliff, "forgetting, remembering, forgetting." And they were looking everywhere, even to the fragments of the past, to try to make sense of the world, to try to find a higher consciousness.

CLOSE ENCOUNTERS

O n March 2, 1972, NASA launched the *Pioneer 10* space probe, a mission to the outer planets that eventually became the first manmade object to travel outside the solar system. This vehicle, which resembles a partly opened umbrella, has stopped communicating with Earth, but it is expected to continue on its course for tens of thousands of years. On the side of this vehicle is a gold-colored, anodized aluminum plaque inscribed with a message for any sentient being that should happen to find it. It includes a diagram of the solar system and Earth, to tell where the object came from, and a picture of a man and a woman, to show who sent it. The astronomer Carl Sagan, who promoted and designed the plaque, called it a "greeting card" for distant aliens. They'll probably look at it, nod, and say, "Very seventies."

The most notable thing about the couple in the picture is that the figures are nude. It is close to unimaginable that the United States government would have disseminated such a picture in the middle of the twentieth century or even, for that matter, at the beginning of the twenty-first. In 1972, though, it seemed more or less reasonable to let it all hang out. The nudity was supposed to have been required in the name of science—to remove any cultural bias from the picture, though Sagan is said to have hoped that the nudity would attract attention to the search for intelligent life in the universe. It certainly did attract attention, if not to space aliens then to the bodies in question.

Both appear to be in their mid-twenties. The man faces forward, his arm upraised in what was hoped would be understood as a peaceful,

"Hi there, I'm human." This was NASA's greeting to aliens, but some thought it was interstellar porn.

welcoming gesture. His hair is longish but parted and very neat, a compromise many young people were making as they made their way into the workforce. He is clean shaven. His musculature is defined, though neither he nor the woman have the kind of buff gym-toned bodies that appeared later in the decade. A rumor circulated at the time that this was, in fact, the body of Sagan himself, though the bodies were, according to NASA, "determined from results of a computerized analysis of the average person in our civilization." His penis is not unduly large. The woman stands almost imperceptibly at an angle to the viewer. Her hair is straight and shoulder-length. She could be a folksinger. Both were, of course, white, more than likely of Northern European origin, and thus unlike most of humankind.

The first people who had to deal with the portent of the pictures were not, of course, space aliens, but rather the editors of the world's daily newspapers. Many simply decided to run the picture as it was, allowing its official government status to trump their own guidelines on nudity and taste. But many others altered it, and in so doing showed a surprising lack of consensus about which were, in the Monty Python troupe's phrase, "the naughty bits." In the original drawing, the nipples of both the man and the woman are understated. But more than one newspaper defied all logic by removing the woman's nipples, while retaining the man's. The *Chicago Sun-Times* decided that the man's testicles weren't fit for a family audience, but retained his penis. *The Philadelphia Inquirer* was one of several newspapers to desex the man completely. "Maybe they're ready for things in outer space that we're not ready for in Philadelphia," one top editor told *The Wall Street Journal.*

Predictably, some people were angry at the government's foray into full frontal nudity, and the criticism came from many sides. "Isn't it enough that we must tolerate the bombardment of pornography through the media of film and smut magazines?" said one angry letter to Sagan. "Isn't it enough that our own space agency officials have found it necessary to spread this filth even beyond our own solar system?" Meanwhile, some feminists argued that the woman's pose was deferential, expressing a view of the proper relationship between the sexes that was coming into question. Indeed, it's difficult to disagree with this point. The couple on the side of the spacecraft were inevitably read as a latter-day Adam and Eve, carrying the attitudes of the patriarchs into the farthest reaches of space. (Still later, there was a gay critique: Why always a man and a woman, anyway?)

An alien encountering this image might not know what to make of it. Certainly, the civilization that launched it on its journey had issues of its own. The human body was, itself, a sort of frontier during the seventies, an arena for exploration, exploitation, improvement, and danger. Two decades earlier, there were almost universally shared expectations about dress, decorum, and sexual expression. During the sixties, some young people began to defy the rules by wearing weird clothes, and sometimes fewer clothes. But it wasn't until the seventies that society's mainstream began to experiment with their bodies. In the sixties, hippies had let their hair grow. In the seventies, middle-aged automobile dealers had shed their button-down shirts and rep ties in favor of open-necked shiny shirts with gold-colored medallions tangled in their salt-and-pepper chest hair. This latter transformation was, perhaps, less endearing than the earlier one but very likely more radical.

One of the things that the *Pioneer 10* plaque—along with the identical one launched in 1973 on *Pioneer 11*—demonstrated was that, even naked, the human body is an expression of culture. For each of us, the body is intensely personal. It is who we are. But societies always have expectations for our bodies. We dress them in ways that show we belong to a family, a community, and a society. Our bodies are instruments of our societies, which have expectations that we will work, we will procreate, and we will fight the society's enemies. We are expected to channel our urges and our energies in directions deemed helpful for the society as a whole.

The complete *Pioneer* plaque diagrammed where we were coming from and some basic knowledge that an extraterrestrial being could probably figure out.

Yet at the time that the *Pioneer* plaque was launched, just about every one of the demands that American society had made on the bodies of its members was subject to question, if not to outright attack. The introduction of the birth control pill during the sixties had turned procreation into a matter of personal, particularly female, choice. With the 1973 *Roe v. Wade* decision legalizing abortion, the Supreme Court took another huge step by transforming child-bearing from a community concern into a purely private matter. At the same time, the triumph of antiwar sentiment over the Vietnam War created a consensus opposing the sac-

rifice of young people's lives and health for goals short of national self-preservation.

Freeing the body and its sexuality from such social control opened the door to kinds of expression that had previously been repressed. Pornography became extremely public, as a handful of films, beginning with *Deep Throat*, became must-see attractions. Soon, respected filmmakers and actors were making movies such as *Last Tango in Paris*, whose content would have been considered obscene only a few years before. Artists began to explore the body and sexuality more blatantly than ever before. In Vito Acconci's 1972 work *Seedbed*, the artist lay beneath a ramp in a New York gallery, masturbating, as he vocalized sexual fantasies about the people walking past. Mannequins wielding whips, and other sadomasochistic scenes, became so prevalent in storefront window displays that they inspired a backlash. The critics weren't those who disapproved morally, merely those who were bored.

Homosexuality, that age-old threat to procreation, was expressed more and more publicly, and the customs and costumes of what had been hidden subcultures became part of the mainstream. Prominent style makers—including artists such as Andy Warhol and designers such as Halston—did not hide their sexual orientation, as their predecessors had. And when Steve Rubell and the social arbiters who ruled the velvet rope at Studio 54 chose the people to mix with socialites and celebrities to make what Rubell called "the salad" that distinguished the decade's quintessential club, they looked for expressively outré male pairs to spice up the mix.

Throughout the seventies, people discovered in their own bodies possibilities for expression and for pleasure that they hadn't imagined before. The wild rumpus had begun.

In 1974, people started running around naked. They would appear, unexpected, and run like crazy to someplace they hoped would be unpredictable. Sometimes, in the midst of their wild rush, they would flash a peace sign or voice some other protest, but most of the time their gesture seemed to be without content. They appeared so briefly and ran so fast they became known as streakers. For nearly three years, there was a strong possibility that any sporting event or ceremony, anywhere in the world, would be interrupted by an unexpected intruder wearing nothing but sneakers. At first, it consisted of solitary men, then small groups, then women, and eventually immense numbers, like the twelve

hundred at the University of Colorado that claimed to be the largest mass streak.

Streaking began on college campuses, where such behavior had long been a part of fraternity initiations and other student revels. But months after the first streakers were identified at the University of Florida in Tallahassee, unclad runners seemed to be everywhere. The streaker who interrupted the 1974 Academy Awards broadcast was no kid; he was thirty-three years old. He provoked one of the most memorable ad-libs in the history of the Oscars when David Niven remarked that the streaker got the only laugh he would get in his life by "showing his short-comings." The incident set the stage for a number one hit single by Ray Stevens, about a streaker who's "just as proud as he can be / Of his anatomy." It also provoked a wave of punditry about what it could all mean.

The voices of authority seemed to agree that streaking was just plain stupid, and hardly anyone, even the streakers, argued otherwise. The fact is that streaking was a ridiculous act, one that called attention not to sexuality but rather—as Niven's quip demonstrated—to human vulnerability. Christopher Lasch, writing a few years after the streaking fad subsided, took a darker view of the futility of streaking; he grouped streakers with would-be assassins as people driven to pointless acts out of narcissistic desperation.

Amid the obligatory disapproval of streaking, there was an undercurrent of relief. If the kids are just doing stupid things, at least they aren't trying to over-turn the system or start a revolution. Maybe streaking was a sign that things were getting back to normal. This was, however, a false hope. Kids running around naked and doing foolish things might have been normal, but the degree to which it captured the imagination was not. The sudden appearance of private parts in public places reflected a new openness to thinking about the body, ex-ploring it, expressing it, and enjoying it.

Streaking was (a) an expression of vulnerability, (b) an act of narcissistic desperation, or (c) something you did when really drunk. This streaker at Auburn University in Alabama seemed to have livened up the party.

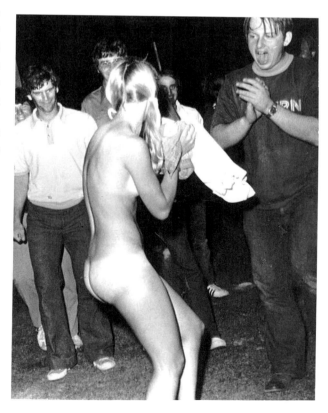

By making the personal visible, streaking dramatized, in its farcical way, one of the major themes of Great Funk–era life.

he Joy of Sex by Alex Comfort was published at almost the same moment as the *Pioneer 10* launch, and like the spacecraft, it featured line drawings of a nude couple. At least they were nude much of the time. She sometimes wore boots or bottomless tights and other bits of clothing to further the fantasies the book described. He was, in keeping with the time, very, very hairy, with a full beard. Comfort, a prolific English writer, believed strongly in allowing all body hair to grow. He was also enthusiastic about the erotic possibilities of the big toe.

The book was the first modern sex manual, and it was a sensation. It became a perennial bestseller. People disagreed about whether the drawings were erotic or repellent, or erotic because they were repellent. The illustrations consciously avoided the swelling breasts and monstrously engorged members that were to become the clichés of pornography that followed. But if you hadn't seen much pornography—and most people hadn't in 1972—it was still pretty racy stuff. The man was said to be either very sexy or scary enough to put young women off sex altogether. (That proved a groundless fear.) Some thought the book romantic, while others complained that the complex, though always clear, instructions made sex sound as difficult and exciting as assembling a tricycle. Some discovered that things they had been doing for years actually had a name, and what's more, that name was French.

This nomenclature was in keeping with the premise of the book, which was that it was a sort of cookbook, as its subtitle put it, "A Gourmet Guide to Lovemaking." Although it took its title from *The Joy of Cooking*, a proudly old-fashioned and middle-of-the-road cookbook, it took its approach from the many cookbooks that appeared in the wake of Julia Child, which affirmed that, if you work at it, the everyday act of cooking could produce extraordinary pleasure. (Comfort's working title was *Cordon Bleu Sex*, but the renowned Paris cooking school wouldn't allow it.)

Comfort later claimed to have written the book in two, or sometimes three, weeks, but rarely has a book been more enthusiastically researched. Comfort said it was the offspring of a passionate adulterous affair with the woman who later became his second wife. And Charles

From the complete and unabridged illustrated paperback edition of The Joy of Sex, *published in 1974.*

Raymond, one of the book's illustrators, performed the maneuvers with his wife while a photographer documented the proceedings. His drawings were based on the photographs and were, therefore, self-portraits of a sort. If the man in both the text and the drawings seems to be having a bit more fun than the woman, that is probably because each was created from his point of view.

The Joy of Sex was not the first book to depict the positions and kinks of lovemaking, but it was the first that wasn't considered a work of pornography. It was for sale in respectable bookstores, usually right on the counter, where the buyer could shamelessly browse through it and bring a copy home. It helped that Comfort had a medical degree, though his style was far from clinical. He was a committed pacifist but hardly a flower child; he was fifty-two when the book was published. The book was an expansion of material he had prepared as a chapter for a 1970 collection of essays on sex, but the chapter was withdrawn because Comfort's concentration on the really-doing-it aspect of sex made the American publisher queasy. Yet only a couple of years later, it shook beds throughout the world.

One obvious reason for the change in sensibility was the demography of the baby boom. Never before had so many young people reached sexual maturity at once, and publishers, film studios, and recording companies anticipated a market of horny young people as far as the eye could see. Yet *The Joy of Sex* and its sequels and imitators were part of a change that was affecting people of

"Bed is the right place to play all the games you ever wanted to play. This is essential to a full, enterprising, and healthy immature view of sex between committed people. You take off your shell along with your clothes."

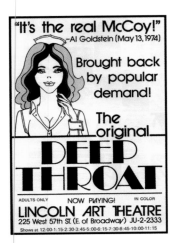

Porno titles got to be so familiar that they became part of every-day speech. "Deep Throat" was a code name for *The Washington Post*'s inside source on Watergate, the debauched Miss Jones was an allegory of America's lost inno-cence, and everybody knew which city Deb-bie did. *Opposite, top*: Harry Reems, the male lead in *Deep Throat*, relaxed in costume. *Overleaf*: Mainstream maga-zines, and films like *Last Tango in Paris*, showed a blatant sexuality inconceiv-able only a few years before.

all ages. It was a do-it-yourself quest for pleasure. In the age of the pill, with the post–World War II ideal of early marriage and big families long past, sex for its own sake—for the fun of it—did seem a newfound joy.

It is mysterious, and ultimately inexplicable, how an image, a be-havior, a quality that needed to be hidden last year can be public, acceptable, and even fashionable this year, while some of last year's enthusiasms become half-forgotten embarrassments. Nevertheless, the emergence of such an unlikely new authority as Alex Comfort would probably not have oc-curred if the authority of government, busi-ness, and religious leaders had remained intact. Failing economies, corrupt govern-ments, failed wars, and the disappearing re-wards of living a life that followed the old rules encouraged exploration. People had to fall back on their own resources. They had to make their own good times. Some awaited the end-time and the Rapture that would follow. Others looked for rapture in more carnal pur-suits, and some people, no doubt, did both.

In the manner of many phenomena of the Great Funk, the openness about sexual pleasure *The Joy of Sex* de-pended on and expanded seems at once radical and intensely conserva-tive. It was radical because it rejected long-held notions of propriety and set personal pleasure above community values. Still, such pursuit of hap-

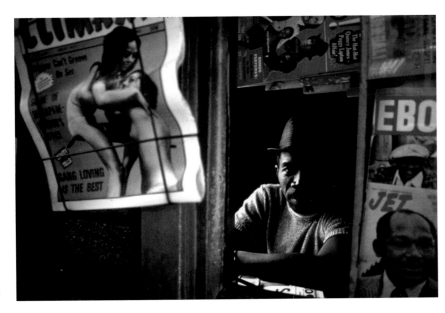

piness seems responsive to some core American principles. It was individualistic, self-motivated, and self-structured. It was a quest for pleasure, to be sure, but it fulfilled a conservative belief that you have to labor for your rewards. *The Joy of Sex* was like any self-improvement program: You have to work at it.

The celebrated 1973 porn film *The Devil in Miss Jones* begins with a young woman committing suicide because she has led a life of total repression and total boredom. Because suicide is itself a sin, this act puts her under the power of Satan who, for the next hour or so, invites her to experience all that she has missed. It is safe to say that she throws off all her inhibitions, even though—or perhaps because—she knows that eternal hell awaits. It's probably best not to overanalyze porn films, but there is little doubt that the proper Miss Jones embodies America itself, a repressed spinster whose inner harlot is dying to get out. By 1973, standards of sexual propriety and obscenity were descending a slope so slippery it might have been spread with K-Y jelly.

The phenomenon *The New York Times* termed "porno chic" actually got under way in the clothing-shedding year 1972, with the film *Deep Throat*. This crude film, made for about $40,000 of organized-crime money, went on to become one of the most financially successful films of all time, with gross revenues to date of about $600 million. Its premise was ridiculous: A woman has her clitoris in her throat and can achieve orgasm only while having oral sex. Linda Lovelace, the actress who played the part, was small-breasted for a porn star, but her girl-next-door looks, combined with her character's avidity for oral sex, made her a fantasy figure for the time. Her costar, who went by the name of Harry Reems, had more than enough to get her excited. That was it, more or less.

The New York Review of Books wasn't far wrong when it called the film "as erotic as a tonsillectomy," but the real story is that such a high-toned publication was paying attention at all. Truman Capote was an early enthusiast, which helped make it a trend among the beautiful people. Vice President Spiro Agnew saw the film at Frank Sinatra's

COSMO

The Living-Together
Handbook—
Everything You Need Know
(Works Terrifically
for Married Couples Too)

Must an Older Girl Be Less
Attractive
Than an Older Man?
Susan Sontag
Writes the
Devastating Truth

The Splurge-
and-Fast Diet

a

riage vs.
at All

at You

nder $10

Jennifer O'Neill is a Sinner.

POLITAN

Mademoiselle
the college issue

august 75¢

clothes you can really wear for campus now— work later

healthy hair & skin: how to get them

contraception: what you don't know and must ask

the "embarrassment" of virginity

james dickey on james dickey

why college anyway? our 20 guest editors speak out

Spec

GLAMOUR
JAN. 60¢

THE BODY THE FACE THE HAIR FOR NOW

THE NO-BRA LOOK THAT'S RIGHT FOR YOUR FIGURE, YOUR ATTITUDE AND HIS

THE KNITS FOR NOW: HOW TO CHOOSE THE RIGHT ONES FOR YOUR BODY

THE NEW MAKEUP STEP BY STEP

YOUR HAIR: MORE LAYERS, MORE SHINE, MORE WAYS TO WEAR IT

The Vanished

Suspense
by Bill Pr
plus Two Illus
Short S
by Anne L

Toutes Dire
by Elizabet

SEPT.

BAZ
YOUR COMPLETE GUIDE

HOW TO LOOK, FEEL, AND BE SEXUALLY APPEALING

YOUR NEW FALL CLOTHES: WHAT TO WEAR WITH WHAT
THE GREAT COATS, DRESSES, SKIRTS, TOPS, ACCESSORIES

THE APHRODISIAC DIET
SLIM DOWN & REV UP

HOW TO GET
SUPER RESULTS WITH THE SEXY NEW MAKE-UPS, HAIRCUTS, FRAGRANCES

UTERINE CANCER
ARE YOU HIGH-RISK?

STEPHANIE-LOUISE
SEXY & BEAUTIFUL

house. Johnny Carson joked about it, introducing it into the mainstream. Soon, the film was playing not in dingy theaters on back streets but in the movie palaces in the center of town (which were becoming a bit dingy themselves). It became necessary to see *Deep Throat* simply to keep up with the culture. And its title became enshrined in our political history when, in their 1974 book, *All the President's Men*, Carl Bernstein and Bob Woodward appropriated it as the name for the informant who helped them expose the Watergate scandals.

The 1971 Rolling Stones album, *Sticky Fingers*, represented a convergence of art, sex, and packaging. Andy Warhol's photo of a male crotch sported a real zipper, heralding the seventies' embrace of erotic—and homoerotic—imagery in mass-market products, especially if intriguing celebrities like Warhol and the Stones were involved.

Deep Throat was soon followed by *Behind the Green Door*, a movie many pornography aficionados affirm had a real erotic kick. The plot of the film has the heroine, played by Marilyn Chambers, abducted to a live sex theater, not unlike the one in San Francisco that was owned by Jim and Artie Mitchell, the brothers who made the film. There she has a series of athletic encounters with a group of nuns, a boxer, and three trapeze artists. At one point, she is pleasuring five men at once, using three orifices and two hands. What added an extra, delicious kink to the whole thing was that Chambers, a sometime model, had earlier posed for a photograph that was, at the time, on display on the Ivory Snow soap powder box, one that promised a product "99 and 44/100 percent pure."

It's important to remember, in an age where pornography is universally available through discreet channels, such as home videos and the Internet, that in the seventies you had to go to a theater to see a dirty movie. "What was special about *Deep Throat* was that it required people to expose themselves, to go into a theater, to be seen walking in or walking out," said Gay Talese, whose book *Thy Neighbor's Wife*, an exploration of American sexual practice, was published in 1981. "That was a revolutionary act in the 1970s."

The places where you could go were multiplying, especially in big cities, where the proliferation of sex-oriented businesses—adult bookstores, porn theaters, sex theaters, gay bathhouses—was seen as an indicator of urban decay. During the decade of the seventies in Los Angeles, the number of point-of-sale outlets for pornography rose from eighteen

to more than four hundred. In New York, its busiest and best-known district, the Times Square area, especially Forty-second Street and Eighth Avenue, became dominated by porn and by the prostitution and drug dealing that often went with it.

Simply counting pornography outlets, though, is bound to understate the degree to which a new level of sexual frankness was permeating mainstream magazines, films, and books. In *Last Tango in Paris* (1973), directed by Bernardo Bertolucci, Marlon Brando, one of America's biggest stars, is shown engaging in an anonymous, sado-masochistic affair with Maria Schneider. It was an extraordinary movie, in part because so much of its dialogue was improvised, but all anybody seemed to talk about was how Brando used some butter. Similarly, what the public most remembered about Erica Jong's 1973 novel *Fear of Flying*—about a woman who goes to Vienna, has a fling with a hot analyst, and overcomes her inhibitions—was the notion of the "zipless fuck." This was a slightly confusing way of saying that women could enjoy brief, intense sexual encounters just as much as men do.

Moreover, the sexual content in magazines such as *Cosmopolitan*, which had since the mid-sixties focused on helping young women to enjoy themselves, became far more explicit. Meanwhile, on the men's side, *Playboy*, which had identified so strongly with the cool, supercompetent, high-tech masculine image of the fifties and sixties, was challenged by publications that were angrier and cruder, the angriest and crudest of which was *Hustler*. This magazine, which began publication in 1974, grabbed attention with its very first issue by being the first mainstream magazine to show pubic hair. Later that year it published the first "pink shots," interior views of vaginas, and in 1975 it featured a spread on interracial sex. In 1976, in a special bicentennial issue, it had pubic hair on the cover. It was also the first men's magazine to show penises. But what enabled it to quickly capture a third of the men's market was not these milestones but its attitude. It caught the antiestablishment mood of the

Is that a microscope you're holding, or are you just glad to *see* me? This shampoo embodied the Great Funk era's erotic obsession with hair.

Whether it was a rock god's golden nimbus, a feminist hero's long tresses, an Afro halo of frizz, a carefully coiffed shag, or simply shaggy, hair was an essential element of Great Funk charisma. *Left to right (top):* a hirsute Californian, a Chicago woman waiting for a bus, *Ms.* magazine founder Gloria Steinem, Jane Fonda in *Klute*; *(center):* reggae pioneer Bob Marley, the pop duo Captain and Tennille, the stars of *Charlie's Angels*; *(bottom):* Led Zeppelin's Robert Plant, a luxuriantly maned couple in Texas, and teen heartthrob Donnie Osmond.

time by showing contempt for just about all politicians, business leaders, clergymen, and academics, while celebrating the ordinary people, with ordinary bodies, who do gross but often pleasurable things. *Hustler* and its publisher Larry Flynt have had frequent tangles with the law over obscenity. In 1988 Flynt won a landmark libel case decided by the Supreme Court—which he had earlier called "eight assholes and a token cunt"— brought by fundamentalist preacher Jerry Falwell. As cultural critic Laura Kipnis has observed, *Hustler*'s rudeness and contempt for authority are themselves a kind of political critique, one that saves it from being merely obscene, as the courts have defined it. Its socially redeeming value is its antisocial attitude, which probably explains why the magazine had its greatest impact during the seventies.

Bette Midler joked about the indignities of working "the tubs," but the newly visible, gay, towel-clad clientele of New York's Continental Baths made her a star.

Flynt used the exposure of pubic hair as a provocation, a step that would make people take notice of his magazine. It was also an aesthetic decision, and almost a moral one. It was a way of showing that the smooth, flawless bodies so long offered by *Playboy* were artificial, inauthentic, out of date. *The Joy of Sex* had made the case that the erotic gourmet was one who appreciated the wet, messy, tangled hairiness of real sex.

More generally, seventies taste sought texture, not sheen, layering, not luster. That was how people decorated their homes and how they presented their bodies. Letting your hair grow was an obvious expression of your sensuous self. In the sixties, hair had been an issue, a mark of protest and symbol of youth. In the seventies, hair was about expression, not confrontation. Long hair did not mean that you were a revolutionary or an acid-dropping dropout; it showed you were in tune with the times. Only the seventies could have produced a shampoo called Gee, Your Hair Smells Terrific.

Wearing an Afro did not mark you as a black separatist; you might even be Jewish. The advent of the permanent for both sexes made genetics irrelevant; even a stringy-haired WASP could double the volume of her head by transforming her locks into a billowing nimbus of frizz. And

young men in the first stages of male-pattern baldness believed that they could camouflage this horrifying sign of age by whipping the hair that remained into a frenzy. Indeed, as this style took hold among whites, blacks began to look for other sorts of expression, such as the oversized braided dreadlocks worn in Jamaica and popularized by reggae musicians.

The shag haircut—short on the top, long on the back and sides—was popularized at almost the same time in 1971 by Jane Fonda and David Bowie. It was worn by both men and women and helped popularize the then novel concept of unisex haircutting salons. This was viewed as a stylish, respectable look, not as the countercultural expression that similar styles had been only a few years before. A variation of this look, later known as the mullet, even became popular with professional athletes and other young men who were decidedly not attracted to Bowie's sexual ambiguity.

Male facial hair, while it did not become the norm, was nevertheless commonplace, and most young men tried it out at one time or other. The preferred beard was not small and stylized, but full and luxuriant, like those worn a century earlier. Baseball players sported handlebar mustaches that made them resemble their turn-of-the-century predecessors, though the stretch polyester uniforms undermined the effect. The bicentennial played into this trend, as many communities made beard-growing a form of commemoration.

For women the imperative was not to have what later became known as big hair but rather to have a lot of hair. One clear role model was the feminist leader, writer, and editor Gloria Steinem, whose flowing blond locks always looked impeccable and unimportant to her. The three heroines of the television series *Charlie's Angels*, which ran for five seasons beginning in 1976, represented a rather different state of consciousness from Steinem's, what might be termed empowered bimbohood. The actresses who played the roles, most prominently Farrah Fawcett, had fantastic figures, but their hair was most memorable. It never appeared coiffed, but no matter how much mayhem had taken place, it was always in absolutely perfect disarray. Such a heightened and unreal expression of authenticity defines Great Funk taste.

Plato's Retreat, a straight answer to the baths, took over the Continental's location in 1977. There was just as much sex but it wasn't nearly so fabulous.

Americans' increasingly evident sexual frankness and unabashed hedonism was attributed, as so many things were, to the advent of the birth control pill, which first became available in 1960. By 1973, ten million American women were using oral contraceptives, including about one-fifth of those between fifteen and forty-four. By firmly severing the tie between sex and procreation, they opened the door to a more exploratory, hedonistic approach to sexual behavior and expression. Still, it is unlikely that the sexual mania of the seventies would have taken the shape it did without the emerging influence of homosexuals.

Although many gay people were and are parents, same-sex relationships do not produce children. Indeed, ancient religious disapproval of homosexuality, along with the condemnation of masturbation, lay in the perception that it would reduce the size of the next generation and threaten the survival of the family, clan, tribe, or nation. In the seventies, though, with its apocalyptic warnings about overpopulation and environmental degradation, many viewed abstaining from having children to be a higher public virtue than childbearing. Indeed, even those who were looking toward the end of the world were not particularly focused on producing future generations.

What was happening then was that heterosexuals, those some homosexuals contemptuously termed "breeders," were becoming more like homosexuals. They were not focused on making families but rather on the pleasure and knowledge that spring from sex itself. They did not have to answer to families about their suitors or sex partners. They were free to invent ways of being sexual that made sense for themselves in their time.

Gay male culture, even before it began to come out of the closet at the end of the sixties, had faced this situation and had created a number of institutions to help gays cope in a society that didn't wish to acknowledge, much less accept, their presence. Among these were gay bars, whose principal function was to provide a place to meet other homosexuals, some of whom might be sex partners. Most cities also had public bathhouses or athletic clubs that were either exclusively homosexual or were discreetly "cruisy."

Gays were coming out and acknowledging their sexuality in greater numbers than ever before. Loving a member of one's own sex could be as real (and as commonplace) as Coca-Cola. But even in New York, many still sought out semi-secret places, such as the Hudson River piers, to meet others.

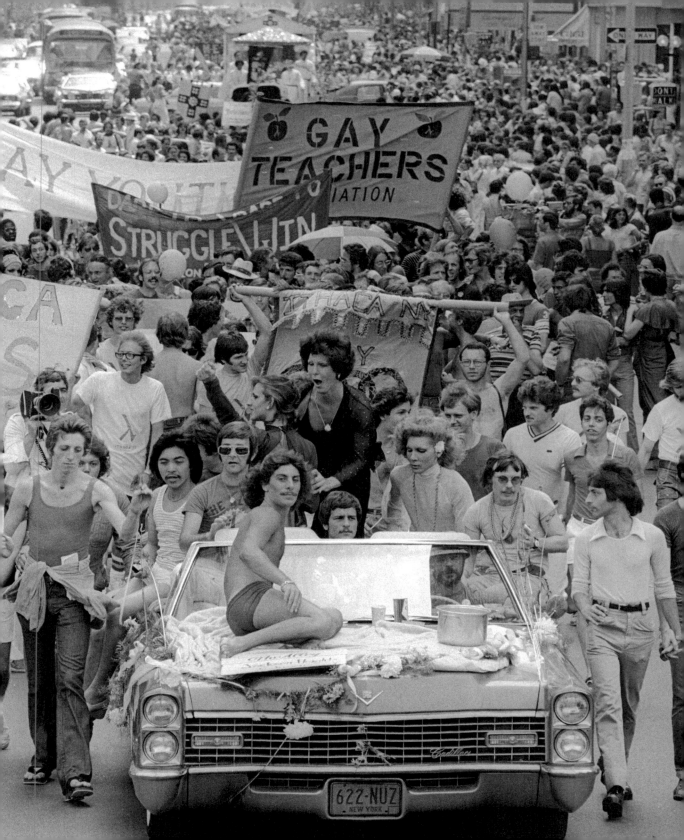

The sometime sordidness and raunchiness of such places has often served as a reason for condemning the entire homosexual culture. But it's important to remember that they sprang up at the margins, without any support from the society at large, to accommodate desires that were widely disapproved of and often illegal. Gays were a little bit like Miss Jones in the famous porn film: They had already committed the biggest sin simply by being homosexual; once condemned they might as well try the others. Moreover, these institutions were created primarily by men, who are biologically programmed to be impatient and aggressive. Thus, while plenty of deeply felt love affairs began (and ended) in gay bars, they have never been places that communicated romance or enduring commitment.

Even though gays had been meeting in bars to find sex partners for decades, T.G.I. Friday's, which opened on First Avenue in New York in 1965, is remembered as the world's first singles bar. It was the beginning of a worldwide chain, and it spawned many imitators. The secret of its suc-

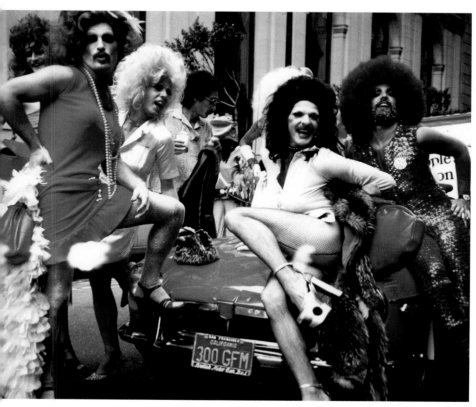

Making yourself visible was both the strategy and the content of gay liberation, which reached its annual climax at marches commemorating New York's Stonewall riots. As these San Francisco Freedom Day revelers asserted, you could be free not simply to be who you were, but also who you pretended to be. Gay hero Harvey Milk took the photograph.

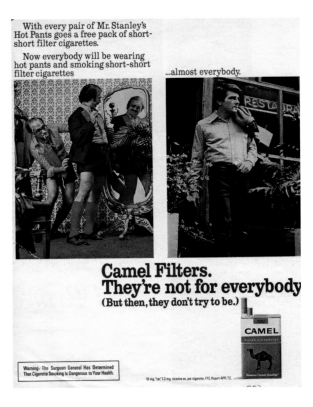

With every pair of Mr. Stanley's Hot Pants goes a free pack of short-short filter cigarettes.

Now everybody will be wearing hot pants and smoking short-short filter cigarettes

...almost everybody.

Camel Filters.
They're not for everybody
(But then, they don't try to be.)

CAMEL

Warning: The Surgeon General Has Determined That Cigarette Smoking Is Dangerous to Your Health.

cess was that it provided a place in which women could be sexual explorers, away from the demands of courtship. In a youthful society, filled with women who were asserting their autonomy, a business that allowed women to seek sensation as shallowly as men do was bound to be a winner.

From the point of view of normal heterosexual relationships, the singles bar was frightening, and it produced a backlash of fear and condemnation that was crystallized by Judith Rossner's 1975 novel, *Waiting for Mr. Goodbar*, and the 1977 film based on it, which starred Diane Keaton. It

was loosely based on the 1973 murder of a New York schoolteacher by a man she picked up in an Upper West Side bar. The novel and film show that the heroine, who begins hanging out in singles bars after the end of a relationship, initially feels freed and empowered by taking control of her own sexual destiny. Then she dies. It was scary, and obviously a real danger, but the book and movie did not stop people from patronizing singles bars.

The most unlikely piece of the gay demi-monde to go mainstream was probably that steamy venue for anonymous sex, the gay bathhouse. Yet during the early seventies, New York's Continental Baths, where singer Bette Midler became a star, became a straight sensation, *the* place for the effete to meet the elite. "One simply had to go there," Frank Rich recalled in a 1987 *Esquire* essay. "The boys were the real main attraction: they didn't bite, as my friend and I had feared in anticipation, but instead were an attractive advertisement for healthy, polite and free sex . . . Maybe the homosexuals were better adjusted than we thought for they seemed to have nothing, anatomically or spiritually, to hide."

In 1977, after the Continental had run its course, its space in the basement of the ornate, Victorian-style Ansonia Hotel became Plato's Retreat, a straight version of the baths. Finally, straight New Yorkers had the opportunity to behave as promiscuously and recklessly as their gay counterparts. Accounts differ on whether it was the place to have hot sex with porn stars or to meet, as writer Steven Gaines put it, "an assortment of kinky types from the suburbs: dry cleaners and their wives or fat men in toupees with their heavily made-up girlfriends."

In fact, Plato's Retreat was only the showiest example of a phenomenon that had been sweeping the country. As early as 1972, the Los Angeles area was home to at least eighteen swingers' clubs where heterosexuals could have sex with one another on the premises. In

The gay image evolved during the decade from the ridiculous effeminate sissy to the pretty boy and finally to the hypermasculine "clone" look, on view in San Francisco in 1978, and popularized and parodied by the Village People.

Gay Pride Day 1978

nearly every city, there were regular motel and at-home "parties" for swingers, as well as places where swingers made contact with one another to arrange sex elsewhere. There were even free newspapers available on street corners that publicized swingers' events. And everywhere there was talk, if not always evidence, of "key parties" in which suburban neighbors casually swapped spouses. In an episode of *All in the Family*, those unlikely swingers Archie Bunker and his wife, Edith, were the unwitting targets of seduction from another couple. ("I think they're AM-FM," Edith observed.)

Gaines's assumption that people need to be attractive to enjoy themselves was decidedly not a tenet of early seventies participatory culture. But by the heyday of Plato's Retreat, standards had changed. Body consciousness had evolved and the unworked physiques that had been so titillating—and easy to identify with—in the early porn films no longer impressed anyone at the neighborhood orgy.

As boomers began to age, they became more responsive to calls for continuing exercise and physical fitness to preserve youth. During the late seventies, jogging was transformed from an activity for a small group of enthusiasts to an almost inescapable phenomenon. Jim Fixx, author of *The Complete Book of Running* (1977), emerged as the first fitness superstar and his sixty-mile-a-week regimen became the aspiration of weekend runners. One of Fixx's most compelling arguments was that prolonged intense exercise would release chemicals within the body that would produce what he called "runner's high." This belief, whose scientific basis is shaky, appealed to those looking for higher states of consciousness and seeking euphoria without drugs. Others found a welcome blankness of mind open to Buddhist or other spiritual insights. (Fixx's regimen, while simultaneously euphoric and Calvinistic, could not forestall a sudden death from cardiac failure while running in 1984 at the age of fifty-two.)

There is a difference, though, between aerobic exercise to promote cardiovascular health and the weight lifting, Nautilus machine workouts, and focused calisthenics intended to sculpt the body. This was yet another area in which gay men led the way.

The remaking of the homosexual male body—the birth of the muscular, masculine "clone"—was one of the chief projects and achievements of the gay liberation movement. While the black civil rights movement had been primarily about laws, and women's liberation was

about consciousness, gay liberation was about the assertion of physical presence. Being African American or female is difficult to disguise; being gay is not nearly so obvious. The difficult, liberating step for homosexuals was coming out. They needed to make themselves obvious and inescapable, normal members of society, without becoming so normal they disappeared.

Gays had long had styles and code words to make themselves visible to one another, but unfortunately, many of these devices had become part of a negative stereotype. Acting like a sissy was actually a good way to identify yourself to other gay men, but it was also a good way to be ridiculed, excluded, or physically abused. Those who fought with police at New York's Stonewall Inn, in what is remembered as the event that galvanized the gay liberation movement, included a large contingent of stereotypical "queens," including men in drag. However, as the gay movement evolved, its logic seemed to lead to what marketers would term a "rebranding" of homosexuality, to make it seem modern, acceptable, and above all, masculine.

This transformation seems not to have happened intentionally. It began with people who were trying to escape old stereotypes. They distinguished themselves from the softness associated with effeminate homosexual men by hardening and shaping their bodies. They wore tight clothing that showed they had been pumping iron and asserted that there was nothing feminine about them. "I'm a lumberjack and I'm okay," went the Monty Python anthem, and many gay men affected the costumes of cowboys and other archetypal masculine occupations. At a moment when many straight men were dabbling in ruffles, shiny shirts, and other manifestations of sartorial flamboyance, these men stuck with plaid shirts and jeans.

The goal was not to look like straight men, but rather to look more masculine than most straights did. Straight men had bushy beards and straggly hair; gay clones had clipped mustaches and short hair. Straight men had beer guts; clones had six-pack abs. Straight men were just guys; clones knew that any way you look is just a guise. The clone look was, in the manner of the historically allusive architecture of Charles Moore or Robert Venturi, ironic and self-conscious. Behind the sneer on many clones' faces, there was a big joke, one that came out of the closet in 1978 with the advent of the superclone singing group the Village People and their big hit "Macho Man."

The gay clone did not have a real impact on straight men's bodies until the eighties, but by the late seventies, there was a tremendous prolif-

eration of neighborhood health clubs and exercise facilities within corporations. These indicated an increased interest in exercise for both health and youthfulness.

The birth control pill promised women far more control over their bodies than they had ever had before. Still, the explosion of pornography, swinging, and other forms of sexual expression and exploration primarily appealed to male fantasies and appetites. When women were freed from the strictures demanded by society's interest in the next generation, they also lost much of their power to say no. Once contraceptive technologies reliably severed sex from reproduction, the respect, and even mystery, that once inhered in women's bodies disappeared, and, very often, in pornography and serious works alike, women were viewed mostly as sexual targets for horny men.

The belief, which may be more common in males than females, that sex can be without consequence, was probably reinforced by one of the greatest legal triumphs of the women's movement: the Supreme Court's 1973 *Roe v. Wade* decision striking down laws against abortion. Americans have been fighting about that decision ever since it was handed down, but at the time, it seemed to come out of the blue. In a time of bad economy, failing war effort, and emerging scandal, abortion was a contentious issue that rarely made the front page. Debates over legalizing or restricting abortion flared in state legislatures and divided the American Medical Association. The U.S. Supreme Court had ruled quite narrowly in earlier abortion cases, which may be one reason that few anticipated that its ruling in *Roe v. Wade* would change everything. In its assertion that not only sex, but also a developing fetus, is purely a private matter, the court seemed to have adopted the radically individualistic attitudes toward sexuality that had emerged in the culture during the previous four years or so. Moreover, although the decision dealt only with whether abortion should be legal, not whether it is advisable, it was nevertheless an authoritative endorsement of an act many still considered reprehensible. In a sense, the Court transformed abortion from a major life decision to an elective medical procedure.

Ultimately, though, the decision probably just amplified trends toward later reproduction, smaller family size, and women's economic independence that were well under way by 1973. Certainly, far more pregnancies ended in abortion. According to estimates by the Alan Guttmacher Institute, the number of abortions—both legal and ille-

gal—in the United States doubled in the eight years after *Roe v. Wade*, from 774,600 in 1973 to 1,553,900 in 1980.

At the same time, though, there was a tremendous increase in the number of babies born to unmarried mothers. In 1970, about one American baby in ten was born out of wedlock, while by 1980 the figure was close to one in five. (For white women, the figure was one in twenty in 1970 and one in ten in 1980, while for African-American women it was more than one in three in 1970 and 53 percent in 1980.) These numbers seem to contradict the belief that contraception and abortion had given women control over their own reproduction, but the facts are more complicated.

A certain percentage of the increase can probably be attributed to the increasing prevalence of drug use, which can lead women to ignore contraception. And much of it can be attributed to poor education. The mere existence of technologies for contraception and legal protections for abortion does not mean that those who need them will know how to use them or have access to them. Out-of-wedlock birthrates were highest for the poorest and least educated. Still, some of the increase in such births came from women's own assessments of their futures. Women who, in prior years, might have been intimidated into shotgun marriages looked realistically at their own, and the babies' fathers', economic expectations and concluded, rationally, that they would be better on their own. (African-American women have long had a clear economic advantage over African-American men.) Moreover, some educated women decided that they wanted to be mothers, even as they knew they did not want to spend the rest of their lives with their babies' fathers.

The greater economic prospects for women, combined with increased control over their own bodies, created what seems to be an irreversible transformation of the nature and structure of family life. American abortion and out-of-wedlock birthrates remain among the highest in the world. As a society we're still struggling to find ways to balance the autonomy of the parents against the needs of the children.

Male doctors see womanhood itself as a kind of disease, asserted the feminist authors of *Our Bodies, Ourselves*. The book encouraged women to examine their bodies and defend them against ignorant and destructive medical practices.

W e are our bodies," declared the collective authors of *Our Bodies, Ourselves*, a groundbreaking 1973 work that took the seventies project of exploring and celebrating the body in an entirely different direction. The technology that had brought about the sexual revolution—the pill—was used by women, who had to experience the physiological consequences. Likewise, abortion can be traumatic. Yet the dozen women who came together as the Boston Women's Health Book

Chewbacca, the hirsute Wookiee copilot in *Star Wars*, may have been an alien, but he was also a seventies kind of guy.

Collective saw little evidence that members of the medical profession and authors of books on health thought of the female body as anything but a messy and mysterious organism, fraught with problems. They quoted a male gynecologist who said the uterus is "a useless, bleeding, symptom-producing, potentially cancer-bearing organ which, therefore, should be removed."

"We decided that there were no 'good' doctors and we would simply have to learn for ourselves," the authors say. One of their fundamental approaches was self-examination, and some passages were written to be read while holding a mirror, so that readers could discover previously unexplored parts of their own bodies. It was easier, however, to learn by looking at someone else's body. Many women recall consciousness-raising sessions at which, speculum in hand, they examined the vaginas of their fellow participants in order to understand what was inside themselves. It's striking that at the same time that *Hustler* was objectifying women by using "pink shots" of women's vaginas, feminists were engaged in much the same exploration. In the latter case, though, it was about knowing enough about their own bodies to claim ownership and control.

While some of what *Our Bodies, Ourselves* said had to be revised in later editions, the book was, from the first, conceived not as a product but as a process. "It was exciting to learn new facts about our bodies," the authors said in their introduction, "but it was even more exciting to talk about how we felt about our bodies, how we felt about ourselves, how we could become more autonomous human beings, how we could act together on our collective knowledge to change the health care system for women and for all people."

It would be difficult to find a more succinct and compelling expression of seventies values than this statement. It takes as a given that the conventional wisdom has failed, and that it remains to people who care, whether they are specialists or not, to solve the problems. Moreover, the solution grows not from a mere marshaling of facts, important as those are, but also out of a sharing of feelings. It rests on a belief that improvement grows from a change of consciousness, the adoption of new

patterns of thinking. Menstruation, the authors say, "is like a tree shedding its leaves in the fall." It's not a curse, it's life, and the message is to face it and get on with it.

ioneer 10 is still hurtling through space, exposing our seventies bodies and seventies values. It won't get near another star where it's likely to encounter an alien for more than seventy thousand years. At the time of *Pioneer 10*'s launch, and for several years after, alien encounters loomed large in popular culture. Most of the time, the aliens' bodies were seen as unlike our own, rather babylike, with big heads. That's how they looked in the movie *Close Encounters of the Third Kind* (1977), though the film's most memorable evocation of their alien and higher consciousness is through lights and music. These aliens were almost disembodied, and they were saviors. (*Star Wars*, released the same year, presented an entire bar full of hairy, grotesque, comically menacing aliens, who were the opposite of disembodied. And the extremely hirsute Chewbacca, Han Solo's alien sidekick, embodied seventies style carried to the extreme.)

Nobody who saw *Alien* can forget the moment when this creature made its entrance by popping from John Hurt's abdomen. The seventies' body was full of surprises.

The tales of those who had been abducted by aliens at the time seemed to indicate that the creatures from space were sexual torturers, or at least gynecologists. Women reported being restrained, both physically and through drugs and other debilitating devices, and subjected to rude, invasive, and painful physical examinations. These sadomasochistic elements did not appear in similar accounts from two decades before, in which abductees were subjected to a joyride and perhaps a minor physical. (In the fifties, sexual abuse of any sort wasn't often discussed.) *Pioneer 10* reflected a belief that aliens would be interested in our bodies, but these accounts suggest that Larry Flynt, not Carl Sagan, should have provided the images.

The most terrifying view of extraterrestrials of the decade, however, was that of the movie *Alien* (1979), in which a rapidly growing creature made its most memorable entrance by exploding from the stomach of John Hurt.

The body harbors secrets and mysteries, and even with a speculum, you can't fathom what's inside. The body was a new frontier during the seventies, and the aliens we most often encountered were ourselves.

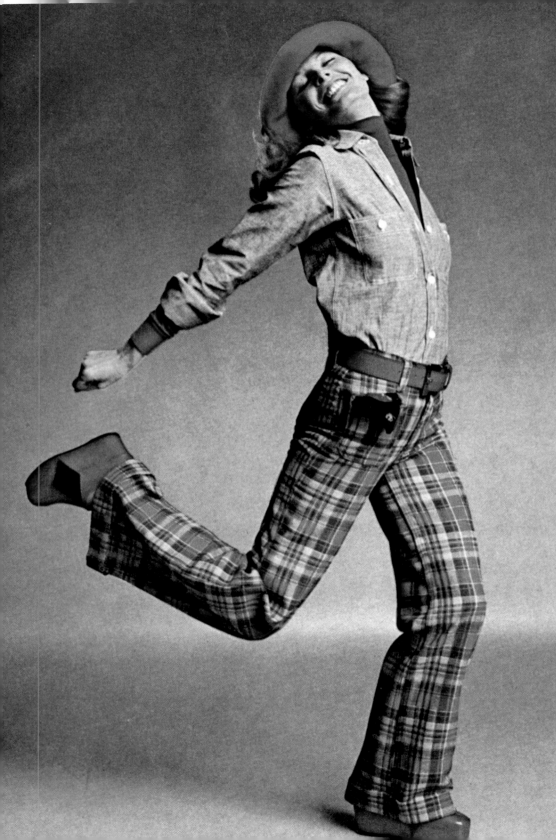

Nights in Green Dacron

Just as the seventies dawned, clothing designers, manufacturers, retailers, and fashion journalists reached a consensus: While it had been proved that mankind could break through previously insurmountable barriers and go to the moon, there was no way that skirts could get any shorter.

The miniskirt trend had been going for several years, and hemlines had been retreating toward indecency. Because fashion is about change, skirts couldn't stay where they were. There was no choice but to get longer.

Some women had already accepted the miniskirt's polar opposite, the floor-length maxiskirt, as a suitable garment for certain occasions. Still, that garment was more of a costume for entertaining or parties than a piece of everyday dress. The new length, a few inches below the knee, was inevitably dubbed the midiskirt. The entire worldwide garment industry was behind it, along with the major department stores and specialty chains and, of course, the fashion press. But the general press, including newspapers and some

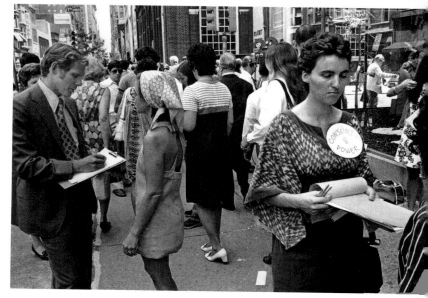

Miniskirt militants took to the streets in 1970 to protest the fashion industry's diktat that women would have to start covering their legs. This was one women's campaign that men were eager to support.

magazines, was skeptical. In keeping with the antiestablishment ideas that were widespread at the time, they complained about how fashion dictators had drawn a line and women were simply expected to replace their entire wardrobes to follow it. Facing such expense was especially burdensome in such an uncertain economic climate. Some newspaper stories quoted experts who argued that women show less leg during recessions and suggested that keeping skirts short ensures future prosperity. Some publications used the opportunity to show large images of women's bare legs and suggest, in distinctly masculine and even sexist tones, that guys should rebel against losing so much beauty and excitement in their lives.

Resistance was futile, fashion critic Kennedy Fraser warned in *The New Yorker.* "No amount of protest will stem the tide of the longer skirt," she wrote, noting how manufacturers and retailers had already invested. "I suspect that resistance is a waste of energy," Fraser wrote, "since you can fight fashion only by being unfashionable."

"The look of today that won't go out of style" was the promise made for these Hart Schaffner Marx business suits. "Sure the basic silhouette is a little more shaped, the lapels a little bolder, the pocket flaps a bit wider," the ad conceded, but this riot of patterns and stripes passed for conservative in 1971.

What happened was that women did resist midiskirts in the most meaningful way they could: by allowing other people to buy them first. Very few women did. Those big investments, both of dollars and of prestige, were lost. The fashion oligarchy had been shaken. A new era had begun in which those who designed, made, and sold clothes would respect the opinions, needs, and desires of the people who were actually wearing their clothes. To this day, there has not been another look that has been promoted with such an air of the inexorable as was the midiskirt.

The midiskirt debacle was the basis of the guiding myth of seventies fashion, which was that fashion was dead. Even fashion magazines like *Vogue* and *Harper's Bazaar* that had been accustomed to issuing arbitrary decrees began to express a new fashion populism. A hundred flowers were growing, and there were hundreds of right ways to dress in a new, postfashion era of individual expression and expanding possibility.

There was some truth in this myth. Fashion authorities were more defensive than ever, and they did look more aggressively outside of the small worlds from which they had often derived their ideas. The rise of

"antifashion" meant that designers and journalists began to look to the streets to see what people were actually wearing. Antifashion began to spawn its own design stars. Some eschewed traditional craft and tailoring, while others created very well-made countercultural creations. There were even a few who made clothes that were striking, practical, and inexpensive. Antifashion was more an attitude than a style, but for a while it was chic, albeit at a time when it was really unfashionable to call *anything* chic.

Despite the well-publicized revolt against fashion, clothes from the seventies are easily identifiable. Indeed, they almost scream out their year of origin. Most men were only dimly aware that their shirt collars had become abnormally large, though they did know that the large lapels on their suits and jackets were new and unusual. Women were crocheting up a storm, making long tuniclike tops, along with handbags, hats, and other accessories, but they felt that they were pursuing a popular and very homespun hobby, not offering themselves as fashion victims. There were a few items—such as hot pants for women and huge butterfly-shaped bow ties for men—that were in style for less than a season but were considered not so much failures as flings, expressions of playful outrageousness that lent spice to the times.

Denizens of the Great Funk were eager to place themselves on display. They sought out different ways of dressing that sought to ignore—or transcend—the dated dictates of taste and fashion. Clothing was becoming more varied, more colorful, more daring. New fabrics and colors were creating new ways to look. Women struggled with contradictory demands to express their curvy femininity and to reshape themselves to fit into what had always been male domains. Young people wore costumes that dramatized aspects of their inner selves. They sought venues—from discos to midnight movies—that allowed them to feel like stars, even though they were performing in the dark.

If, during the fifties, the suppressed libido of the populace manifested itself in the voluptuousness of their winged automobiles, during the seventies, people's bodies became the canvas on which they expressed their dreams, fantasies, and values. Those who lived through the time might look today at old photographs and exclaim, "I can't believe I

If you wanted to grab attention with big lapels, these members of the rhythm-and-blues group Crown Heights Affair showed how it was done. They wore these shield-collared coats on the cover of their 1975 album, *Foxy Lady*.

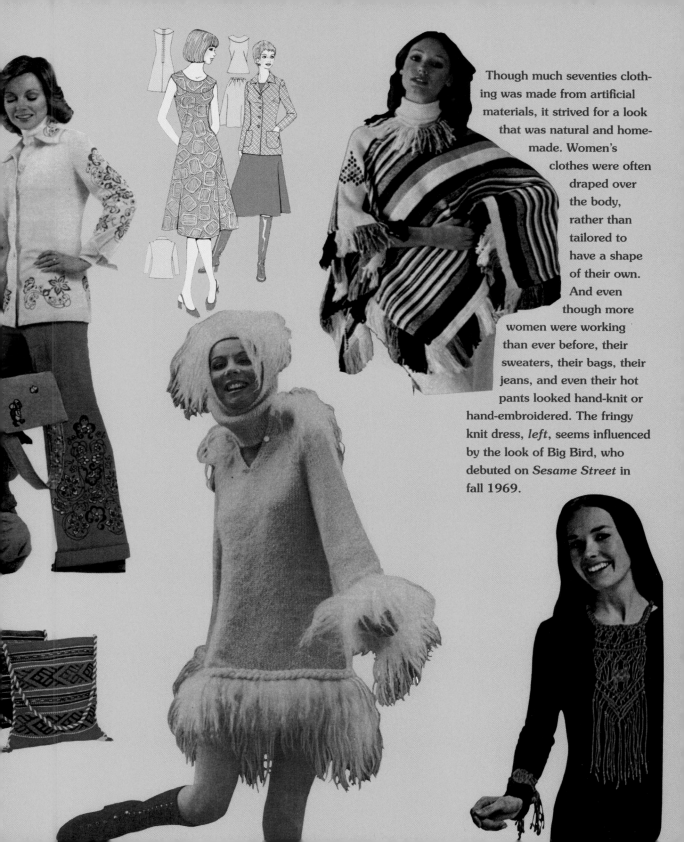

Though much seventies clothing was made from artificial materials, it strived for a look that was natural and home-made. Women's clothes were often draped over the body, rather than tailored to have a shape of their own. And even though more women were working than ever before, their sweaters, their bags, their jeans, and even their hot pants looked hand-knit or hand-embroidered. The fringy knit dress, *left*, seems influenced by the look of Big Bird, who debuted on *Sesame Street* in fall 1969.

wore that thing!" What might be more embarrassing is that most of them had carefully considered the outfits immortalized in those snapshots and concluded that they looked pretty damned good in them.

Dressing in the seventies had a lot in common with home decoration. The goal was to create an individualistic composition, one that embraced the natural and the fake, the nostalgic and the futuristic, and an overlay of pattern and texture. Just as householders scoured flea markets for furniture finds, they rooted through piles of vintage clothing to provide a unique accent or a signature statement. And just as folkish tiles gave a touch of authenticity to homes, so did folk costume, both real and simulated, provide an aura of integrity to many wardrobes. Embroidery, even when it was made by machine, spoke of a respect for the handmade on all sorts of garments, and it provided an extra layer of decoration and information besides.

Clothing styles are inevitably faster changing and more varied than home-decorating styles, but both spoke of a way of seeing and organizing the world. Both sought to reconnect with old traditions and crafts, even as they celebrated what seemed to be unprecedented opportunities to express one's own individuality and creativity. Like the postmodern architecture that was becoming popular at the same time, much seventies dressing got its power by increasing the scale of conventional clothing elements. Thus collars became huge, men's ties were biblike, platform shoes were vertiginous, pants flared, then billowed. What was more important, though, was the overall effect of these disparate elements. The goal was not the

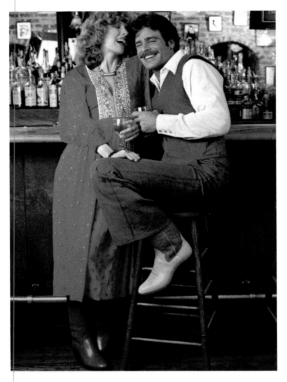

more usual one of trying to bring the elements of the ensemble into harmony but rather to accept and celebrate disharmony, and make a really interesting noise while doing so.

The look created by Ralph Lauren and worn by Diane Keaton in Woody Allen's Oscar-winning 1977 film, *Annie Hall*, for example, was a highly stylized yet believable vision of a certain kind of dressing. While it looked forward to the tailored, WASP fantasies Lauren perfected during the eighties, it felt right at the time the movie appeared because it was put together in a very contemporary way. It appeared entirely improvised, based on such "found" elements as men's vests and ties, a batik print blouse, long sweaters, and scarves juxtaposed with an insouciance that moviegoers could only dream of attaining. Her clothes were supposed to be like her conversation—scatterbrained yet charming—and

her driving, which was fast, risky, and effective.

Punk fashions, which began to emerge in New York City about 1974 and which reached their peak in Britain during the following three years, strove to be loathsome, not winsome. Yet this self-consciously obnoxious way of dressing, with its torn clothes, obscene graphics, and Day-Glo hair, depended, as the *Annie Hall* look did, on juxtaposition and the unexpected use of ordinary elements. Nothing could be more common than a safety pin, but having one sticking through your eyebrow or your thumb was the sort of thing people remembered. It had a more visceral impact than a girl in a necktie, but both these fashion

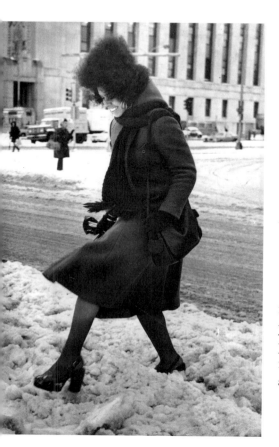

Great Funk fashion often juxtaposed disparate, incongruous elements. The look worn by Diane Keaton in 1977's *Annie Hall* made random, often masculine elements look elegant, but more often, as with the booted couple, *below left*, the clashing elements simply clashed. Exaggerated dress reached a peak with platform shoes. They could be treacherous to wear, but at least they kept your feet above the slush.

Punk, epitomized in
its purest form by the
Ramones, *above*, and
somewhat more glam-
orously by the New
York Dolls, *right*,
sought to shock and
disgust, not to charm.
Their clothes, like
Annie Hall's, reflected
the Great Funk prac-
tice of salvaging old
things and using them
in new ways.

statements display the seventies strategy of juxtaposing disparate elements while turning the familiar into something entirely unexpected.

One cliché description of the seventies is that it was "the decade that taste forgot." It's more accurate to say that it was the decade that consciously, even willfully, sought to forget about taste. For a society dedicated to experimentation, taste was little more than a litany of things that shouldn't be done. And more important, taste was produced by tastemakers—upper-class consumers, manufacturers, designers, and their captive press—who had positioned themselves as authorities about how everyone should dress and behave. In an age when all authority was at best suspect, and at worst discredited, those who advised people not to mix plaids or wear fabrics that shine too brightly or cling too tightly were easy to ignore. Indeed, as the decade wore on, the erstwhile tastemakers went out of their way to embrace freedom, individuality, aggressive display, and more than a little trashiness themselves. Taste wasn't forgotten. But the tastemakers had been rejected, and it would be years before they got their confidence back.

There's one other thing worth mentioning about the great hemline flap: Skirts did eventually become longer. They didn't do so all at once, and they didn't reach the precise length that the fashion authorities had decreed. But this does not mean women's initial rejection of the longer hemline was insignificant. Rather, the gradual acceptance of longer skirts sheds light on women's shifting sense of themselves.

The ever-shorter miniskirt may have been the most pervasive symbol of sixties liberation. It was never quite certain whether it embodied sexual liberation or women's liberation, because, for many, there did not seem to be all that much conflict between the two. For the wearer of the miniskirt, erotic pleasure was part of being a free woman, while men ogling at miniskirt-clad women could feel reassured that females were almost as eager for sex as they were. The miniskirt was a fashion for the young, which was a reasonable response to a moment when the largest generation in American history was reaching young adulthood. Still, it seems clear that a large percentage of the women born a generation before the boomers, many of whom wouldn't think of wearing the briefest, most fashionable minis, nevertheless partook of and celebrated both kinds of liberation. These slightly older women had lived with the rules, stereotypes, repression, and discrimination against which the women's

The miniskirt, the maxiskirt, and especially the hated midiskirt dominated fashion debate early in the decade, and women's rejection of longer hemlines convinced many that fashion was dead and "antifashion" had triumphed. Yet the distinctiveness of the silhouettes, the textures, and the draping of seventies fashion are unmistakable.

movement had rebelled. They had to struggle for freedoms that boomer women accepted as a birthright.

Coming when it did, at the beginning of a new decade, at a time when it felt like the world-changing energies of the sixties were winding down, the midiskirt seemed to be sending a signal to all women, boomers and preboomers alike, that the party was over, and now it was time to return to modesty, seriousness, and normality. There were many people who saw the sixties as a terrible social aberration. Many of them had voted in 1968 for Richard Nixon, who had served as vice president during the fifties, which were remembered as benign by some and repressive by others. Nevertheless, women had changed since the Eisenhower era, and while most of them were not political or social radicals, they were unwilling to see the clock turned back. The fashion and clothing industries introduced the midiskirt as if it were a decree that times were changing drastically. Women didn't buy the idea, and they didn't buy the skirts and dresses, either.

Women didn't like to be bossed around, but they were willing to buy clothes that they felt were trying to meet their needs. In the seventies, one such need was to be taken seriously in the workplace and not appear to be mindless sex objects. In the office, celebrating sexual liberation was less important than projecting power and competence, so the miniskirt had to go.

Moreover, showing leg was hardly the only way to be sexy. Designers turned their attention to the entire body, using jerseys and stretch fabrics, and billowing, silky synthetics, to emphasize the curves of the female form. Breasts returned, not as the bullet-shaped projectiles of the fifties but in a softer, more natural form that reflected both the bra-free rhetoric of some feminists and the seventies tastes for the authentic and the tactile.

At the same time designers and customers were skirmishing over hemlines, a far more radical and long-lasting change was taking place. Women were wearing trousers. Perhaps the reason this was scarcely commented on at the time was that nearly all women had long been wearing pants some of the time, as casual clothing. And a handful of women, including some glamorous style setters, had worn pants most of the time. What was new in the seventies was that just about all women started to wear pants in settings where they had not done so before. Trousers weren't just for the weekend in the country; now they were for the day at the office or the evening in town.

Obviously, manufacturers were making trousers for them to wear, and designers were creating new styles that suited new occasions, but there was neither fanfare nor controversy. This is curious. Bra-burning, for example, seems to have happened only once, yet people have been talking about it for decades. An entire sex blithely appropriating the defining garment of the other seems a far more radical step. "I wear the pants in this family!" generations of men had declared, attempting to defend their traditional primacy. Suddenly, by the winter of 1972, it became obvious that men weren't the only trouser wearers in the family, but hardly anybody made any noise. "The course of this revolution was so gradual," wrote Fraser, "and its supporters were so many and varied that scarcely anyone but bank executives and restaurateurs bothered to comment, let alone take a stand."

It's difficult to say for certain why a dog doesn't bark, but there's a case to be made that trousers sneaked in under cover of nakedness. The leg-baring miniskirt had

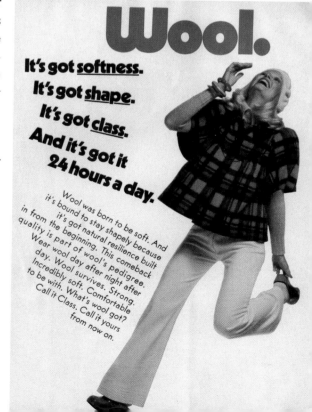

Nothing expresses the anything-goes mood of seventies dressing better than hot pants, which were (very briefly) considered acceptable for weddings and other formal occasions. This was a pattern you could knit yourself.

created so much distraction—in the form of condemnation, celebration, and analysis—that there was scarcely any comment about how many legs were being covered completely, by what had long been seen as an unladylike garment. (Actually, many of the apparently exposed legs were often covered by panty hose, a product that was first marketed on a large scale in 1965, just in time for the miniskirt. It may be that panty hose were themselves pants in disguise.) The hemline wars continued the diversion, and by the time it became obvious that a revolution had happened, it was already too late to do anything about it.

Trousers came into universal use at a time when fashion was preoccupied with dramatizing femininity, softness, and curviness. Trousers were seen more as convenience than fashion, and at the moment of acceptance, at least, they weren't seen as an attempt by women to make themselves masculine. Indeed, if there was a crisis about masculinity, it was not so much about females becoming too manly but rather about males not being manly enough. The claims of women for equal participation in the economy, the workplace, and the society at large were far from settled in the early seventies. Yet the symbolically potent matter of women in pants somehow slipped below the radar.

One possible exception to this silent acceptance was the titillation and mild furor that came with the introduction in 1971 of hot pants, which were very short shorts, often made in luxurious or unusual materials. Although this garment soon became associated almost exclusively with prostitutes, at the time they were introduced, hot pants were viewed as perfectly proper. *McCall's Needlework and Crafts*, a very middle-American publication, even offered a pattern for home knitters. (It was a difficult project; if you had started knitting when the pattern first came out, you might just have finished a pair before the garment went out of style.) People debated issues like whether they were appropriate for wearing to weddings. At the time, only a little more than a year after the midiskirt debacle, hot pants were seen as a surreptitious return of the miniskirt. The important thing, though, is that they were pants. Controversy about whether these particular pants were acceptable for formal and professional occasions only underscored the reality that pants themselves had already been accepted.

As it turned out, of course, hot pants were not accepted, and looking back, it is hard to believe that they were ever taken seriously. They were, though, and that fact tells us much about how open and experimental people were willing to be.

Several variations on trouser-based garments did become fashion

clothing staples during the early part of the decade. Perhaps the most universal were leotards, and their one-piece variation, the unitard. These form-fitting garments, previously worn only by dancers, epitomized the seventies compromise of revealing shape when covering skin, and they served as the inner layer of the multilayered outfits many women wore. These garments often seemed not so much to clothe the wearer as to apply colors, patterns, and textures to the naked body. They also made it possible to wear the loosely knitted and crocheted dresses and tops that were popular at the time without appearing indecent. And although the look appeared before the 1973 oil crisis forced homeowners and businesses to lower their thermostats, the multilayered approach to dressing became downright practical once everyplace got cold.

The availability of artificial fabrics pushed men's clothing in some unprecedented directions. The patterned suit, *below*, represents a road most men did not take, but the tieless leisure look became widespread enough to inspire a line from Levi's, *left*.

A related garment that never became quite so widespread, but was nonetheless influential, was the one-piece, zipper-fronted jumpsuit, worn by both women and men. This too was a garment type that had long existed, though it was mostly associated with automobile mechanics and people from other planets in science fiction films. Elvis Presley, who by his seventies Las Vegas phase combined elements of both, often performed in jumpsuits festooned in fringe or chains, or decorated with sequins and medallions. He helped establish the idea of the dressy jumpsuit, and some high-end designers and apparel makers produced their own designs for both casual and evening wear. For a time, they were the thing to wear when it was, as the disco lyric went, "time for a cool change." Then they reverted to being appropriate only for an oil change.

One facet of the experimental attitude toward dressing was the widespread embrace of a variety of artificial fibers, materials, and blends that are remembered, contemptuously and often inaccurately, as "polyester." These artificial fibers had tremendous appeal to consumers who wanted to

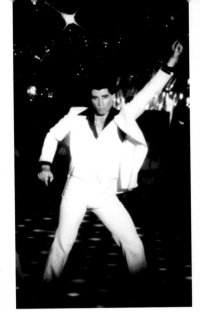

John Travolta's outfits in the 1977 film *Saturday Night Fever* represented the apotheosis of polyester, and more than a few mothers were tempted to dress their sons in homage to the disco hero. The 1978 Quiet Riot album cover, *below*, affirmed that men, whether macho football player or glam rocker, were as one in their wearing of Spandex.

look spectacular—and who weren't fond of ironing. These fabrics promised the look of luxury materials, along with the assurance that they would be difficult to ruin and their maintenance could be trouble-free. Lurex, an English-made metallic and plastic fabric, was very luxurious, and it was used by some of the world's most famous designers to make iridescent, body-hugging evening dresses that are remembered, celebrated, and collected by museums, as the height of seventies style. However, the less expensive fabrics— the ones that mimicked silk, the ones that were uncannily iridescent, and the ones that managed to be soft and rough at the same time— are the ones that live in infamy.

Polyester isn't entirely the seventies' fault. Artificial fabrics had been available since the 1920s, and widely available since the forties, though most of the time they were blended with natural fibers like wool or cotton. By the seventies, though, advances in chemistry, production, and dyeing made it possible to engineer fabrics, and especially knits, that looked, felt, and hung just as a designer desired. Consumers were willing to experiment, and so was everyone else. Early in the decade, at

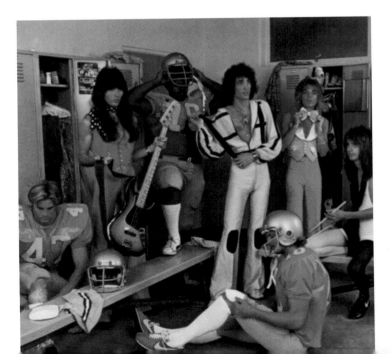

least, men and women were delighted by shining, clinging, eye-popping, trouble-free clothes.

Take, for example, Quiana, a kind of nylon made by DuPont that was marketed as an affordable and convenient substitute for silk. It was so well accepted that the word even gained popularity as a name for baby girls. It spoke of elegance and luxury. Many of the fancy men's shirts of the period, the ones guys wore open almost to the navel, with a medallion nestling in the chest hair, were made of Quiana. John Travolta wore Quiana shirts in the film *Saturday Night Fever* and while doing so summed up the affordable showiness and swagger that these fabrics made accessible to all.

Clothing buyers were daring, and manufacturers followed suit. Early in the decade, DuPont entered into an agreement with a clothing manufacturer to use one of its products in a new line of fake fur coats and other garments. The material had hitherto been used to make car polishing cloths and paint rollers. The coats produced looked like particularly tightly sheared shearling, though even with real fur accents at the collar and sleeves, some of its paint-roller roots showed. And if you ventured out in wet weather, you risked looking like a cake that had been left out in the rain.

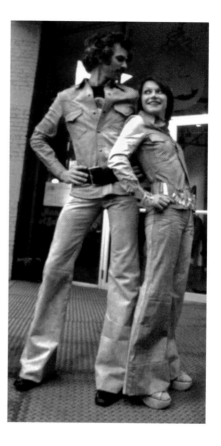

It was commonly observed that men's and women's outfits were rapidly converging, and a unisex future was coming soon.

Halston, who was probably the most celebrated clothing designer of the era, won much of his reputation for his experimentation with the high-end synthetic ultrasuede. His first design in this fabric was for a raincoat, a decision that was based on his misapprehension that this washable fabric was also waterproof. In fact, it was extremely absorbent. With a stylish disregard worthy of Marie Antoinette, he declared that his mistake would not inconvenience any of those who had bought his expensive coat. "Rich people don't get wet," he explained.

Buyers of clothes made from materials like Quiana and Dacron polyester were looking for visual appeal, novelty, and ease of care. Tailoring was relatively unimportant, even in high-end women's clothing, but draping and stretching were. New ways of standing, lounging, dancing, and living seemed to call for new fabrics. Texture, too, was often very important, especially for items that were meant to be shiny or clingy,

The leisure suit seemed an ideal outfit for the sort of home holiday celebrations where one might have to feign fascination with a spaghetti server.

though some polyester knits didn't feel good against the skin.

A new kind of garment that grew directly out of the availability and properties of polyester was the men's leisure suit. This was a matching combination of jacket and trousers, usually in a lighter, less formal color than was usual for men's dress suits. It was intended to be worn with a pullover, often a turtleneck, or an open shirt whose large, spreading collar would make a layer atop the flappy lapels of the leisure suit. Sometimes there was stitching around the breast pocket, to express that this was a suit of a different kind and, very likely, a different color as well.

The leisure suit was, in many respects, only a slight modification of another newly popular clothing type, the women's pantsuit. While there were well-tailored examples of both, made in natural materials like wool and silk, the typical leisure suit, like most women's pantsuits of the time, was made of polyester and shared the virtue of being semidressy yet easily washable. Men's leisure suits even came in what had hitherto been women's colors, such as lime green and powder blue. The big difference was that women's versions typically had straighter fronts, without the big lapels that served at the time as a mark of masculinity.

While the leisure suit is remembered now as a garment for lounge lizards, used car salesmen, and other sleazy types, when it was introduced, it was understood as a kind of compromise. Those who bought it acknowledged that times had changed and the old rules no longer applied. They didn't necessarily want to turn the clock back, but they didn't want anarchy either. Besides, there are real advantages to suits. They simplify the lines of the body and take attention away from potbellies and spare tires, which were made all too evident by double-knit sport shirts and other popular garments of the era. Jackets provided warmth and useful pockets.

Photographs of men in leisure suits are poignant because they show us men who are trying to move into a new kind of society even as they are anchored to the old. They are trying to take a half step into a revolution.

The leisure suit was quite a successful product for several years. What doomed it was a sudden revulsion against polyester and its ilk that set in around 1977. Indeed, at the very moment that John Travolta was striking his *Saturday Night Fever* pose, most consumers were headed in the opposite direction. In a 1999 history of artificial fibers, Susannah Handley describes Travolta's persona: "A disco dancing idol, clad in a white Dacron flared leisure suit and a black Quiana shirt, his wardrobe spoke volumes about the showy but tacky clothes that finally led to the downfall of the fifties' 'miracle fabric.'" She attributes consumers' rejection of such clothing to "the dread combination of static, perspiration, and sliminess next to the skin."

That's certainly true enough, though it doesn't account for the many years in which men and women were willing to live with those drawbacks in order to enjoy the benefits of these modern materials. People are willing to put up with a good deal of discomfort in their dress, as long as it makes them look more like the people they want to be.

Polyester fabrics had stopped doing that by the late seventies, perhaps because they had been so common. Between 1966 and 1976, worldwide production of man-made fibers had increased more than eightfold. That was probably more than enough. If in the twenty-first century we are contemptuous of seventies polyester—even as we wear so many chemically engineered fabrics ourselves—we're only echoing those who, in the seventies, got tired of it first. In 1977, DuPont was so concerned about the turn away from Dacron that it put out a defensive press release on "Polyester: The Misunderstood Fiber." That wasn't the problem, though. People at the time knew

Jeanswear was a late-seventies revolt against the age of the polyester leisure suit, though decades later, it can be hard to understand what was really different.

the material all too well, and it was no longer what their fantasies were made of.

The fall of artificial fabrics coincided with the rise of fashionable denim jeans with designer labels. It seems undeniable that these two trends were related. Jeanswear, as the fashionable offshoots of denim clothing became called, filled up the spaces in the stores recently vacated by synthetics. All-cotton denim is a familiar natural material, one that most Americans had been wearing, at least some of the time, for the previous two decades. Over time it becomes soft and friendly to the touch, and while it doesn't stretch like polyester, gradually it fits itself to the body. Like polyester, denim is easy to care for. Indeed, the more you abuse it, the better it looks. Denims were, therefore, the sartorial equivalent of comfort food. Jeans with a denim jacket are a real leisure suit.

The challenge to those selling denim clothes was not to make wearers like them but rather to convince consumers that they were an acceptable way to dress. During the polyester years, the makers of traditional blue jeans, preeminently Levi Strauss, had missed an opportunity. Even as such outrageous garb as hot pants were, however briefly, considered dressy, the jeans makers stayed close to their work clothes heritage. They didn't even offer products designed to fit well on most women's bodies. Even though jeans were worn by both sexes, and were predominantly sportswear, they were considered to be outside of fashion, and that was, to be sure, part of their appeal.

Embroidery made jeans a little more special, but ultimately it was designer labels—and a real effort to reshape them so they fit better on women's bodies—that made a perennial garment into fashion. Top seventies model Patti Hansen—who went on to marry rocker Keith Richards—helped make denim hot as the decade closed.

Calvin Klein Jeans

What transformed blue jeans from generic comfort gear into real clothing wasn't design but marketing. The first step was to charge more for them, a step that not only made them appear more precious to the buyer but also made them more profitable for retailers, thus encouraging more advertising and better store display. These social-climbing trousers needed a name to give them some cachet, and in 1978, along came Gloria Vanderbilt. She was not a

designer but rather an heiress, who had had an often troubled and much chronicled life. Her very name evoked visions of gilded mansions, vast estates, grand ballrooms, and yachts nobody could afford. She spoke about offering women better-fitting jeans, and she delivered to some degree. But what she really brought to blue jeans was an aura of social approval. If Gloria Vanderbilt said jeans were welcome in better places, then it must be true. The little swan embroidered on the rump provided the confidence to walk in the door. Later in 1978, Calvin Klein, who was one of the most celebrated clothing designers of the time, introduced his line of jeans. While Vanderbilt's name made jeans socially acceptable, Klein's advertising presented them as sexy. Proper and hot is a very powerful combination, and designer jeans played a big role in dress during the late seventies and long into the eighties. As they became fashionable they metamorphosed, appearing in a large range of colors, washes, leg profiles, and fits. Jeanswear evolved from a fashion into a whole genre of clothing, one that has waxed and waned in popularity over the decades but has never gone away.

Even uniforms that had remained the same for generations became less formal and more expressive during the Great Funk. Nuns, *above*, traded medieval for businesslike. *Below*, knuckleballer Joe Niekro pitched for the Astros in rainbow stripes, at the peak of baseball's polyester era.

One perennial appeal of jeans is that they constitute a kind of uniform, a mode of dressing that doesn't require much attention or contemplation. They didn't become truly fashionable, however, until they became less uniform, so that wearing them could be a kind of personal expression.

During the seventies, uniform dressing came under challenge. That was true for such customary uniforms as the men's business suit, as well as for some venerable, official uniforms. For example, the nun's habit—with long veil and starched wimple beneath the neck—had remained virtually unchanged for

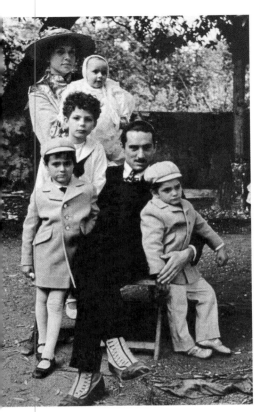

nearly five hundred years. It had been adopted at a time when it was a version of polite lady's clothing and stood impervious to centuries of fashion. Yet in the seventies, it was radically simplified, to the point where it nearly disappeared. This was a result of reform movements within the church, but there was also a feminist component to the change. It began to seem ridiculous to burden women with so uncomfortable and unwieldy a garment. Something similar happened to the nurses' uniform of white dress, white cap, and white stockings. Increasingly, women and hospitals adopted less symbolic, more practical uniforms, often with pants.

And even that nineteenth-century survivor, the baseball uniform, underwent a startling though short-lived transformation during the seventies. The availability of polyester and other man-made fabrics, the need to stand out on color television, and a desire to appeal to young sports fans led several teams to make some changes. In 1975, the Houston Astros played in rainbow-patterned shirts. In the mid-seventies, the Chicago White Sox played in a mix-and-match combination of tops and bottoms that resulted in different looks on the field from day to day. Those uniforms also featured shirts that weren't meant to be tucked in, to convey an

The Godfather: Part II was one of countless movies that conveyed the subliminal message that criminals are the best dressers. And so-called blaxploitation films like *Shaft, right,* owed much of their appeal to good-looking African-American actors in stylish costume.

attitude of informality that was new to the sport. These uniforms also boasted collar details that recalled those that had disappeared from most baseball uniforms early in the twentieth century, a nod to the nostalgia boom. But most teams opted for a double-knit futuristic look. The players looked like inhabitants of a minor planet on a *Star Trek* episode. In 1979, the Philadelphia Phillies management decreed that the team would play in all-burgundy uniforms on Saturdays. The team was laughed off the field, something that wouldn't be all that surprising except that the Phillies

were fielding one of the best teams in their long and mediocre history.

Even as the majority of people sought new and innovative kinds of informality, there was one group of people who were believed to be upholding the old sartorial values of fine materials, good fit, and assertive formality. These were criminals.

You can say what you will about the murderous ways of the Corleone crime family, the fictional Mafia gang chronicled in the movies *The Godfather* (1972) and *The Godfather: Part II* (1974), but they always looked nice when they went out. Marlon Brando as the patriarch looked great in his tuxedo worn with a blood-red boutonniere, and the children in the sequel wore custom-tailored matching blue suits. Al Pacino's suits were made from natural fibers, fine soft wool for winter, nubby raw silk for warm weather, and in one scene he actually wore an ascot. These clothes were, of course, evidence of the Old World values that the films claimed the family embodied, and their propriety made a contrast with their outbursts of shocking violence and brutality. Still, though both films were enormously popular and critically admired, their effect was probably to discourage people from wearing the kind of clothing the characters wore. Audiences understood the movies as an indictment of the corruption of American life. To imitate the costumes, however glamorous, would be to buy into the corruption.

The opposite held true, however, for the kind of criminal elegance visible in the genre of movies known as blaxploitation films. In these films, most of which were made between 1970 and 1975, the drug king-

A Chicago youth, *above,* displays the urban dandyism that both shaped and reflected the style of black-oriented crime films. *The Harder They Come* (1972), a Jamaican film that helped popularize reggae and became a stoners' midnight mainstay, was marketed as an exemplar of violent glamour.

Hats were a fundamental ingredient of urban, black, masculine style. (White men generally went hatless.)

pins, pimps, and others who live outside the law all sport wardrobes that communicate clearly that crime pays very well indeed. Richard Roundtree, playing the title private eye in *Shaft* (1971), the film that established the genre, looked great in his soft leather trench coat and blue-gray turtleneck. But his wardrobe was modest beside the well-tailored suits and striped shirts worn by Moses Gunn as a black crime boss trying to defend his turf against the Mafia. He looks like an executive with swagger. In *Superfly* (1972), Ron O'Neal wore some of the most over-the-top costumes of the seventies—including a bright white suit and a huge, floppy, subtle-patterned light blue topcoat—in his portrayal of a cocaine dealer trying to make a final big score before getting out of the business completely. And although Pam Grier, the genre's greatest female star, was best known for outfits that exposed nearly all of her large breasts, she sometimes wore evening gowns and a white fur coat.

While African-American religious and civil rights leaders condemned the blaxploitation movies, they were very popular with audiences. The broken-down, lawless cities they depicted were not far from the truth, and the prominence of criminals and the pervasiveness of violence were hardly foreign to the experience of the films' mostly black audiences. The movies didn't actually endorse criminality, but they did make it look awfully stylish. What was new about the movies was that Roundtree,

Gunn, O'Neal, Grier, and the others held the screen like stars. They had charisma and great outfits, and they elevated to the level of movie fantasy aspects of the styles on the street. The urban glamour that these movies showed was derived from the styles found in African-American communities, which have long supported a tradition of outré dandyism. And even when, as in *Shaft*, the main character was not an outlaw, the films did heighten and disseminate a look of drug-dealer chic.

What musicians wore was even more influential than what movie stars wore. The outrageousness of what many people wore out at night was surely shaped by the emerging aesthetic of the arena concert. And this kind of performance was shaped in turn by the demographics of the baby boom generation. Young people were willing to turn out by the tens of thousands to see their favorite performers, and much pop music performance moved to vast stadiums and only slightly smaller arenas in which most of the audience could see the singers and instrumentalists only from a great distance, though the sound from the stage was relayed at ear-splitting volume. There was little choice for performers but to make a spectacle of themselves, largely by wearing costumes that could make a strong impression from very far away. In turn, many members of the crowded boomer generation sought to use a distinct style of dressing, either to make themselves stand out in the crowd, or more often, to establish solidarity with some of the others in the audience.

To be sure, many musicians—from Cab Calloway and his zoot suits to Elvis Presley in his pegged pants—had worn distinctive costumes, elements of which were imitated by their fans. Even country

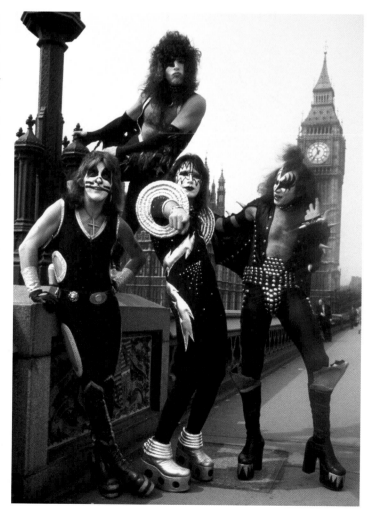

Arena rockers like Kiss dressed to look distinctive from very far away.

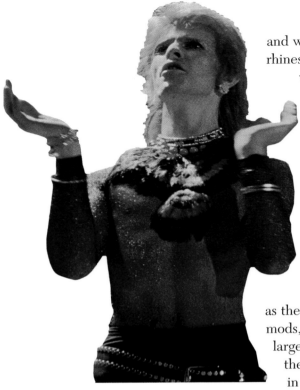

and western music had produced its share of rhinestone cowboys, though not until 1975 was there a hit song about the phenomenon. And only in the seventies did fans begin to define whole musical genres through the performers' costumes, a set of distinctions that in turn induced their fans to form cliques in their schools based on their adaptation of the values and dress of the performers they admired.

This phenomenon was shaped largely by English performers, who partook of a long tradition of outrageous costumes and pantomime, as well as the more recent phenomena of teddy boys, mods, and rockers—youth cultures defined largely by their dress. Androgyny, especially the rejection of male buttoned-down dress in favor of more ornamental and sexually revealing clothing, had emerged as an issue

David Bowie forged a new persona for each album and tour, thus demonstrating how one person can project a range of personalities, genders, and perhaps even species.

during the sixties. But when David Bowie's 1970 album, *The Man Who Sold the World,* was released in the United States, the British cover, which showed him in a dress, was jettisoned in favor of a less confrontational image. Bowie solved the problem two years later with his breakthrough album, *Ziggy Stardust,* and especially in the live concerts in which he performed the songs from that album. He was still extremely sexual, and extremely ambiguous, but it was all right because he was now presenting himself as an alien from another world, what he called a "space oddity."

In contrast to such hyperkinetic arena performers as the Rolling Stones' Mick Jagger, Bowie's movements on stage were restrained and highly stylized. But his look, from his unnaturally red shag haircut on down, was striking and extensively scrutinized. "His clothes are particularly dramatic," noted the British publication *Music Scene* in 1973, "and include one outfit consisting of knee-high boots, a shortie kimono and fish-belly white tights! He also appears swathed in a beautiful multi-coloured cloak . . . Bowie hairstyles and colourings were much in evidence on both males and females who no doubt wished it could have been them up there performing 'Ziggy Stardust,' 'Oh You Pretty

Things,' 'Prettiest Star,' 'Jean Genie,' 'Changes' and 'Space Oddity' and soaking up the adoration." Still, if you merely listened to the music, you would probably never figure out that Bowie was inaugurating not only a new genre of music, glitter rock, but also a new set of genres defined as much by costume as by sound.

Following his run as Ziggy, Bowie began a pattern of creating a new persona— dissolute hipster, "plastic soul,"

robot—with each new album or tour. This willingness to try on identities was part of Bowie's aura, and it endeared him to his fans, many of whom were experimenting with their own identities.

Bowie seemed to have been an inspiration to Patti LaBelle, who transformed her sixties-style girl group, the Blue Bells, into the glamour-soul act La Belle. Eschewing the identical costumes of the previous era, each member of the trio had her own style of costume within an overall bird-of-paradise-from-outer-space theme. Sometimes they dressed in stretchy silver lamé outfits that seem to have been made for some odd, nonhuman creature. While Patti LaBelle herself tended to sprout feathers and wings from many unlikely directions, Nona Hendryx was consistently even more outrageous. One of her outfits featured an enormous piece of white fake fur that reached from her crotch to her breasts.

Larry LeGaspi, who designed many of La Belle's costumes between 1972 and 1982, is one of the unsung masters of Great Funk style. His costumes helped remake George Clinton's group Parliament into Funkadelic, by putting Clinton in outfits that on different occasions featured a fur-covered football helmet topped by a television antenna, shredded leopard skin pants, enormous chicken feet, and elephant tusks

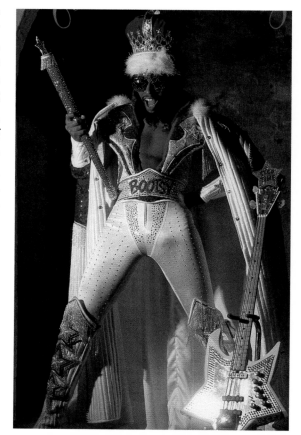

between his legs. LeGaspi, who owned a shop in New York's Greenwich Village, also once designed costumes for a group of elderly people who were planning to wait in the desert for a spaceship to land. They figured that they should look like the people they were planning to greet.

Kiss, famous for the singers' painted faces and leather outfits, was also dressed by LeGaspi. Kiss built upon the glitter rock foundation of Bowie and La Belle, and it certainly had an element of sexual ambiguity. But its music derived from the crude, loud, hypermasculine style of heavy metal. This booming, literally overwhelming music was designed for huge arenas, and, although the seventies brought a plethora of new music genres and subgenres, heavy metal dominated the decade. It was defined nearly as much by its sadomasochistic costuming as by its pounding beat. Kiss and some of the other glam rock bands capitalized on sending a deeply mixed message that allowed their fans to play with androgyny even as the music literally screamed machismo.

The designer Bob Mackie made costumes that transcended arena rock and entered the mainstream. A sheer gown he designed for Cher, a composition in flesh and feathers, with some beading and sequins to keep it from being indecent, appeared on the covers of both *Time* and *Vogue* in 1977. The costumes he designed for *The Carol Burnett Show* were often parodies of historic styles that were simultaneously striking and very funny. That program ran at 10 p.m. on Saturdays, just as many people were doing their own dressing up to go out for the evening.

One of the places they were going was to midnight movies, a peculiar phenomenon that arose at a few big-city theaters starting in 1970. *El Topo*, the first of them, opened at the Elgin Theater in New York late that year. The management tolerated marijuana smoking, and being high more or less defined the small but disparate midnight canon. Among others were the Jamaican film *The Harder They Come* (1972), with its great reggae sound track and authentic third world texture, and David Lynch's *Eraserhead* (1977), a surrealistic seventies masterpiece

Babs Johnson, the character played by the transvestite Divine in *Pink Flamingos*, reveled in her status as "filthiest person alive," and thus became queen of the midnight movie circuit.

of squalor and Great Funk grotesquerie. John Waters's 1972 film *Pink Flamingos* starred the full-figured transvestite Divine as a proud piece of trailer trash determined to defend her status as "the filthiest person alive." Waters said he aspired to be "a negative role model for a whole new generation of bored youth," and he succeeded beyond his wildest dreams. The film, which was crudely made, as well as just plain crude, cost $12,000 to make and earned more than $10 million largely because its audiences came back again and again till they knew the film by heart. It became a kind of low mass for stoners.

The ultimate midnight movie was *The Rocky Horror Picture Show* (1975), a musical about a naïve corn-fed couple who venture into the lair of a transvestite mad scientist. It flopped quickly during normal viewing hours, but it was resurrected spectacularly as an audience participation midnight spectacle. "Let's do the time warp again," proclaimed one of its production numbers, and lots of people chose to do it again and again and again. Members of the audience came to the theater dressed as their favorite characters. They mimed the songs and threw rice at the screen. As the film played, for years at a time at some theaters, what was on the screen became increasingly irrelevant as each theater developed its own stars from the audience, who were recognized by their peers and who sought to outdo themselves in their costumes and the creativity of their response to the movie.

Wearing Bob Mackie's outfits, Cher often seemed to transform herself into something other than human. *Below*, midnight movie-goers transformed into the outré characters from *The Rocky Horror Picture Show*.

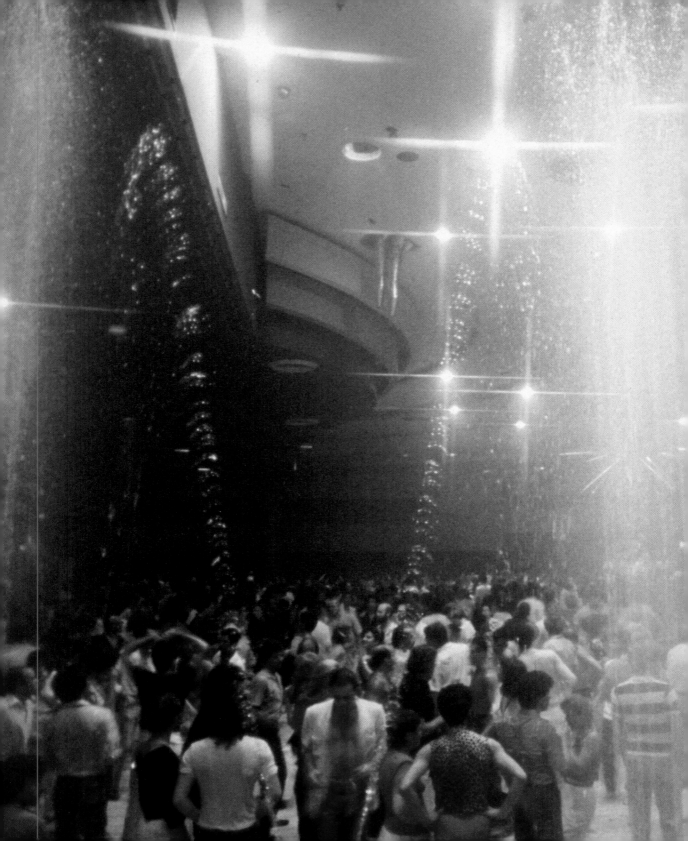

Rocky Horror unleashed a never entirely hidden desire. Everyone in the audience wanted to be a star. Everyone wanted to be somebody else, and be less inhibited, more sexy, more scary. The ritual gave people a chance to indulge this fantasy. And the other audience members were willing to tolerate your indulgence—so long as you were willing to acknowledge that they were stars too.

The ultimate venue for seventies participatory fabulousness was the disco. While arena concert audiences often dressed up and danced in the aisles, there was never any question that the main attraction was up on the stage. At the disco, though, the dancers were the stars. The music was, by definition, recorded, and even this was manipulated and transformed by the DJs, whose mixing, bleeding, and cuing of recordings was a creative performance in itself. But this virtuosity was unseen. The pulsing strobes and fake starlight from the disco ball shone on the sweating, writhing, undulating bodies of the dancers themselves.

Discotheques first appeared in a handful of cities during the sixties, where they were frequented by the group of international celebrities, socialites, rich people, and pretty people then known as the jet set. It was a form of café society brought up to date for the age of rock and roll. Seventies disco, with its huge dance floors, dazzling lighting, and never-ending music, was a very different phenomenon. Its music had the same sort of layering you found in the clothing and interior decoration of the period. At bottom was a funky, rhythm-and-blues beat derived from the "Philly sound" and often played by the same musi-

In case the heat of the disco beat wasn't enough to make dancers lose themselves in the scene, clubs used strobe lights, mirrors, smoke, special effects, and, in the case of New York's Bond's, fountains.

cians. Atop this lay a frankly artificial, synthesized sound—aural Dacron—often created by Europeans. Soaring strings gave it an almost operatic quality, and the top layer was the vocal, which added an element of the emotional and handmade. The discos of the seventies first appeared in large abandoned spaces, old restaurants and warehouses, often in

very poor neighborhoods. Many of these discos played funk music for largely African-American crowds. These places could be huge, but they were more or less underground. The same was true of the gay discos that sprang up in New York City and on Fire Island during the middle of the decade and were quickly replicated elsewhere. At these gay clubs, a handful of entrepreneurs and disc jockeys were able to gather their audiences even before the music industry started to create distinctive music to be played in the discos. To put your newly gym-hardened body on display on the disco floor was a way to truly demonstrate that you were out of the closet and fully embarked on a new life of pleasure and excitement.

The rhythm of disco songs maintained a steady 125 to 160 beats a minute. Disco dancing would have been good aerobic exercise if those doing it hadn't simultaneously been abusing their bodies by taking quaaludes before they went out, snorting cocaine in the bathroom, and sniffing amyl nitrate poppers to heighten the intensity of their feelings as they danced. Disco songs' similar rhythms made it relatively easy for DJs to move seamlessly from song to song. Over the course of the night, they typically built the excitement over long periods of time, subsided, and built again to larger and larger climaxes. Sex wasn't a subtext; it was blatantly

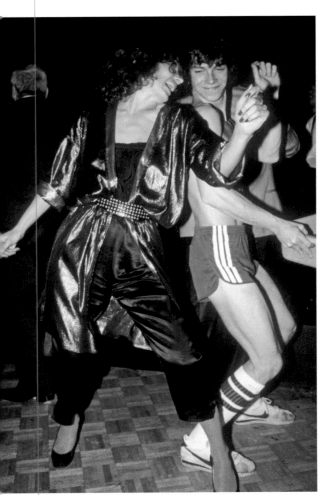

the subject. Was Donna Summer actually having an orgasm on the 1975 track "Love to Love You, Baby"? It sure sounded like it.

The sex on disco records was almost entirely female, and thus it offered a kind of corrective to the thrashing, aggressively male sexuality of heavy metal. At first glance, though, it

does seem peculiar that it was a gay male audience, one that had very limited interest in female sexuality, that made songs like Summer's popular. If you consider, though, that the sex in the songs is about surrender—about getting fucked—then it all makes a bit more sense. Men playing a passive role in sex has always made the straight male world squeamish about homosexuality. Songs of abandon and receptivity that encouraged the gay disco dancers to shake their cool thing enabled a public celebration of what had long been a cause for shame. ("Shame," by Evelyn Champagne King, was one of the great disco songs. She's angry at a man who cheated on her. The guys on the dance floor could identify with that, too.)

As happened in other areas, a straight public soon embraced this African-American and gay innovation. Straight discos opened in a number of cities, but none really took off until April 1977, when Studio 54 opened in a former television studio in New York. At previous discos, people had gone in order to make themselves stars. At Studio

Opposite: Donna Summer seemed to be in sexual ecstasy on the record "Love to Love You, Baby," which made her queen of disco; and Margaret Trudeau, the wife of Canada's prime minister, released some inhibitions at Studio 54, dancing with a busboy. *Above*: Studio 54's co-owner Steve Rubell was very picky about who he let past the rope; part of the pleasure of being there was knowing others had been rejected. *Left*: Making an impression at the disco often involved a careful balance of dressing and undressing.

54, people went to be among stars. Bianca Jagger, Brooke Shields, Cher, Margaux Hemingway, and Donald Trump all turned up for the club's opening, and amid the excitement, Frank Sinatra and Bianca's husband, Mick, failed to make it inside. A later event, Bianca's thirtieth birthday party, at which she entered riding a white horse, made the club the premier place to see and be seen. Studio 54 had good DJs, but those responsible for creating the scene each night were the men who decided who would get in the door, ideally a piquant mixture of celebrities, beautiful people, and people who were beautiful. Until its owners went to jail for tax evasion, it was the most successful disco ever, but except for the rampant drug use, its combination of high public profile and exclusivity was antithetical to the underground but essentially inclusive spirit of earlier discos.

The film *Saturday Night Fever*, which opened at the end of 1977, represented a further turning point in the development of disco, because it presented an alternate version of disco's origins and appeal. It was based on a *New York* magazine article about dancing as a route to recognition for aspiring ethnics in the city's outer boroughs. The article's writer later admitted that the story was just about entirely fabricated, with hardly any factual basis. The film's rather *Rocky*-like plot, combined with a score largely by the Bee Gees that was a bit lighter (and whiter) than most disco music, helped make disco a mass phenomenon. Discos were no longer a late-night big-city phenomenon. They were being added to Howard Johnson motor lodges off the interstate, and in onetime furniture stores on the way to the mall. At the peak, in the late seventies, discos could be a very profitable business, paying off the expense of high-end sound-and-light shows in just a few months.

Disco music grew in popularity during the two years after the film was released and even began to dominate the playlists on pop music radio stations. It also provoked an antidisco backlash that reached some sort of a climax in one of the dumbest events of the entire decade, Disco Demolition Night at Comiskey Park in Chicago on July 12, 1979. Steve Dahl, a radio disc jockey whose station did not program disco music, had begun a "Disco Sucks" campaign, largely to promote his show. The Chicago White Sox were fielding a dismal team that year, and in order to attract fans to a doubleheader, the team cooperated with Dahl on a promotion that set ticket prices at 98 cents apiece, provided you brought a disco record to be blown up on the field between games. The park filled to more than capacity, beer drinking was at record levels, and pot smoking was rampant. When Dahl blew up a box of records, fans streamed

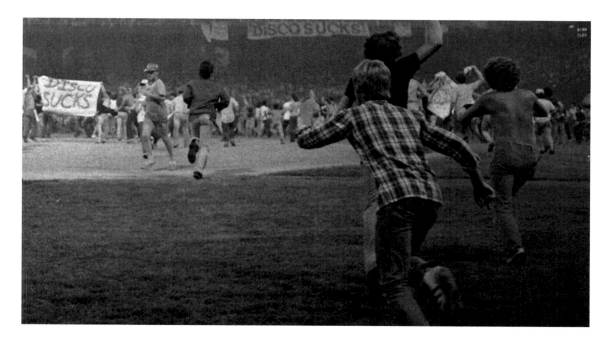

from the stands, threw records and firecrackers, and caused enough disorder that riot police had to intervene and the second game was canceled.

It was, at heart, a publicity stunt gone bad, but the vehemence of the crowd stunned even those who were fanning the hostility. The disco haters, primarily young males, were irritated that disco was forcing the loud aggressive rock they liked off the radio. It wasn't a crowd that really liked to dance.

Disco Demolition Night is an event that may not have nearly as much meaning as has been attributed to it. It didn't kill disco; that continued into the eighties, and dance music based on it has never entirely disappeared. And it wasn't a call for a return to propriety; the crowd was obscene, rowdy, and stoned. But it does suggest that as the seventies drew to a close, some people were anxious about a form of entertainment whose roots were in black funk, whose songs are often an expression of female sexual pleasure, and whose refiners and popularizers were unashamed homosexuals. "Disco Sucks" contains the suggestion that the music was feminine, or gay, and the rioters were probably equally frightened of both.

Disco Demolition Night at Chicago's Comiskey Park in 1979 turned into a dangerous, drug-addled defense of a beleaguered normality.

JUNGLES WITHIN

Gimme shelter! The seventies abode featured plants, funky finds, and plenty of texture.

About a third of the way through the seventies, around the time that a beleaguered President Nixon began addressing the portraits on the White House walls, Americans began talking to their houseplants.

The peculiar thing is that Nixon's late-night, one-way conversations were, when they were revealed after his resignation, viewed as evidence of near madness. Meanwhile, the idea of having a heart-to-heart with the aspidistra did not seem bizarre at all. Rather, it was viewed as a form of sensitivity, earth-friendliness in action. Moreover, many believed that talking to plants had a scientific grounding.

The source of this belief was a 1973 book, *The Secret Life of Plants*, by Peter Tompkins and Christopher Bird. It recounted experiments that the authors said demonstrate that plants have feelings, communication abilities, and perhaps even ESP. Scientists, using lie detectors

and other electronic devices, were, they said, able to measure reactions to humans' actions, thoughts, and attitudes. In what the authors cited as the seminal example, Cleve Backster, a lie detector expert, hooked up a plant to a polygraph and was able to measure its stress when he so much as thought about burning its leaves. In another experiment, Paul Sauvin, an electronics whiz, rigged up a way of sending a telepathic signal to a philodendron with which he had a particular rapport, to trigger the opening of his garage door. Because he knew the plant would respond only to him, Sauvin said, the system was secure from burglars. (Sauvin seemed to be assuming a loyalty from his plant that he had never tested. Would the philodendron have opened up to another who lavished equal attention?)

Householders were entreated to express their individuality, but macramé and mini-blinds provided the touches that many people wanted.

A lot of people read *The Secret Life of Plants*, enough to make it a bestseller, while many more absorbed its theme, appropriately enough, by osmosis. Most people really didn't dwell on the book's suggestion that their spider plants could read their minds. But they figured that an occasional compliment or affectionate phrase certainly couldn't hurt. At the peak of the plant-talking craze, one could see ambitious young women, home from a day of trying to shatter the glass ceiling, unashamedly cooing sweet nothings to their rubber plants.

Still, though the publication of the book was a necessary precursor to the plant-talking phenomenon, it is not a fully satisfying explanation. There are lots of books, after all, but hardly

any cause behavior that might, only a few years before, have been viewed as evidence of insanity.

In fact, what people said to their plants was less important than what the plants said to them. During the seventies, people needed and wanted houseplants. There was a green explosion both in the number and variety of plants people grew in their houses, a trend that quickly made its way into building lobbies, shopping malls, and offices as well. Even corner bars and roadhouses were colonized by ferns and spider plants, and turned into a new kind of drinking place. These plants filled a niche that was not so much ecological as psychological, as people sought to live in places that were "real," not plastic, places where growth all around could, perhaps, reflect and encourage one's growth both as a

People rarely went to the extreme of wallpapering foliage on their ceilings, but lots of rooms did look like secret gardens.

spiritual being and as a custodian of the planet. Plants were a way to express one's connection to nature and to an increasingly beleaguered Earth, even as they helped make sheltering hiding places from the modern world.

T he proliferation of inner jungles and personal Edens was part of an enormous change in the way people thought about, furnished, and decorated their homes. What happened was a great deal more than a change of style; it was a complete change of sensibility. It signaled

The shaggy flokati rug was intended to make the Louis-the-whatever furnishings informal and up-to-date.

a shift in the way people felt about their place in the world. Airy spaces gave way to ferny hallways as Americans retreated from an ideology of openness and shared progress into a postoptimistic state in which they tended their own ficus trees and false aralias. That's not to say, though, that our homes embodied pessimism. Growing plants is an optimistic act, one in which hope and effort are, more often than not, rewarded. But if you look at the plant-filled dwellings of the seventies in contrast to what had come immediately before, it is obvious that householders were taking cover in their indoor rain forests.

Midcentury dwellings could be "colonial" or "French provincial" or eclectic in their decorative style yet be modern in their mood. They tended to share a sense of brightness, airiness, and optimism. Change was something to be embraced, and flexibility was a virtue. That meant a house could be a series of welcoming, useful spaces, rather than a warren of single-purpose rooms. The home might have risen on a muddy lot in what used to be a farmer's field or a second-growth forest, but midcentury homes were understood as part of a wider world of shared progress. In many communities, opaque fences were illegal, and everywhere, the draperies stayed open on the picture window, and people lived in the open.

Modernist furnishings were the exception, not the rule, yet this approach to living expressed distinctly modern attitudes. It had its origins in the celebration of technology and of the social and material progress that it made possible. The informality and openness of house plans—whether they were cloaked as Cape Cod or contemporary—was consonant with the rejection of old ideas about class, hierarchy, and polite behavior. You might admire fine things from the past, but even museums tended to display their antique treasures in a modern, open style. In your home, which served as a platform for your progress and a showcase for your achievements, you would probably do the same. Outdoor plants were important, especially those around the base of the house that garnished it, as critics said, like parsley. And the space of the houses often flowed outdoors into gardens and could serve as outdoor rooms, though these were rarely planted densely. But aside from the odd African violet or two, houseplants were not part of this vision of domesticity.

In the late sixties, however, people's houses began to change. The clean, uncluttered look of midcentury confidence was not simply out of style. For many, it was wrong, a symptom of a cold, technocratic culture of death, the forces that brought forth such horrors as Vietnam. Indeed,

one of the horrors of Vietnam was defoliation, the wholesale use of plant killers in a failed attempt to drive the Vietcong guerrillas out into the open where Americans could beat them.

People began to place plants, including big, broad-leafed, bushy ones, on hangers in windows or in large pots on sills. They were there, people said, because the plants needed the light. But the householder's need was for a barrier between the world outside and the nest within. Such placement of plants began the transformation of the house from showcase to refuge. Soon, plants no longer sat alone in a pot but were clustered into domestic minijungles that required daily attention. And at least some began to fantasize about making friends with the plants and asking them to guard the garage door.

Instead of interiors that welcomed the new, householders embraced eclecticism and clutter, a layering of textures and patterns. Patterns became bolder, and people felt free to juxtapose two, three, or five bold patterns. Moreover, geometric patterns gave way to irregular ones, based on plants and other natural forms. Smoothness gave way to texture, as ceilings became nubby and carpets became shaggy. Rooms that had previously demanded to be polished now offered themselves to be stroked. And old-fashioned houses, ones whose dust-collecting moldings had once been disdained, became highly desirable. Victorian was back, only this time without prudery and with drugs.

Though such dense decor appears neo-Victorian in retrospect, few people had the sense that they were participating in a revival. They were creating home interiors that made sense to them, ones that reflected all the aesthetic, social, political, and environmental phenomena of their times. Indeed, the intensity of the interiors—their relentless pattern and ornament, their softness, their tactile quali-

Not even the austerely geometric Parsons table escapes the onslaught of pattern and imagery in this fantasy of a single man's bedroom.

ties, their warm and earthy colors—is most simply and accurately seen as a quest for comfort in a difficult and seemingly deteriorating world.

"Young people often want old, imperfect but well crafted pieces in their homes," wrote Paul Wilkes in the 1970 *House and Garden Guide for Young Living.* "It's maybe a way of going on record against the impersonality that lies beyond our threshold and making our house an escape, a refuge—a comfortable, at ease place to drink hot cider, listen to music, enjoy close friends." Wilkes said when he and his wife first married, they bought classic modern furniture, but in about 1968, they decided to get rid of it. "Looking back, it was cold, slick and impersonal," he concluded. "Its biggest shortcoming was that it was perfect, and we had done nothing to make it so."

Some home remodelers actually got rid of functioning modern appliances to make way for nostalgic but less convenient antiques like this range.

The year 1968 does seem to be about the moment when the modernist dream of progress and technological mastery turned cold. Modern living, like modern furniture, wasn't perfect, but it did dream of perfection. It demanded good housekeeping, a concept that inspired its own feminist critique. It demanded a clarity of vision that was difficult to achieve in such complicated times. And it demanded not simply a belief in the future but also an eagerness to jettison the past. But at a time when the future wasn't working as well as it used to, and perfection was starting to lose its luster, people were attracted to things that had been buffeted by time and had survived.

Householders weren't focused on filling their house with masterpieces, modern or otherwise. Rather, they looked for good, honest stuff, and lots of it. Even though the seventies were years of economic stress for many, little austerity was visible in houses and apartments. There was, instead, an aesthetic of accumulation. Nothing sought to be beautiful in itself, unless you count some of the old modernist pieces hidden beneath strata of books, throws, and flowerpots. In sum, all these disparate fragments were believed to add up to an environment that was unique; no two cluttered lairs could ever be alike. Each item in the room was assumed to have a personal meaning for its occupant. The plethora of colors, patterns, and textures provided a sensory experience that

**Even chairs that
sought to express a
modern look still
needed to envelop
those who sat in them.
The result: top-heavy
floating hugs.**

sought to be fully enveloping and, therefore, sheltering, a home that was a true nest.

People filled their houses with "finds," items found in flea markets, crafts fairs, dusty antiques shops, or the offbeat retailers located on the bohemian shopping streets that were starting to spring up in hitherto derelict districts of most major cities. The streets and the items sold on them were often described as funky: earthy, unsophisticated, close to the roots, and hence authentic. Those who had their domiciles designed

by well-known decorators were just as likely to end up with interiors as overstuffed as those householders who did their buying at the Salvation Army. The quest for quantity prevailed at every price point. You could fill your home with finds, or find someone else to do with it, but having a collection was proof of the personality required to make a house a home. "Collecting is no more than a development, a degeneration of the need to project an atmosphere around oneself," wrote Mario Praz in his classic 1962 history, *Interior Decoration.* "It can be only a pleasant distention, a not reprehensible plumpness, but it can also be a tumor, and alas, a cancer." It is difficult to look at upscale design magazines of the era, such as *House Beautiful* or *House and Garden*, without finding malignancy on every page. Indeed, the professionally decorated houses appear in retrospect to be more grotesque than their improvised, no-budget, hanging-bead, brick-and-board bookshelf, and rubber-tree counterparts. They have too much stuff and too little funk.

Still, when a decorative approach is so pervasive, both high and low, it's clear that it reflects a sense of life that's widespread. More stuff doesn't sound like a style, but it may be that it reflects something deeper than the styles that are defined by chair profiles and fabric patterns. The density of the decoration in houses has waxed and waned over time, and when it rises, it means that people are seeking shelter from the world outside.

The last time house interiors had been so enveloping had been in the late nineteenth century. Industrialization had made it possible, for the first time in history, for the great majority of people to lead cluttered lives. Falling prices, first for fabrics, then for furniture, and eventually for every accoutrement of domestic life, allowed more people to have more of everything. "Rugs appeared," wrote Virginia Woolf in *Orlando*, of the Victorian mania to cover things. "Beards were grown; trousers were fastened tight under the instep. The chill which he felt in his legs the Victorian gentleman soon transferred to his house; furniture was muffled; walls and tables covered; nothing was left bare . . . Outside the house, ivy grew in unparalleled profusion. Houses that had been of bare stone were smothered in greenery."

Though the draping, layering, and crowding of the Victorian interior was made possible by industrialization, it was, paradoxically, a reaction against it. The world of commerce and industry was tough, harsh, dirty, and dangerous, no place for a family. The house was a refuge from this hostile world, a place where a woman could preside as "angel of the household" and raise proper, well-behaved children. Critiques by Woolf

and others of this overstuffed world were motivated by the suspicion that women didn't need quite so much protection, that the draped and furbelowed house was a well-upholstered prison.

The return of high-density decorating in the seventies was also a reaction to the industrial world, which by this time seemed to have run irretrievably amok. Pollution was increasing, resources were disappearing, work was becoming emptier and less rewarding. The whole project of modern living, once shared by the entire society, seemed bankrupt. It made more sense to shore up your fragments against the ruined world outside your doorstep. And it made sense to fill it with green plants as reminders that humans' connection to the earth and the living world is more profound than individuals' connection to the technological society humans had created. Thus, in both cases, the cluttered home embodied a paradox: Material abundance was a

Much home decor was heavy, both literally and visually. This earth-toned bedroom features a puffy leather chair, a ponderous "Spanish" bedroom set, and even a bedspread that evokes the rock strata of the Grand Canyon.

way to escape a materialistic society and express higher values.

The seventies revival of a Victorian approach to furnishings often included a lot of actual Victorian items. There were, after all, a lot of them made, and they had long been disdained and thus were low-priced. The acquisition of nineteenth-century items, and also zigzaggy deco and streamlined moderne objects from the pre–World War II era, seemed to conjure up earlier, better worlds. As Wilkes noted in his essay, people often feel more comfortable with their grandparents than with their parents, and grandmotherly objects provided reassurance in difficult times. Such nostalgia embraces the old without worrying too much about history. Most often the emotion is that expressed by *House and Garden* in a 1973 article hailing the return of the gazebo, which the magazine termed "a romantic souvenir of an earlier, more gracious era." For the nostalgic, every earlier time is more graceful, more peaceful, and more civilized than the present. Homeowners of the seventies were emulating their Victorian forebears by creating fanciful, cluttered environments

that sought to shut out reminders of an ugly world. But Victorians surrounded themselves with possessions so that they would show that they knew how to use them, thus proving their status and good manners. Seventies acquisition was haphazard, and few worried about having good manners.

Feminism was a potent force during the Great Funk, but women seemed to have forgotten that for Virginia Woolf's generation, getting rid of all the draperies, swags, and antimacassars of the late nineteenth century was viewed as a liberating moment for women. During the seventies, women's magazines often showed women entertaining at home in long Victorian skirts, usually with the message that being a feminist in the world at large didn't mean you couldn't be really feminine at home. "You've come a long way, baby!" said the slogan for Virginia Slims, the leader in a new and peculiar product niche—the feminist cigarette. But in terms of fashion, at least, the path led to the flowing draperies and flowing dresses against which earlier generations of women—those who had seen smoking as a provocative act and didn't yet know it was a deadly one—had rebelled.

I t looks so real," said a 1974 advertisement for Flintkote's Dover Slate flooring, "it's unreal!" The flooring was, of course, unreal in the literal sense. It looked something like slate and thus appealed to the Great Funk taste for objects and materials that were basic and earthy. But real slate is a difficult material, too heavy for many settings, inclined to chip, and generally difficult to take care of. Seventies householders wanted to live in a houses that had a high-maintenance Victorian look but they didn't want to spend their lives cleaning. Houses became dirtier in the seventies both because they contained more dust-catching items and because, with more women in the workforce, less time was devoted to housekeeping. (In surveys, men claimed to be doing more domestic chores, but scarcely enough to notice.) Thus, although there was a general rejection of the look of modernity, people were quite willing to make use of modern materials and products that were easier to clean and maintain than the authentic finishes and artifacts they valued so deeply. The Flintkote advertisement caught the paradox nicely. People wanted things that looked real. But, in the lingo of the time, "unreal" was a term of high praise. It implied that what was described was better than could be expected, perhaps better than real. People used mind-expanding drugs to artificially make the ordinary more interesting; they used artifi-

This Liberty Bell–pattern carpeting commemorated the bicentennial, and its colonial-era motifs were deployed in patterns and colors that could have happened only in the 1970s.

RED CURRANT

BLUE LAGOON

COLONIAL GOLD

GEORGIAN BLUE

cial products to demonstrate their devotion to the real. As Sylvester, the gay, drag-clad disco diva, sang, "You make me feel, *mighty real."*

There was also, of course, something weird about hearing a building-materials supplier use such a hippie-derived phrase. It was slightly embarrassing, like parents who were trying to be "with it." Much of this same quality comes through in the products themselves. A change of sensibility and style is something manufacturers of furniture, flooring, fabrics, and other household items welcome. Even those who respond quickly to changes in clothing are likely to keep their household furnishings until they become too dowdy to bear.

Despite the economic difficulties of the seventies, makers of household goods had two things going for them: a huge new generation of household-forming age, along with an enormous shift of taste that could be expected to encourage others to update their homes. No matter what their purported style— colonial, French provincial, or contemporary—most of the decor offered to the mainstream market appears unmistakably seventies today. It is heavy, sheltering, enveloping, distressed, and very likely orange.

In the early seventies, for example, furniture marketers promoted what were termed Spanish and Spanish-colonial designs, especially for the bedroom. Despite the seventies hunger for the handmade and the real, the decade's interpretation of Spanish was not about craftsmanship or integrity but about

patina. Though the pieces were massive, their materials weren't solid, and they tried to express an unearned sense of timelessness by applying finishes that signaled age without really looking old.

The "Spanish" furniture, which became popular for a time though never ubiquitous, was probably inspired by a far more widespread enthusiasm for colorfully patterned tile and tilelike floor and wall coverings. Traditional ceramic tiles represent the quintessence of seventies taste, coming as they do from an ancient, widespread, low-tech craft tradition. Those that were decorated with geometrical or botanically derived designs provide what was then considered a desirable density of decoration, a highly ornamental background against which other systems of pattern could be juxtaposed.

Real ceramic tile was, however, expensive to buy and install, so building materials brands like Armstrong, Congoleum, and American Olean came to the rescue with lighter-weight products made from vinyl and other artificial materials that provided the decorative punch of real tiles but in a more affordable way. In the decorating magazines of the time, articles often featured houses and apartments with ceramic tiles imported from Mexico, Italy, or North Africa. But elsewhere in the magazines were pages of advertisements for industrially made floor and wall products that promised to add decorative richness while being soft on the feet, a real seventies selling point. Toward the end of the decade, as the mania for pattern subsided a bit, unadorned quarry tile did enter the home improvement mainstream and formed a transition to the luxurious granites and marbles that became popular in the decade that followed.

As the bicentennial approached, furniture makers returned to one of the recurring themes of American decorating, the English-derived "colonial" style. Still, seventies colonial is very different from fifties colonial or twenties colonial. Beds

Metallic surfaces were out, and silver seemed too shiny and cold, even for silverware. Towle's "Tree of Life" placed a "timeless" pattern of vines and flowers against a gold vermeil background. *Left*: A snail coffee table, accented with a sculpted tortoise, rebels against the jet-age design that came before it.

There goes the sun; Aquarian draperies were nubby and sheltering. *Below*: **Sitting in a velour beanbag chair was like sitting on a teddy bear's lap.**

were more likely to have canopies and others were four-posters with big, round cannonball finials. Overall, the furniture was heavier and darker in tone than was Mom's more modern (and marginally more authentic) colonial. And while the decorative motifs in the upholstery, the bedspreads, the throw pillows, and the rugs often reproduced motifs found in antique artifacts, they were used in a clashing profusion that owed little to the 1770s and everything to the 1970s. The Liberty Bell carpet, touted as "the most charming Early Americana since Betsy Ross plied her needle," incorporated a colonial drum, spinning wheel, "Stars'n'Stripes medallion," rooster, floral plaque, and the Liberty Bell in cartouches framed in a dense, all-over pattern. It was available in four colors: red currant, which was essentially orange and gold; blue lagoon, which was orange with blue accents; colonial gold, which was a light orange with gold accents; and Georgian blue, which was green with light blue accents. That's a virtual anthology of seventies color schemes. Its soft fuzzy pile was made with Antron III to "preserve newness." Still, colonial or not, it's a Great Funk period piece.

Just as period styles inevitably take on the characteristics of the period in which they were produced, so do designs that are intended to be timeless. Reed and Barton's sterling silver flatware Tree of Life pattern was an interesting attempt to inscribe the emerging values of the era into a precious and permanent object. Silver has, for centuries, been a sensitive social and aesthetic indicator because although it speaks of posterity, it also represents the dreams and pretensions of those who are just getting married. The handles of the forks, knives, and spoons, shaped as elongated ovals, featured a relief of a woody vine, sprouting flowers, with two birds perched on its branches. It was available with a gold vermeil background, which accented the imagery and gave the flatware a warmer

look than silver usually has. "This design has appeared in virtually all civilizations and cultures since the very beginning of time," said its advertising. This claim was meant to appeal to both the giver of the silver, who could be assured that it wouldn't be trendy, and to the young recipients, who probably picked the pattern and were looking for things that embodied primordial truths. (In 1979, vast quantities of heirloom silver were melted down, when the price of the metal skyrocketed as a result of the attempt by Texas oil heirs Nelson Bunker Hunt and William Herbert Hunt to corner the market.)

Carpeting in bathrooms was definitely in, despite the impossibility of keeping it clean.

Even modern pieces that sought a simpler, airier look rarely escaped the massiveness that was characteristic of the period. Chairs, for example, might have sleek metal legs but heavily cushioned seats and backs made them appear top-heavy. People wanted to be enveloped and comforted by their furnishings, whether they were looking back to an imagined past or striving to be up-to-date.

For example, in 1974 Sears introduced its Aquarius line of drapery materials. The name indicates that they were aimed at a youthful market—those who believed that the world was entering into a new age of enlightenment, or who had at least heard the song from the 1968 rock musical *Hair*. The draperies were not about enlightenment, however. They were heavy and deeply textured. Vertical stripes of the bright earth tones popular at the time—deep orange, gold, brown, and tan intersected with horizontal textured bands to give a sense of depth and layering. Thus, they didn't "let the sun shine in," as another of *Hair*'s songs exhorted. Quite the contrary, they kept the world out and helped create what people seemed to want, a richly textured and patterned interior space. You don't see much sun in the rain forest, and that is what people were creating in their houses and apartments: a complex ecology of living things and sensory stimulations that overwhelmed yet comforted those who dwelled there.

Soft shaggy carpeting made the floor habitable and turned every room into a playroom—especially for dust mites.

"Tactile" is a word with distinctly Great Funk overtones. If there is one thing the seventies weren't, it's smooth. Like granola, a food that traces its popularity to the 1969 Woodstock Festival, the seventies were textured, and the substantial was digested along with the sweet and the nutty. Fabrics were nubby and sometimes fringed. Ceilings had deeply textured popcorn surfaces. Even some home appliances substituted textured panels for the expanses of sheet metal found on earlier products. In a Great Funk abode, your fingertips should never be bored. (With all its crannies and interstices, dirt and leaves, the seventies home was also a paradise for dust mites and other undesirables. But people didn't seem to become allergic to it until it had gone out of style.)

Nobody would ever mistake a seventies living room for a formal Victorian parlor. Every room was supposed to be comfortable; indeed, every room was conceived as a potential playroom. It was full of soft cuddly things, some of which were furniture. Sofas were covered in teddy bear plush, and shag carpets softened the floors.

The softness of many seventies rooms—particularly those of newly adult baby boomers—often appears infantile. And the pleasure of things

that are soft and strokable can't be denied. Nevertheless, those who furnished their dwellings in this way didn't think in those terms. Pop art, though a sixties phenomenon in the art world, was very much a seventies phenomenon in the home. Claes Oldenburg's oversized soft sculptures of mundane objects were highly influential, and in 1970, the Italian designers Jonathan De Pas, Donato D'Urbino, and Paolo Lomazzi carried the logic further when they unveiled Joe, a soft leather chair in the shape of a baseball glove. It was prohibitively expensive but very well publicized, and it helped popularize the idea that furnishings could be big yet toylike and soft. The pop sensibility was a part of the postmodern architecture and decoration that was emerging in the seventies. Those who liked big floral patterns could be reassured that some big-name architects used them too. Most people ignored the postmodernists' intellectual complexities and simply accepted the license to do as they pleased.

Neither pop nor postmodernism, however, can explain the shag carpet. The extremely long-piled rugs were not promoted by tastemakers. Nor were they extensively advertised by manufacturers. Long-piled shaggy rugs had been around for centuries. Hand-knotted rya rugs from Finland were expensive and considered respectable for modernist interiors. In the seventies, some argued that the thick, enveloping rya rugs were a response to cold weather, and that shag rugs were a good way to keep warm in times of scarce and expensive energy. But shag carpeting became popular before the 1973 energy crisis, which may have sustained the trend but did not start it. The seventies embrace of the shag seems to have been a grassroots phenomenon, appropriately enough for a floor covering that turns a room into a woolly meadow. Shags sometimes looked like meadows on acid; early seventies Sears catalogs showed shags that mixed as many as four aggressively contrasting colors.

One function of the shag was to make the floor habitable. It turned the floor from a place to stand into one where you could also

Using multiple colors in shag enhanced the sense of texture, while dueling patterns seemed to communicate richness.

Poppy, *above*, was a nice color for a refrigerator, but buyers didn't go for it, nor did they like the Warhol-inspired flower pattern, woodgrain, or stripes. They did, however, like avocado and harvest gold.

sit, sprawl, or snuggle. Never before had so many young, limber Americans been finding new places in which to live. The shag carpet made a soft place that blurred boundaries. You didn't have to worry about how many chairs you had when you invited friends over. It was open, informal, seemingly unstructured, sensual. Flokati rugs, made from soft, repeatedly washed wool, were even more sensual because that shag feels like fine, smooth hair rather than yarn. These were used as bed covers as well as on the floor.

Still, the popularity of shag rugs was not solely, or even mainly, due to young people shagging on them. (That's British slang, which Americans hadn't yet learned.) They were used in many places where such activities would be unlikely. For example, a gold shag carpet was installed in the office of the governor of Colorado, in observance of the nation's bicentennial. (It was ripped out in 1992 because it impeded wheelchair access.) Shag rugs were installed in nursery schools and cocktail lounges and other public places. They provided visual texture along with a welcome softness underfoot. They warmed up the room, psychologically if not literally. They provided a lively ground for Americans' indoor Edens.

Freezer on the bottom with optional decorator trim kit
Model BC-20N

Freezer on the side
Model SD-25N

Freezer on the top
Model TD-20N

Every moment has its colors. Seventies colors are unmistakable and widely despised. In large part, this is because they are now the colors an earlier generation used to mess up a beautiful house or the colors of the musty, cheap motel. The avocado green and harvest gold appliances are what get flung out in the long-overdue kitchen renovation.

For decades, manufacturers of fabric, paints, wallpaper, flooring, appliances, and virtually everything else that's visible in

the home have met regularly to coordinate their color palettes. The immediate purpose is to assure that next year's sofas won't clash with next year's draperies. The longer-term purpose is to create fashion; all the

participating companies stand to make more sales if people discard still usable items because they look dated. But there is no guarantee that people will buy into such fabricated trends.

During the early seventies, there was heavy promotion in advertising and in the press for appliances in a color called poppy, a deep but vivid red. But consumers didn't warm to this hot new kitchen color, probably because they surmised that they would be tired of a red stove long before there was any good reason to replace it. A bit later, Amana tried selling refrigerators with a choice of decorative front panels that included vivid stripes, woodgrain, and a bold floral pattern most likely inspired by Andy Warhol's series of flower paintings of 1964 to 1970. Consumers were cool to this idea too, possibly because the refrigerator door, with its palimpsest of messages, invitations, and child-produced art, was already replacing the dinner table as the center for family communications.

Still, appliance buyers showed no such resistance to avocado or harvest gold. People can be convinced to change their colors, but only if it is in a direction that feels right to them. Moreover, while a clothing color can be embraced this season and discarded as a mistake the next, most people move slowly with their interiors. They cost too much money to change on a whim.

In 1972, Braniff Airlines hired artist Alexander Calder to create "Flying Colors," a series of designs for its aircraft, including this 1975 tribute to the bicentennial. They looked terrific, but they were an indication that jet planes had ceased to be exciting.

What we think of as seventies colors—the burnt oranges, the chocolate browns, the woodsy greens, the golds, and the warm tans—had an extremely long run from the late sixties into the eighties. When even a maker of sterling silver feels a need to get a warm tone onto its flatware, it's obvious that people are caring a lot about color.

One thing that's notable about seventies color is that there was more of it. During the sixties, sales of color televisions skyrocketed, and by the seventies, most households had at least one. One result was that television personalities such as Doc Severinsen, the bandleader on *The Tonight Show*, began wearing outrageously contrasting outfits that were an almost nightly target for Johnny Carson's jokes. Another was that seventies television programs—unlike the films of the time—often had a cheap, overdone look about them that was largely the product of too much color. The art critic Douglas Davis speculated that mistuning and interference produced colors on the television screen that nobody had ever seen before and that this artificial brilliance was having an impact everywhere.

Similar phenomena surfaced in other media. Newspapers began including color in their advertising, and many, especially in Southern states, used color throughout the paper, though the printing was frequently off-register and the resulting colors were bizarre. Before 1970, architectural magazines hardly

Copper-clad pots and cupboard doors, terracotta-like tile and "bronze" appliances were meant to make this kitchen look modern yet authentic and natural. Aluminum cookware turned green and harvest gold, while the Crock-Pot, a newly popular appliance that promised old-fashioned, yet effortless, slow cooking, had an orange exterior that communicated warmth.

ever printed a color illustration; color simply wasn't considered relevant to the subject. But once color photos became standard, architects suddenly lost their fascination with bare concrete and started dressing their buildings with the same polychromatic abandon seen in Doc Severinsen's wardrobe. Home decorating magazines had long featured color, but by the seventies, the houses they showed seemed to boast more color per square inch than ever. *House and Garden* even rounded up a group of experts who agreed that brightly striped and patterned sheets lead people to have more interesting dreams.

"Anyone who steps off a flight from most of Europe . . . finds the American landscape in 1976 to be 'active' with color," wrote Davis. "White tennis shirts are now scarlet; lips and nails form a spectrum of brash orange, shiny pinks, or even azure; black suits are now yellow; dress shirts open and multicolored; cars striped down the middle; and public plazas aglow with sleek, red Calders . . . If a monochrome landscape means uncertainty of taste, we are now certain, very certain."

If there was certainty, it was that the old ways of doing things had failed, and it was up to a new generation to do things differently. Many of the phenomena Davis cited—those yellow suits and brash orange

Even a small swatch of drapery material seems to contain more colors, textures, and hints of pattern than you can count. And when this aesthetic is applied to a whole room, such as this "colonial" bedroom, it is easy to get lost amid the swags and shams. The effect is, depending on your taste, either cozy or claustrophobic.

Talk about a colossal screw-up.

Boston's John Hancock Tower, *below*, was supposed to rise from the medieval tangle of the old city's streets and shimmer on the skyline like an enormous prism. Its lower floors would reflect the ornate masonry of its neighbors, including the landmark Trinity Church. Its shaft would change with the sky—glowing at sunset, disappearing in the clouds, standing as an abstract sculpture in the bright blue sky.

It was a forward-looking gesture for a staid company in an architecturally conservative city. But its design, by Henry N. Cobb of I. M. Pei & Partners, also looked back to one of the iconic architectural images of the century, a never-built glass skyscraper designed in 1922 by Ludwig Mies van der Rohe for a site in Berlin. The design probably wasn't buildable when it was designed, but half a century later, the vision could be realized.

Or could it?

Even while the building was under construction, huge double-glazed panels, measuring four by eleven feet, began to pop out and fall hundreds of feet to shatter on the sidewalks below, which were closed off. And the empty openings were filled with plywood. At first they looked like Band-Aids, but eventually there were so many temporary panels that it threatened to turn into a 790-foot plywood skyscraper.

Architecture has a way of projecting the values and anxieties of an age on a monumental scale. In a time of rampant inflation, military failure, political crisis, and environmental panic, the wounded skyscraper seemed to offer inescapable proof that nobody knew what they were doing.

Architectural modernism, with its promise of technological and social progress, faced challenges in the early seventies. Urban renewal projects, which swept crowded old cities clean and replaced them with towers in a landscape, had proven to be failures. When they consisted of offices, they spawned dull, lifeless places in which to work. When they housed poor people, they became dangerous hells in the sky.

The historic preservation movement, which had long been of interest mostly to the proverbial "little old ladies in tennis shoes," was now a mainstream cause. It sprang from a deep and widespread conviction that anything new would inevitably be inferior to anything that was old. Although the growth of the preservation movement is often attributed to a rise of patriotism fueled by the bicentennial celebration, its deeper cause was skepticism about the entire postwar promise of a modernized future. A crippled giant standing next to the strong, vigorous mass of Trinity Church, John Hancock was the failure seen round the world.

Architecture is an inevitably optimistic and expensive pursuit. How can one make buildings when confidence and authority are absent?

The architect Louis I. Kahn, designer of the Kimbell Art Museum in Fort Worth, Texas, *above*, probably the decade's greatest building, proposed going back to fundamentals and creating

an architecture based on primordial desires and values. Kahn was not interested in progress. He wanted instead to give contemporary form to age-old desires to learn, to worship, to work, to see.

Kahn, though a much admired teacher, had for decades seemed out of step with his times and his profession. Even in the seventies, when the number of people wishing to go back to basics mushroomed, that more often meant a commune in the country than Kahn's expensive, intricately detailed buildings.

Still, Kahn, who died in 1974, was a seventies thinker way ahead of his time. Unlike most of his colleagues, he looked at all of history for inspiration, not just at the twentieth century. His architecture was all about human relationships rather than utopian visions. And he had an openness to the sensual that makes visiting his buildings memorable.

The Kimbell, for example, is an extremely repetitious building: a series of concrete vaults both inside and out. But it is never monotonous, largely because the building seems to take in the sunlight and bounce it off its walls. It makes

concrete, which is often the dullest and most alienating material, into a sensuous surface that also seems to glow.

The building also has a humility not often associated with famous architects. It does not try to upstage the old masters on its walls. Nevertheless, being there can be an almost spiritual experience.

There was something quixotic about Kahn's quest to reconstitute a lost golden age, and even those who loved his work could not continue his pursuit. Robert Venturi, who had worked with Kahn, and Denise Scott Brown, Venturi's wife and partner, reminded their colleagues that they lived in a fallen world, one in which architecture is a marginal art, only rarely meant for the ages. Franklin Court, their most compelling design of the decade, grew from a radical conclusion: that the site of Benjamin Franklin's house was not a place to construct a new building. They put the museum they were hired to design underground, and erected only a metal structure, evoking the profile of Franklin's long-demolished home, to mark the place.

The house Frank Gehry designed for his family in Santa Mon-

ica, California, *above*, toward the end of the decade distilled Great Funk values and pointed to a way forward. It consisted of an ordinary suburban house that seemed to have gotten into a nasty collision with something else entirely. It had a distinctly punk sensibility that embraced the ugly and incongruous, but somehow ended up feeling sweetly domestic, if jaggedly so, on the inside.

Gehry celebrated offensive materials, such as chain-link fencing and corrugated metal siding. He loved the look and feel of unfinished buildings, and at his house, he tried to make that fleeting quality permanent. It was an architecture that sought not perfection but the excitement of becoming.

Indeed, Gehry created memorable architecture out of the same stopgap materials that made the John Hancock appear to be such a failure. As for the Hancock building itself, the cause of its problems was found, a solution was developed, and today the building is the minimal monument it was meant to be. As with many phenomena of the Great Funk, its problems weren't quite as great as they appeared.

lips, for instance—would have been considered before, and since, as evidence of bad taste. But taste is merely another sort of authority, and the breakdowns of the seventies brought every kind of authority into question. Even the traditional tastemakers, the editors, department store buyers, and decorators who had been used to laying down the law about how things should look, had to cultivate a newfound humility. Their role was not to declare what was in but to point people toward the materials, products, and approaches that would enable them to express their individual vision.

In the field of color, just about every rule was being broken. Uncomplementary colors vied for attention in the same room. Paisleys and plaids mixed promiscuously with flowers and stripes. Less wasn't more anymore.

The philosophy was anything goes, and a lot of peculiar hues, patterns, and textures turned up in the seventies environment. But what anything went with—those oranges, browns, golds, and greens—remained the base colors for carpets, upholstery, floor coverings, draperies, and other interior furnishings from the late sixties into the Reagan years. This was a very long run for a look. The moon-shot modern style of the early sixties—hard-edged, metallic, and shiny, mostly monochromatic with bold splashes of primary color—was an expression of technological faith, confidence, and competence. People sought a look of seamlessness; the clean machine was an ideal, and James Bond, or maybe John F. Kennedy, was the dashing hero on the scene. This look emerged in the Kennedy years, but it didn't survive to the end of the Johnson administration, barely half a decade. But the Great Funk's muddy hues, soft edges, fuzzy surfaces, and burgeoning ornament and vegetation held on for more than a dozen years.

From the point of view of the seventies, the confidence of the early sixties had been revealed as a delusion, and the objects that embodied that era's technological hubris were ridiculous at best, menacing at worst. Woody Allen's 1973 film *Sleeper*, though set centuries into the future, is actually a seventies send-up of the dreams and designs of the previous decade. (Indeed, most of it was shot in actual sixties buildings in the Boulder, Colorado, area.) It showed a world where people lived in buildings that looked like concrete eggs, in which life had become so completely artificial that humans had lost connection with one another and had to retreat into a machine—the orgasmatron—to have sex. Like Miles Munroe, the hapless health food store owner played by Woody

Allen, members of the audience felt they had to struggle to escape or, better, avert this future.

By contrast, the muddy hues, lumpy textures, and overgrown vegetation of seventies domestic life were marks of integrity and good intentions. They affirmed that those who occupied the spaces were people who had outgrown recent, empty dreams of technological transcendence and had chosen life, in all its messy luxuriance. Clashing patterns reflected life's exciting diversity. And shag carpet, like a full beard or an unmowed lawn, was a celebration of growth—the force of life that encourages optimism even when man-made systems break down.

There was a peculiar thing about all those houses, and particularly apartments, with their overactive pattern and overgrown plants: Nobody was home, or at least hardly anybody. Never before had so many Americans lived alone.

Despite the difficulties of the economy, the seventies brought a boom in housing construction. That's not too surprising when you consider that the largest generation in history was setting up housekeeping. Unlike the housing boom of the post–World War II era, however, a significant percentage of the new dwellings were in apartment buildings, condominiums, and other forms of multiunit housing. Most of these places were spacious enough for at least two inhabitants, but a large number of people were living alone.

While the media were preoccupied with the phenomenon of young people living together in what had, until recently, been sin, the growth in people living alone was explosive but less noticed. In 1960, about one in seven Americans lived alone, while by 1980, the figure was approaching one in four. Many of these one-person households consisted of young unmarried adults. Earlier, such persons would very likely have lived at home with their parents until marriage. In 1960, the median age of marriage for women was twenty, though during the seventies, the average age of marriage rose as the decade wore on. Another significant group of single-family households consisted of older people who had outlived their spouses and wanted to maintain independence from their children, the parents of the baby boom generation. The generations of young adults, their parents, and their grandparents maintained their separation from one another, and this often meant that both grandparents and their grandchildren were living alone. While many of these

people had cats or other pets, others didn't want to deal with feeding and cleaning up after animals. They were happy to learn that plants could be more than decor, that they could be a surrogate family.

One reason that people began talking to their plants may be that there was nobody else at home with whom you could have a conversation. Plants were a reason to go home, because they require nurturing and care, though not too much. Thus was born the phenomenon described by the short-lived catchphrase and business name, Plant Parenthood. Raising and caring for plants was defined, as never before, to be a form of responsibility. *House Beautiful* even ran a feature about a plant seller at New York's very upscale Bergdorf Goodman who said that she would not sell a plant without assessing the character of its potential buyer. If she felt a person lacked the seriousness and skill to successfully raise the plant, she would refuse to let him or her have it. For baby boomers, with their long experience of overcrowding, owning or, as it was often expressed, "adopting" a plant could have the same painful yet exciting sense of danger as applying to Harvard or showing up at the door of Studio 54: You might get turned down. For those who made the cut, good stewardship of the plant, or more likely minijungle, was another arena for achievement.

The responsibilities imposed by the plants also had an impact on relationships between individuals. If, for example, you had to leave home for a while, it was necessary to get someone to come in periodically to water, fertilize, remove dead leaves, and perhaps say a kind word or two. The plant-sitter relationship imposed an odd yet intense sort of closeness. The sitter was under a heavy burden: If the plant owner returned to a mass of brown leaves and shriveled vines, the friendship might wither as well. Plants were an extension of yourself and an expression of your competence and care. The negligent, brown-thumbed plant sitter did not merely abuse the flora but showed disrespect for their owner as well. Moreover, the plant owner had to be at peace with allowing the sitter access to bureau drawers, refrigerators, medicine cabinets, and other private domains. The role of plant sitter was typical of the ad hoc intimacy that people of the Great Funk forged to replace more traditional ties of marriage and family that many were deferring, if not rejecting.

Still, although plants, and especially quantities of plants, require a certain level of commitment in care, the level of responsibility doesn't rise to even that demanded by a cat or a dog, let alone a spouse and children. At the time and ever since, self-absorption and the inability to make and follow through on commitments have been persistent com-

plaints against the baby boom generation. There's no question that it takes a pretty high level of egotism to believe that your plants have any interest in what you say. The plants do, after all, have lives of their own.

Yet in a time as unsettled as the Great Funk, with jobs uncertain and inflation rampant, it probably made sense to stay loose and not count on anything being too permanent. Raising a ficus tree is one thing; raising a son or daughter is something else entirely. People understood that. Still, under the circumstances, maybe it was worth trying your luck with the tree before taking a risk on the kid. If women defer having children during their period of highest fertility, that inevitably leads to a generation with smaller families. That's what happened, even though many boomer women had children when they were older. At the time, young women responding to polls said they expected to have smaller families than was typical in their parents' generation, though they expected to have more children than they eventually had. At the time, though, with careers to create and challenges to overcome, commitment lite seemed like the way to go.

A Pet Rock asked little, gave less.

Uneasiness about this culture of low-maintenance attachments produced one of the quintessential objects of the Great Funk years: the Pet Rock. This was an ordinary piece of rock, packaged in a slickly designed but seemingly environmentally sound brown cardboard box, complete with airholes. "WARNING: Open box carefully," the package instructed. "DO NOT remove rock before reading instructions." Gary Dahl, the writer who created this extraordinarily successful 1975 fad, was satirizing several different phenomena. It presented a thoroughly commonplace object as scarce, something that struck a chord when the world seemed to be running out of everything, and everything seemed to be getting expensive. (This part of its appeal still works; in 2005 one was offered on a collectors' Internet site for $69.95, a price the seller justified because "No more Pet Rocks are being made.") The chief joke, though, was that by making literal an absurd extreme, the Pet Rock pointed up a widespread reluctance to take any responsibility or to make any commitments. It seemed to be a comment on attitudes toward pets, but its subliminal message was about relationships between people. It broke out commercially because it aired an anxiety. It appeared at a moment when people were talking to their plants and believing they were receiving a response. But nobody can expect a meaningful relationship with a rock.

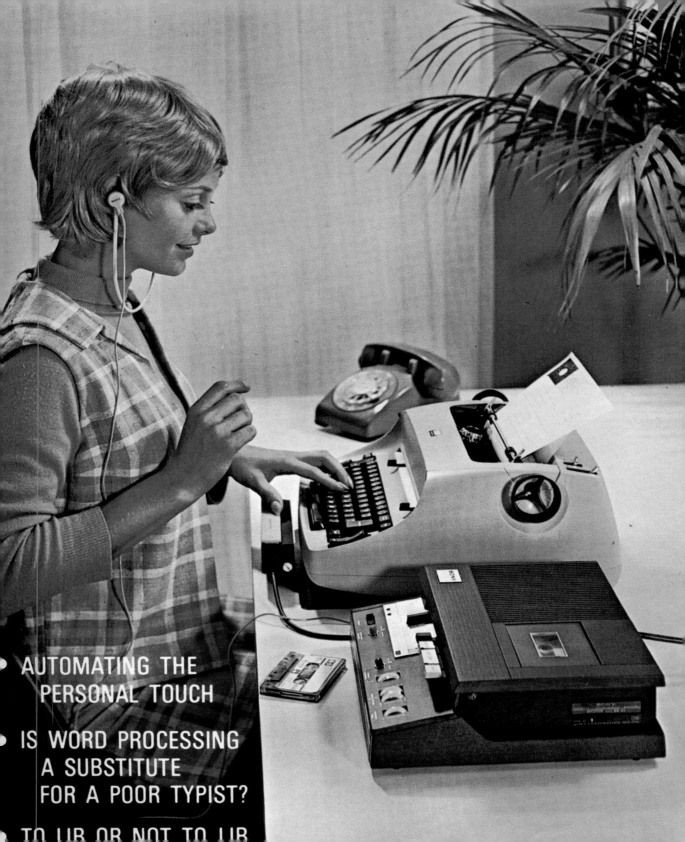

AUTOMATING THE
PERSONAL TOUCH

IS WORD PROCESSING
A SUBSTITUTE
FOR A POOR TYPIST?

TO LIB OR NOT TO LIB

NOT READY FOR PRIME TIME?

**And wouldn't it be nice to live together
In the kind of world where we belong?**

**—THE BEACH BOYS,
"WOULDN'T IT BE NICE" (1966)**

In this song, one of the sweetest of the sixties, the composers Brian Wilson and Tony Asher conjure up a teenager's longing for the simple pleasures of domesticity. They are not looking forward to a revolution, just to a time when the singer and his girlfriend will be married and sleep in the same bed all night and wake up together. They are looking forward to being grown up.

For the oldest members of the baby boom generation, the intended audience for this song, this day of fulfillment was not far away. It would come in the late sixties and early seventies. This song expresses a lovely, almost reasonable optimism; its longing for adulthood is universal and timeless.

The anticipation of "a world where they belong," though, is special to its time. The baby boomers heard, almost from infancy, that they were going to change the world, and it was presumed they would improve it. The seventies would be the time when they would come into the society as adults, members of the largest, best-educated, healthiest generation the country had yet seen. It all had to work out for the better, didn't it?

Well, no, it didn't. The seventies proved to be a terrible time for the baby boomers to enter the workforce. Indeed, it might be more accu-

Women had been in the labor force for a long time, but starting in the seventies, even women with young children expected to have jobs.

rate to say that the seventies were a terrible time *because* the baby boomers entered the workforce. Their maturation was a shock to the system, one that confounded nearly all expectations.

The problem was not, as some had anticipated, that boomers thought and felt in a way that was different from their parents, though this was surely true. Unlike earlier generations, who had experienced the Great Depression and World War II, the boomers had more positive expectations about life and its meaning.

This changed consciousness was, however, on a collision course with harsh realities. The country was not ready for so many new adult workers, including women who, unlike their mothers, expected to work through their prime childbearing years. The glut of young workers contributed to higher unemployment and runaway inflation. Office jobs fell in status and moved into cubicles. The economy did eventually digest this change, though average wage rates have been stagnant ever since. Moreover, some boomers were able to harness their new culture to new technology and create some surprising inventions—preeminently the personal computer—that would shape future decades.

Still, it's striking that a decade for which so many people had such high hopes turned out to be as messy and difficult as it was. That's doubly true when you consider that one explanation for the thwarted expectations—the sheer size of the baby boom generation—had been studied and commented on for nearly twenty-five years.

There were a few notes of warning. For example, in 1967, *Fortune* ran a series of articles about what American life would be like in the seventies. Such forecasts were a proud tradition of the magazine, which had on several previous occasions provided prescient analyses not merely of the economy but also of the society that was to come. And its view of the seventies was probably more accurate than any other that could be found at the time. It was absolutely on target in warning that the boom times of the early sixties—and by extension of the entire post–World War II era—had been fed by extraordinary circumstances that couldn't be expected to continue. It noted that an economy that had been driven for more than two decades by newly formed families might look very different in a time when young people were delaying marriage and children. The magazine looked toward more fashionable times, in which Americans would buy more clothes and fewer appliances. It saw that

more women would have their own money, and, for at least part of their lives, they would spend much of it on themselves.

Most important, it warned that the nation was in danger of making promises to itself and the world that it might not be able to deliver. *Fortune*'s writers and economic analysts saw themselves to be not in a time of turbulence and revolution but in an era of euphoric generosity, in which just about everything seemed possible. "The expansion of goals has resulted from basic social realities," the first article said. "Growing national wealth has made it possible to conceive of very large social undertakings. Rising levels of education brought enlargement of sympathies, widenings of horizons. And various public problems have come to seem much more pressing than they seemed in the fifties." Writing at a time when the United States was racing to land men on the moon, no idea, no matter how ambitious, could be denigrated as mere pie in the sky. Yet this organ of managerial capitalism was warning, ever so discreetly, that the economy was heading for some rough fundamental adjustments and might not be able to generate the wealth necessary to fulfill all the dreams that were on the table.

The magazine's warnings were low-key. Its audience was made up of managers, and their deepest belief was that everything could be managed. The sixties were a time of tremendous confidence in managerial competence. This went far beyond the business community. Government was trying to become more like a business, so Robert McNamara, who used to run Ford, was running—reluctantly, we now know—the Vietnam War. Universities, too, were becoming more like corporations, with institutions like the University of California seeking to produce excellence on a mass production basis. And even a fantasy figure like James Bond was a creature of a large organization that was kept busy gathering information and developing gadgets for his use. Management, technology, and a cool attitude could accomplish just about anything.

The "turbulent sixties," the time of youth rebellion, antiwar protests, black power, and social upheaval was actually fairly short-lived, from about 1965 to 1969. It was an outgrowth of, and reaction to, a slightly different sixties, one based on technological and organizational mastery. The cold precision of IBM and NASA helped set the tone for the era of SDS protests and LSD visions. (And the key research on LSD had been done by the CIA.)

The United States was the richest, most powerful nation ever known, with a wealth of knowledge and research capacity beyond anything

that had ever been seen. It could shoot for the moon and mobilize all the science, engineering, technology, and salesmanship to enable it to achieve its goal. The premise of Lyndon Johnson's Great Society was that through a concentration of money and expertise, it would be possible to solve a large range of chronic social problems, from poverty to underachieving schools and students to health care. Johnson and his advisers believed it could all be done while fighting a war in Asia. The radicals' critique of this agenda argued with priorities—especially military ones—but it agreed with the general assumption that anything was possible. During the sixties, the portion of African Americans living in poverty was halved from two in five to one in five. Liberals saw this as a sign of success, radicals as a moral failure. To many, Johnson's ambitious program seemed like half measures. Perfect fulfillment, perfect freedom were within our grasp. That would happen soon, probably in the seventies.

Everybody—establishment and counterculture alike—depended on continued affluence. For the establishment, a smoothly running economy vindicated their authority and made them rich and powerful. Charles Reich's supposedly antimaterialistic young depended on economic prosperity; there's more time to cultivate deeper values when your basic needs are met. Political dissidents had an interest in continued American wealth because they wanted to redirect its use to make a better country and world. As the sixties drew to a close, and the war in Vietnam looked increasingly futile, there were good reasons to be worried about the nation and its future. But the continued success of the economy was not near the top of anybody's list.

By 1970, it was clear that the post–World War II era of confidence and competence was over. The spectacle of the world's greatest military bogged down in Southeast Asia signaled an end to an era in which one American triumph had followed another. Even the sight of Americans walking on the moon in 1969 didn't seem like the great achievement that had been anticipated for so long. The shooting in Ohio of Kent State University students—four of whom died—by National Guard troops in May 1970 heightened the sense that the country was at war with itself. It was a moment of profound disillusionment, but it did not lead toward the "revolution" that had been so much a part of radicals' rhetoric. Americans stopped worrying about rebellion because they were starting to worry how their dollar was losing ground at the supermarket and how their pay wasn't rising as fast as they had expected. And

the baby boomers started to worry about whether they were going to be able to get a job.

Ever since the baby boom began in 1946, commentators had been talking about the way members of that generation would remake American society. Before the eldest boomers could even walk, marketers were working on ensuring prosperity and forestalling another depression, by making them whine for the products of their choice. As the first generation reared on television, they were consumers virtually from the womb, and researchers kept tabs on their fashions, tastes, and aspirations. Ford developed its first Mustang, introduced in spring 1964, with the hope that it would become a graduation present for the first class of boomers to finish high school. The movie, music, radio, and fashion industries served and flattered them. The problem was that, while American industry had an exquisite understanding of the boomers as customers, it had no idea about what would happen when they went to work.

While the media had long depicted the baby boomers as little princes and princesses of privilege, toddlers, tots, or teens who would one day bestride the world, for members of the baby boom, the view was somewhat different. The oldest of them were born into a country just recovered from war and depression, one in which there had been a long-term decline in family size. At first, the boom was seen as a very short-term phenomenon, one that would dissipate once oversexed ex-GIs stopped trying to make up for lost time. Thus, some school districts were reluctant to invest in new schools, while others, in suburban areas, couldn't keep up with the new houses full of children that were appearing almost overnight. Many early boomers spent their first years of schooling attending double sessions or using temporary classrooms.

Some of the same problems reappeared when the boomers went to high school, even though the boom had been going on for a decade and a half. And although, from the time they were infants, a high percentage of boomers were expected to go on to higher education, colleges and universities often put off expansion until they knew the phenomenon was real, so the earliest boomers experienced crowding there too. Even the 1969 Woodstock Festival, that defining event for the generation, was, in essence, a vast crowd of boomers whose needs nobody had anticipated. At every stage in these early boomers' lives, people in author-

ity seemed unable to cope with so many people who were the same age. These young people who had spent their lifetimes hearing how lucky they were had experienced bureaucracy and alienation from an early age. The mismatch between humane rhetoric and mass-production schooling helped produce a generation that was highly skeptical of good intentions.

When the television program *NBC Saturday Night* (later better-known as *Saturday Night Live*) began in 1975, its young regular cast was introduced as "the Not Ready for Prime Time Players." This started as an inside–show business joke, a reference to another program called *Saturday Night Live*, which starred the sportscaster Howard Cosell. Over time, though, it became a better joke as such performers as Gilda Radner, John Belushi, Dan Aykroyd, and Chevy Chase emerged as true stars. Their sensibilities—Chase's self-aware smugness, Radner's winning befuddlement, Belushi's wildness—were different from what was found on prime time. They were like their viewers, looking at the world in a different way than their elders did, and like their viewers, they were clearly ready to succeed. They were most certainly ready for prime time. The question was whether prime time was ready

Saturday Night Live's regular cast was called the Not Ready for Prime Time Players, a plight with which their boomer fans could identify. Here, Dan Aykroyd, Garrett Morris, and John Belushi appear with guest star O. J. Simpson.

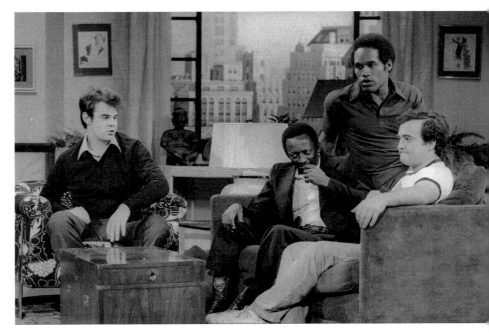

for them. This was the problem that most baby boomers faced as they sought to enter life's prime time and become real, responsible, wage-earning grown-ups.

The oldest boomers, the Not Ready for Prime Time Players' contemporaries, had the greatest experience with crowding. They were also the ones most affected by the Vietnam War, because although their large numbers meant only a minority of young men had to serve, the possibility of being drafted influenced the educational, career, and life choices of many more. Nevertheless, as they entered the workforce, these earliest boomers, especially those who had graduated from college and avoided the war, were fortunate. They were like the first people in line at a buffet table. Good jobs were fairly plentiful, and barriers to getting them weren't overwhelming. Very quickly, though, the table was picked over. Good jobs were taken, and in an economy that was shaky to begin with, opportunities for younger boomers were scarcer. Employers began demanding more education and more experience than they had only a few years before. The later boomers were forced to be less expansive in their ambitions than the earlier ones. As the decade wore on, and the economy deteriorated further, the disparity between the younger and older boomers became more and more stark. The younger boomers accused the older ones of selfishness and greed, and complained that their bad behavior had ruined things for those who came after. Meanwhile, the early boomers, like most lucky people, felt they deserved their good fortune. Still, you can't help when you're born, and the values that most affected the boomers' and the nation's economic fate were ones that older and younger members of the generation shared.

The most important was the expectation that women would have life-long careers, just as men do. This, too, was something that should have been expected. Feminist consciousness-raising played a big role in this change, of course, but ever since the young boomer females had entered high school in the early sixties, they had been telling pollsters that they expected to have careers. Apparently, nobody believed them. Instead, it was assumed that middle-class women would interrupt or postpone work while they raised a family. Without much debate, and relatively little self-consciousness, this assumption simply disappeared during the seventies. Late in 1973, the number of families with working mothers exceeded those with nonworking mothers for the first time. By 1975, the percentage had risen to 53 percent, a big change in a short time, and the percentage continued to accelerate. At the same time, the

number of families headed by women who had never been married was rising dramatically.

In addition, young women were delaying both marriage and childbearing. This was a return to a long-term trend that had been interrupted, most dramatically, by the mothers of the baby boom. But at the time, it was such an abrupt reversal that it elicited all sorts of theorizing and speculation. Was this the result of the birth control pill? If so, would American families be much smaller? Or would this delay of childbearing simply produce a delayed second boom? Were young people reluctant to bring children into an overpopulated, polluted world with shrinking resources? Or were they simply unwilling to grow up and become responsible people like their parents?

In fact, most people make such decisions based not on abstract principles but rather on the day-to-day realities of their lives. At a time when many aspects of life seemed to be out of control, the pill did increase women's control over their bodies and the shape of their lives. But the decision to stop taking the pill could be made at any time. While the birth of the baby boom had been an expression of confidence in the future, the seventies provided plenty of reasons to stop and wait to see if things would get better.

The boomers had been born at a time when it was impossible to imagine that a baby could be a bad thing. But as they reached their childbearing years, popular culture began to spawn infant monsters. In a series of horror movies, beginning with *Rosemary's Baby* in 1968 and including *The Exorcist* (1973) and *The Omen* (1976), children were literally demonized. They were Satan's spawn or possessed by evil spirits. In *It's Alive* (1974), a minor example of the genre, a mutant newborn answers the obstetrician's slap by eviscerating the doctor and proceeds to terrorize the nearby suburbs, even as his parents agonize over whether he's evil or simply confused. For the parents of baby boomers these movies surely had some resonance, as their children turned out to be so unlike what they had expected them to become. But the boomers themselves were the real audience for these films. Perhaps they had grown up around too many children. Perhaps they were afraid of the changes chil-

dren would introduce in their lives. Very likely the monster children provided them with an irrational but subliminally satisfying excuse for living their lives as they were, without children.

The economy in which the boomers had grown up was shaped by a shortage of labor. The last few American generations had been small in number, and that born during the thirties was the smallest since the Civil War. There was little immigration. Moreover, there were artificial shortages, caused by biases, practices, and laws. For example, even though, contrary to popular belief, the employment of women increased during the fifties, there were many careers, even entire industries, where women wouldn't have been considered for employment. It was unusual for middle-class mothers of young children to work. In addition, many jobs were also off-limits to African-American men and women. The result was that life was good for white male wage earners. Companies didn't want to lose them, and when low-skill jobs dropped out of the economy because of automation, companies were willing to train them for higher-skill, higher-paying

LOTS MORE WORKING

Numbers of Americans over 16 who were employed

1970	78,678,000
1971	79,367,000
1972	82,153,000
1973	85,064,000
1974	86,794,000
1975	85,846,000
1976	88,752,000
1977	92,017,000
1978	96,048,000
1979	98,824,000
1980	99,303,000

Antidiscrimination laws and changing values offered more jobs to minority group members, as well as to women, but industrial jobs were starting to move overseas.

IMITATION MAN LOOK

Never wear—

Man's fedora

Shirt and tie

Pinstriped or
chalk-striped suit

*This drawing shows movement—
unlike our test drawings,
which never do.*

Women with professional ambitions weren't supposed to look *exactly* like a man. Almost exactly was preferable.

positions. In many industries, unions were strong, and they won good wages and generous benefits for their members. Employers were very loyal to their workers; they had to be because there weren't all that many workers available.

The post–World War II world posed little competition to American economic might. In most areas of manufacturing, the United States was unrivaled, at least until the late 1970s. Manufacturers in the automobile, appliance, and communications industries did not have to worry about competition. It was much easier to raise prices to compensate for rising labor costs than it was to sustain loss of production because of strikes. Thus, at a time when other countries were counting on government to provide health insurance and pensions for workers, Americans let business and labor unions take care of these problems.

It would be wrong, though, to view postwar America as a workers' utopia. Many manufacturing jobs offered high salary and good fringe benefits, but craftsmanship and pride had been drained out of them. Likewise, many white-collar jobs demanded conformity and obedience but little creativity. In compensation, the jobs paid men enough to support their wives and children in a way of life they could hardly have imagined two decades earlier. The rewards of work were realized in a nice house with a couple of cars, Blue Cross, and paid vacations. The job was what one did to attain a higher standard of family life; workers had stopped expecting it to be rewarding in itself.

Yet women wanted into this world of work, even though they had spent their childhoods being told that home and family were where happiness was found. And many men wanted to find meaning in their work, though they wanted good pay and benefits as well.

Even if expectations had remained the same, and women had stayed home with babies and men were satisfied to earn good wages, the arrival of baby boomers to the workforce would have jolted an economy shaped by labor scarcity. Add to that the arrival of women expecting careers and

paychecks comparable to those of men, and competition from lower-wage workers in Japan and elsewhere who were making products competitive with American goods. The result was more like an earthquake. Work in America has never been the same.

In 1973, the real, inflation-adjusted wages of men began a steady, long-term decline that has continued, despite a few upward blips, into the twenty-first century. Women, who have traditionally made less than men, have substantially closed the gap. But this was achieved not by raising women's wages but by lowering men's to what had been women's levels. Family income has risen substantially, but that is because households with two working spouses have become the norm. Over time, middle-class standards of consumption have become far more expansive—with bigger houses, more cars, new kinds of technology—than the boomers' parents had ever aspired to.

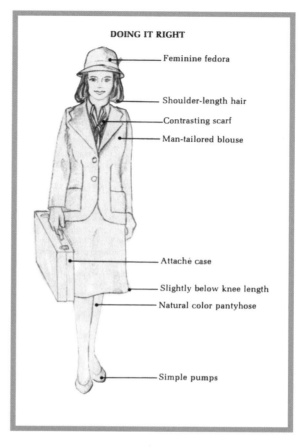

DOING IT RIGHT

Feminine fedora
Shoulder-length hair
Contrasting scarf
Man-tailored blouse
Attaché case
Slightly below knee length
Natural color pantyhose
Simple pumps

THE WOMAN'S
DRESS FOR SUCCESS BOOK

John T. Molloy
author of the best-selling
DRESS FOR SUCCESS
America's best-known clothing consultant tells what to wear and why.

It turned out that Reich and others were wrong; boomers had nothing against materialism. But in order to achieve these material goals, boomers had to work longer and spend less time with their families.

Boomers who had taken a course in elementary economics had encountered something called the Phillips curve. This graph showed a tradeoff between inflation and employment. When more people work, prices go up, and when fewer work, prices go down. In this model, an economy in which prices and unemployment rise at the same time was inconceivable. Yet that's precisely

As women went to work in the mines or, perhaps, the gas station, new jobs opened up for child-care workers, some of them men.

what happened throughout most of the seventies. The combination of unpredictable rises in prices combined with uncertainty about job prospects became known as stagflation, a bastard offspring of stagnation and inflation. It was the single greatest cause of the malaise for which the decade is remembered. Stagflation was probably a bigger factor in people's lives than Watergate, the two oil embargoes, or any of the other high-profile crises of the age. Indeed, the general skittishness caused by stagflation led Americans to react more acutely to other crises than they would have if the economy had followed the textbook.

How did this supposedly impossible state of affairs come to be? People are still arguing about it, and they have filled many shelves of books with their analyses. Just about everyone agrees that at least three presidents, Congress, and the Federal Reserve all could have done a better job of running the economy. The fight is over who blundered worst, and how.

Some people believe that the Phillips curve was simply a delusion that is irrelevant to the whole matter. Still, it is obvious that the boomers' entrance into the labor force upset one of the major assumptions behind it, which was that the size of the labor force would remain stable. It stands to reason that a sudden increase in the number of people available to work would raise unemployment. And when unemployment rises, according to the theory expressed in the Phillips curve, government ought to increase spending and lower interest rates in an effort to get the economy moving faster. That's exactly what was done. While this strategy might have worked when the economy wasn't swamped with new workers, the infusion of money only added fuel to the fire of inflation. There weren't enough productive jobs for which the workers could be hired. What was needed was restraint and time to adjust. This happened at the end of the decade, and it proved painful.

Americans hadn't lived through such a time of economic misery since the thirties. Bette Midler wasn't (entirely) kidding when she titled an album *Songs for the New Depression*. What happened in the seventies

was, in many respects, the opposite of what had happened in the thirties. During the Great Depression, money actually increased in value, but now it was falling in value as never before. Perversely, this turned out to be good for those who had mortgages and other obligations; they were able to pay off their debts in cheaper dollars and possibly sink what they

saved into a retirement home. For boomers, too, the lesson of the decade was to go into as much debt as you could, though many didn't have much choice. Debt, like sex, was no longer a cause for shame.

Perhaps the most important difference, though, is that the Depression ended with an economic boom that was caused largely by the country's preparations for war. The Great Stagflation ended with a bust, one typically attributed to the oil embargo of 1979 that followed the revolu-

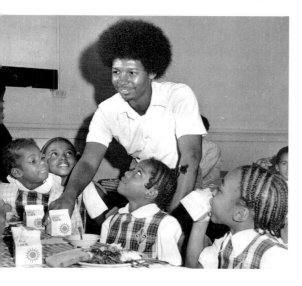

tion in Iran. It was, in fact, self-induced, the result of Federal Reserve chief Paul Volcker's policy of wringing inflation out of the economy with high interest rates. Still, the end of the Depression left Americans with a mood of optimism about expanding opportunities. The stagflation taught the children of these optimists— the ones who had been looking forward to adulthood along with the Beach Boys—that the world they encountered wasn't necessarily the one they anticipated. Their careers would not be like those of their parents, only more responsible and more meaningful. Rather, their experience would be more precarious, their workplaces more impersonal, and their progress not assured.

Keypunch operator was an important job in the early decades of computer use. This student was learning the skill at Colorado College so that she could eventually use a real computer.

When General Motors opened a new plant in Lordstown, Ohio, in 1966, it was a portent of the new boomer-staffed economy. There were six applicants for each of the five thousand jobs initially offered, a ratio that was more like a selective university than an automobile plant. GM went out of its way to recruit a young workforce, many with more schooling than had been typical for automobile workers. It was also one of the first plants to hire women for heavy manufacturing. It was an attempt to start fresh with a younger workforce without strong union loyalties or extravagant expectations. Although it made relatively luxurious Chevy Impalas at the time it opened, a few years later it became the plant where GM produced a small, inexpensive car, the Vega, in an effort to compete with imports, especially those starting to come from Japan. Boomers were a big market for such cars, of course, but GM was also trying to take advantage of the large size and availability of the boomer labor force—including returning Vietnam veterans—to roll back both costs and union power. Lordstown was, at the time, the most automated automobile plant in the world, with computers monitoring the entire process and three dozen robots on the assembly line.

Ultimately, though, Lordstown became famous not for its innovation but for its labor strife. This followed an organizational change that re-

sulted in a substantial speedup of production. While the plant had previously turned out a car each minute, its new goal was one every thirty-six seconds. Manufacturers have attempted, and workers have resisted, such speedups ever since factory production was invented. At Lordstown, however, the workers revolted against not just GM but also against their union, the United Auto Workers, which they saw as insufficiently concerned with working conditions. At first, resistance was passive; workers simply skipped a car every so often, allowing it to move through the assembly line with parts missing and assemblies uncompleted. Even a perfect Vega wasn't a great car. The knowledge that they were unreliable, perhaps sabotaged, was terrible for sales. Eventually, in 1972, this confrontation led to a series of wildcat strikes that in turn won widespread media attention and the discovery of a new phenomenon, the bored boomer worker. Long-haired, sideburned assembly-line workers gazed from the covers of magazines. While the stories were often sympathetic to the workers' complaints, the pictures of angry, long-haired strikers sent a different message: the protest generation has gone to work, and now it's messing up your cars.

Many of the workers quoted in those stories said that they wanted their jobs to be more satisfying. This declaration of changed consciousness was in keeping with the long-established boomer story line. The stories gave much less attention to GM's strategy of finding what they hoped were younger, more compliant employees and making them work harder. While its smaller numbers gave the older generation an edge, companies could assume the boomers were threatened by competition from their peers for high-paying jobs, while responding to threats from overseas. This latter story line would dominate American life for the next three decades.

Many of the baby boomers' parents who worked in factories were determined that their children would get the education to qualify them for white-collar jobs. But a funny thing happened in the office during the seventies: It became more like a factory.

Throughout the seventies, many of those who had white-collar and clerical jobs found themselves inhabiting a whole new kind of workplace, one whose very nature and structure reflected the increasing precariousness of the workaday world. This was the open-plan, "office landscape" system of movable partitions with walls that stopped just short of the ceiling. The coming of cubicle culture was about far more

The office landscape, featuring flowing spaces, low partitions, and plenty of plants, was introduced as a reform of office design. This woodsy interior at the Weyerhaeuser Company's corporate headquarters in Federal Way, Washington, near Seattle, was one of the most celebrated examples.

than decor. It was a cultural revolution, one that stripped many office workers of their status, even as it helped make the integration of women into managerial positions less visible and contentious.

Before the seventies, most managers had private offices, whose size and location expressed their position in a well-understood and relatively stable hierarchy. "A name on the door rates a Bigelow on the floor," said one rug maker's slogan, encouraging everyone to see a carpeted private office as evidence of career success. Meanwhile, the executives' secretaries and other support staffers—the vast majority of whom were women—worked in the open, with little privacy except perhaps for a frosted glass divider and a "modesty panel" to block the view through the kneehole of her desk.

Open-plan office systems got their start in Germany in the mid-sixties. Eberhard and Wolfgang Schnelle, brothers who were management consultants, proposed that office design reflect the flow of communication. This meant, they said, that offices should not be enclosed boxes, but rather, flowing landscapes.

The United States proved to be far more receptive than Europe to these ideas, but their essence was lost in translation. Although the

Schnelles advocated curving walls and other irregularities in office layouts, nearly all the furniture manufacturers that got into the business during the seventies introduced systems based on rectangular grids. These are the easiest to lay out and fit together, and they make efficient use of expensive space. The result, though, is that what started out as a romantic conception of the workplace became even more relentlessly regular than what it replaced.

Although the Schnelles had said that their landscapes, punctuated with plants and gathering spaces, should reflect an analysis of communication in the office, U.S. interior designers and their clients argued that open offices would, by themselves, improve communications within the company. Subsequent evaluations have proved this assumption false. Employees feel more comfortable communicating with one another when they have an expectation of privacy. This finding did not slow the spread of cubicles throughout the land, which suggests that communication was not most companies' top priority. Surveillance—the illusion of being able to judge who is working productively and seeing who is talking to whom—was probably more important to employers than improved communication.

199^{00} or $9.00 monthly—
see page 572 for
full credit terms

The Businessman's Dream Calculator

Top-of-the-line office technology, ca. 1973, this Commodore calculator seemed to do it all. At $199, it was quite expensive.

The main reason companies embraced the open office, however, was the pace of change in the workplace. The spread of computer terminals was forcing companies regularly to tear up floors and ceilings and break down walls. Moreover, companies were moving people from job to job and changing the definitions of jobs more frequently than ever before. The old hierarchical system of private offices was deemed inefficient, at least for those not at the top, and the open-plan office was a good alternative. When, in 1976, partitions became available that incorporated their own wiring, it was clear that open offices would become standard for all. (The tax advantage of office systems, which can be depreciated quickly, as furniture, rather than slowly, as building improvements, also played an important role.)

Still, although the reasons for each company's decision to go to open-plan offices appeared pragmatic, open offices gave form to massive social changes that appeared in the seventies and have shaped our work experience ever since.

The fixed office was the embodiment of fixed status, an artifact of the world of the lifetime job. Open offices appeared as the nation was mov-

ing from a period of labor shortage to labor glut, and they remind those who work in them that companies are not static institutions but ongoing projects that are subject to change without notice. You can't afford to be complacent in an open office. You can't let your guard down.

The coming of the open-plan office pulled many of the midlevel executives out of their private offices and placed them in cubicles. At the same time it enhanced the privacy, comfort, and square footage of large numbers of female clerical employees, many of whom got new titles and increased recognition of their responsibilities. Open offices were never a feminist goal. They did help businesses to accommodate themselves to women's changing career aspirations. If women were to move up, there needed to be a face-saving way to let men move over and make room, or even to move down.

The ball of an IBM Selectric typewriter, an icon of the modern seventies office.

While the original goal of the open plan was to make the organization transparent, its long-term virtue was to make status and hierarchy ambiguous. In a company with closed offices, a man whose job required him to sit in the typing pool with the women would be perceived as something less than a man. But when large numbers of men were required to leave their private offices and work in the open, at workstations identical to those of workers performing what had been women's tasks, the stigma was removed. It then became easier to discard the whole idea of women's jobs and men's jobs. Companies had greater latitude in designing jobs and giving positions to people who were best able to do them, regardless of sex, age, race, or any other factor. Obviously this picture is idealized. Women's changed career paths have aroused plenty of resentment and resistance over the years, and there are still remnants of women's work in offices. Yet the excuse for upheaval provided by the introduction of the open office allowed changes to happen faster and less painfully than they might have.

If the open office seems like a low road to equality—one that places most of the workforce in circumstances only marginally better than those hitherto experienced by secretaries and stenographers—that is the baby boomers' fate. In a world crowded with people who were schooled and ambitious, middling success was far less comfortable than it had been for their fathers' generation.

If you were to visit an office of the seventies, you would still see people engaged in antique tasks. They would be writing letters on IBM Selectric typewriters. You would see fingers darkened by carbon paper. Executives would be talking into Dictaphones. And clerks would be working at keypunch machines, turning data into forms that computers could understand. The computers themselves were away from the office, in rooms of their own, but they nevertheless created many of the tasks that office workers were required to do.

Most people went through their lives seeing a computer rarely, if at all. But they were aware that they were living in a computerized world. Their paychecks, printed on card paper with machine readable holes, carried the computers' universal commandment: "Do not fold, spindle, or mutilate." So did voting ballots, automobile registration forms, and just about anything else that had to be processed by a corporation or a bureaucracy. Thus, the computer, though out of sight, was hardly out of mind. It served as a potent symbol of a dehumanized, regimented future that many feared was inevitable.

In 1970, *Life* magazine asked Norman Mailer to look forward to the decade ahead. The novelist imagined two possible futures, one an irrational time of revolutions and counterrevolutions, and another rational but even more bleak. "Its reason would be the logic of the computer," he wrote, one characterized by "inchings toward nuclear installation, a monotony of architectures, a pollution of nature which would arouse technologies of decontamination odious as deodorants." He added, "In the

Women workers dominated the making of computer chips, as in this 1973 scene at Intel. Their clean-room outfits were known as "bunny suits."

Ted Nelson's double-sided book *Computer Lib/Dream Machines* (1974) prophesied that linked computers and databases would make supermen of us all.

society of computer logic, the atmosphere would obviously be plastic, air-conditioned, sealed in bubble-domes beneath the smog, a prelude to living in space stations. People would die in such societies like fish expiring on a vinyl floor. So of course there would be another society, an irrational society of the drop-outs, the saintly, the mad, the militant and the young." Mailer identified the planner and the swinger as the necessary dreams of this computer civilization, and "both would meet in the orgies of the suburbs."

Mailer made the predictions in the context of a series of articles he did for the magazine about the moon landing, and he was, like many Americans, both repelled and seduced by the style of the space program. NASA had turned a quest into a bureaucracy. It wrung all emotions out of its language. Its administrators behaved with quiet confidence to create an aura of technological inevitability. From the way they talked, it seemed as if nothing could possibly go wrong. And even when things did go horribly wrong, as happened in January 1967 when three astronauts died in an Apollo capsule that caught fire during training in Florida,

NASA kept its cool and stayed focused on its mission. A vision of progress this impersonal could not be denied. Mailer and other cultural observers sometimes deplored the future of sterility, control, and universal mind-altering medication that the increasingly technocratic society portended; they did not doubt the competence of the technocrats. Indeed, one of the worst things about the technological society was that it worked.

"He thought of the Seventies," Norman Mailer wrote, referring to himself, "and a blank like the windowless walls of the computer city came over his vision." Mailer's view that the computer would be the chief tool for creating and maintaining a totalitarian near future was widespread at the time. It was a centralized spy, organizer of information, and enforcer—Orwell's Big Brother realized.

In movies, in comic books, and throughout the culture, the computer was a powerful symbol. Fortunately, though, there were some who saw it as a gadget, something you could learn from, learn about, and play with that might enable you to do some really cool things. These people were members of a subculture of technofreaks. They joined computer clubs, like the near-legendary Homebrew club in Silicon Valley, which produced many of the pioneers of the personal computer industry. They weren't Reich's sexy young saviors; they had belonged to the math club in high school. Yet at least some of them showed stirrings of Consciousness III. They believed that technology doesn't exist simply to further

Silicon Valley's now legendary Homebrew Computer Club drew people who wanted to make the computer personal, whether they were working engineers or high school students. Bob Lash, a student at Palo Alto High School, was one of its youngest members, and from 1974 to 1976 he built this imposing device.

corporate power; it can also be an instrument for personal exploration and expression. And they developed the personal computer as part of an informally collaborative collective endeavor. They were PhDs and high school dropouts, petty criminals and minimoguls. But they came together for a time—actually just a few years in the midseventies—and cobbled together some gadgets and ideas that have profoundly changed the way things have been done ever since.

The Altair 8800, introduced in 1975, did nothing useful, except gather people around it to figure out what it could do. The prototype of the first Apple computer, *below*, which followed shortly after, had a homemade Great Funk vibe.

Although the personal computer had its greatest impact in later decades, nearly everything that has happened, including the growth of the Internet and the rise of hypertext and the World Wide Web, was part of the conversation in the seventies. Because it has had such an impact on everything since, the pioneering years of the personal computer have been, deservedly, much chronicled and mythologized. And because the computer is, as Mailer noted, a narcissistic invention that creates its own reality and because some of its creators have narcissist tendencies themselves, those who celebrate it often claim that the personal computer is the *only* important thing that happened in the seventies. The break-in at the Watergate in 1972, this thinking goes, pales in significance next to the previous year's break-in by future Apple Computer founders Steve Wozniak and Steve Jobs at a Stanford University research lab. There they were able to obtain the frequencies that would allow them to make blue boxes—devices to trick the telephone system into letting them make calls for free. Manufacturing and selling these illegal appliances were Jobs and Wozniak's first business, until they were robbed by some more conventional criminals and presumably scared straight.

This raffish heritage of illegality is part of the romance of the computer age.

It is undeniable that knowledge and gear that had been smuggled out of high-tech companies like Hewlett-Packard and Intel played a role in the development of the personal computer. In the early days, there was quite a lot of overlap between the shady side and the corporate side of computers. For example, the hacker known as Cap'n Crunch, who discovered that a whistle packed in breakfast cereal would let him fool the phone system, later wrote the word-processing program that was bundled with the first IBM PCs.

It's likely that most of those who gathered at the early swap meets of widgets and ideas were primarily interested in the technology. Their political or social ideology was vaguely antiestablishment and certainly anti-IBM. Still, their interest was in what their gadgets might be coaxed to do, rather than any larger implications. "We learned as much as we could about our technologies and kept alive our sci-fi dreams of a future when *everyone* could have a computer," recalled Lee Felsenstein, who was at the center of the seventies computer scene. "Never mind that those things were not very well thought out or that most people didn't consider them fun. We hadn't spent all that time learning all that stuff because someone had asked us to. It had a beauty all its own which we could understand and which we wanted to share with everyone."

Felsenstein was a rare and influential social thinker among the techies. He had been strongly influenced by the educator–social reformer Ivan Illich, who opposed a technological society based on mass production and advocated technology that people could learn to control and use for their own ends. (This was the premise of *The Whole Earth Catalog*, which was first published in 1968 and became increasingly computer-oriented in later editions.) Illich termed this socially and personally empowering approach to technology "conviviality." In 1974, Felsenstein designed what he called "The Tom Swift Terminal, or a Convivial Cybernetic Device"—fusing the

The Commodore PET was one of the earliest personal computers on the market, introduced in 1977. People still feared the computer as Big Brother, so Commodore decided to market it as a harmless companion.

boys' fantasy and technophilosopher strains of the microcomputer movement—and sold the plans for 25 cents each.

Also in 1974, Ted Nelson, who had been working on his ideas about linking and disseminating information at various East Coast universities, at a New York publishing house, and in conjunction with a New Jersey high school computer club called the R.E.S.I.S.T.O.R.S., self-published his book *Computer Lib/Machine Dreams.* (It was actually two books, bound back to back.) He wrote about the prospect of "a screen in your home from which you can see into the world's hypertext libraries . . . offer high-performance computer graphics and text services at a price anyone can afford . . . send and receive written messages . . . [and become] a part of a new electronic literature and art, where you can get all your questions answered." Project Xanadu, as he called it, would be everything that has emerged on the World Wide Web and, as he would note today, much more. He even included a singing commercial for his idea, which promised "All the things that man has known / Comin' on the telephone." This was a truly visionary idea, especially since hardly any of the devices that would make it possible existed yet. The book sold briskly to computer enthusiasts, perhaps because it proposed that what they were doing was central to civilization and human progress. "I want to see computers useful to individuals, and the sooner the better, without [un]necessary complication or human servility being required," Nelson wrote. "Simply as a matter of citizenship, it is essential to understand the impact and uses of computers in the world of the future. Computers belong to all mankind."

The first device that could be called a personal computer wasn't introduced until 1975. Its inventors toyed with calling it the Little Brother, a riposte to Orwellian fears about computers. The machine, eventually called the Altair 8800, was certainly nothing to be frightened of, because it was entirely useless. It had no display other than some lights on the front and no keyboard or other input device. Its elements were poorly configured, and with only 256 bytes of memory, it could barely do anything. But though it was technologically unimpressive, Felsenstein recalled, "This was raw standardized opportunity. And nobody was looking! We could do anything we wanted to." What became the Homebrew Computing Club was formed by a group of people who wanted to play with an Altair and figure out how to make it do something.

"The theme of the club was 'Give to help others,'" Apple cofounder Steve Wozniak recalled. "Each session began with a 'mapping period,' when people would get up one by one and speak about some item of in-

terest, a rumor, and have a discussion. Somebody would say, 'I've got a new part,' or somebody else would say he had some new data or ask if anybody had a certain kind of teletype. During the 'random access period' that followed, you would wander outside and find people trading devices or information and helping each other."

Eventually Wozniak and Jobs started building their own computers, the Apple I and II, which they presented every few weeks to the club to hear criticism and suggestions. "I'd even go over to people's houses and help them build their own," Wozniak said.

"Everyone attending the club in 1975–76 knew there was a big computer revolution occurring and the rest of the world wasn't aware of it yet," Wozniak recalled. "That's why there was so much excitement and spirit. We were finally going to get control of our own computers."

The Homebrew Computer Club started with about thirty geeks, and it ended up producing more than twenty companies. Its utopian moment couldn't last, of course, and the advent of the personal computer has not brought transcendence and liberation, while the Internet has brought as much trash and fraud as beauty and truth. And Microsoft, a company that rose out of the hobbyist culture, has proved to be as formidable and ruthless as IBM ever was. Yet the technology did change the world, and few who have it would choose to do without.

Even though most people never encountered a personal computer before the eighties, it probably required seventies culture to exist. Its invention depended on a lot of people who had time on their hands. It grew from vaguely antiauthoritarian attitudes held by people who believed that the big guys didn't know what they were doing. It was individualistic yet cooperative. Few expected to make a killing—financially, at least. (Computer-based games were murderous from the start.) Some of them expected to change the world. Most wanted to be able to do cool stuff. They made a world where they belonged, and eventually the rest of us joined them.

DELIVERANCE
AND DENIAL

The Great Funk ended, quite abruptly, shortly after noon on Tuesday, January 20, 1981.

It came to a close when, only a few minutes after Ronald Reagan was sworn in as president of the United States, the fifty-three American embassy workers who had been held hostage by revolutionary students in Tehran for 444 days were finally released.

For more than a year, Americans had made themselves feel humiliated and angry. They tied yellow ribbons to trees and pinned them on themselves, and, as the days wore on, the yellow had faded. ABC's late-night "America Held Hostage" reports had started as a response to a crisis and lasted long enough to become an alternative to Johnny Carson. The previous April, Americans had launched Desert One, a military strike to rescue them. That ended in fiasco when three helicopters malfunctioned, and another collided with the transport plane, killing eight American soldiers. Following that failure, the hostage crisis had begun to seem permanent. So when the hostages came home, Americans were truly ready to turn a page. The nation had suffered through too many crises.

In November, voters had gone to the polls and rejected a moralistic president who passed judgment on the public even as he caused pain and committed

Ronald Reagan projected himself as a confident grown-up, comfortable in the presidency, and as a hero riding to the nation's rescue.

Today, only a handful
of people know what it means...
Soon you will know.

JACK JANE MICHAEL
LEMMON FONDA DOUGLAS

the
China
Syndrome

Written by MIKE GRAY & T.S. COOK and JAMES BRIDGES
Associate Producer JAMES NELSON · Executive Producer BRUCE GILBERT
Produced by MICHAEL DOUGLAS · Directed by JAMES BRIDGES
"SOMEWHERE IN BETWEEN" by STEPHEN BISHOP

A confluence of fiction and fact made Americans nervous in 1979. First, *The China Syndrome* dramatized the dangers of a nuclear meltdown, then right after, it seemed to be happening for real at Three Mile Island, an atomic power plant near Harrisburg, Pennsylvania.

blunders. Now they were ready to settle in with a new president who was also a familiar, grandfatherly figure. They wanted to be reassured. They wanted life to be more normal—and more like the forward-looking, optimistic America of the post–World War II era.

Decades don't usually have clear beginnings and endings; they bleed into one another, and certainly 1980 was a continuation of the seventies. But even though much of what made the seventies was still present in the eighties, the change of tone that began in 1981 was extremely dramatic. Americans changed parties in Washington, and they also changed their clothes, changed their styles, changed their attitudes toward life. People became less experimental, less open, more concerned with traditional measures of prosperity and success. And except for those facing the new plague of AIDS, people became less prone to panic.

This change did not come gradually. The final years of the seventies were, if anything, more disconcerting than the first ones. The Islamic revolution in Iran in 1978 set off a chain of events that led to the second oil embargo, a re-run of gas station lines and shortages that made people even angrier than the first one had. In 1979, the hit movie *The China Syndrome* raised the fear that a nuclear power plant would melt down catastrophically. Then on March 30, a few weeks after the film opened, a leak at Three Mile Island in the middle of the Susquehanna River south of Harrisburg, Pennsylvania, suggested the threat could be real. "The world has never known a day quite like today," CBS anchorman Walter Cronkite, believed to be America's most trusted man,

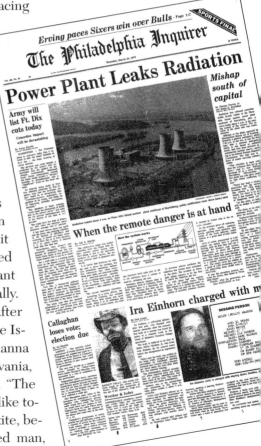

The down-to-earth Jimmy Carter sought to downplay the pomp of the presidency, but he did rub shoulders with an emperor, the shah of Iran, whose days were numbered. The shah was deposed in 1978, setting off a new oil shock and a hostage crisis with which Carter seemed unable to cope. "America Held Hostage" became a nightly television program, anchored by Ted Koppel.

intoned as he began his newscast. "It faced the considerable uncertainties and dangers of the worst nuclear power plant accident of the atomic age. And the horror tonight is that it could get much worse. The potential is there for the ultimate risk of meltdown at Three Mile Island . . ." It didn't happen, of course, though a much worse accident happened at Chernobyl, Ukraine, in 1986.

As the seventies waned, the economic pain only became worse. President Carter had appointed a new chief of the Federal Reserve, Paul Volcker. He was determined to use harsh policies that would bring down inflation once and for all. The immediate result was that mortgage rates approached 20 percent, and the cost of living rose more than 10 percent for a couple of years. This tough and painful policy had real human costs. Among those who lost their jobs in the aftermath was President Carter himself.

Moreover, the chronic problems that caused so many of the anxieties of the Great Funk years had not been resolved. The oil that made our prosperity possible was still in unreliable hands. Global warming still loomed. Many cities were still deteriorating and the contrasts between

First Lady Nancy Reagan ordered an enormous new set of White House china in red, her favorite color. This dramatic departure from the ostentatious simplicity and self-denial of the Carter years seemed to signal that the age of austerity was over and it was okay to be opulent. Gold bathroom faucets quickly ensued.

rich and poor were growing. Stagnating wages meant that working mothers were not a choice but a necessity, and many families were struggling to manage the consequences of this change. Illegal drug use was still rampant. Single-parent families were still rising in number.

"Are you better off than you were four years ago?" asked Ronald Reagan in the key sentence of his presidential campaign. For most people, the answer seemed to be a no-brainer. Four years earlier, Americans had looked to Carter as an alternative to the corruption of Nixon and the seeming haplessness of Ford. Things had only become worse. Reagan represented not just a change of party but also a changed way of thinking and even a changed way of being. Americans were ready to see him succeed. The release of the hostages simultaneously with Reagan's inauguration allowed the new president to point to a success in the first minutes of his administration. Other problems would take years to resolve, but this dramatic event changed the tone of the country.

The end of the Great Funk was brought about by an act of collective will, or perhaps an exercise in mass denial. Those who, only shortly before, had been mad as hell and weren't going to take it anymore had decided that they simply didn't want to be bothered.

Ronald Reagan sought an amiable, grandfatherly persona, in some respects a second coming of Dwight David Eisenhower, who had presided over more normal times during the fifties. Still, the public understood the differences. Ike had been a genuine war hero, the orchestrater of victory over the Nazis in World War II.

Reagan was an actor, one who had occasionally played heroes but more often amiable sidekicks. Many remembered him primarily as pitchman for General Electric, where he was indelibly identified with the slogan, "Progress is our most important product." A nation that had been skeptical of the old idea of technological mastery that GE was selling was hungry for some progress by 1980. Like spectators at a performance, Americans seemed truly eager to suspend their disbelief and return to thrilling days of yesteryear.

AT&T's New York headquarters building looked to many like an expensive piece of old furniture, which seemed just about right.

While seventies tastes valued fragmentation, improvisation, salvage, and stunning juxtaposition, the eighties embraced formality, control, ostentation, and order. The seventies table could be set with intriguingly mismatched plates. The eighties table took its cue from First Lady Nancy Reagan, who promptly ordered a new set of White House dishes, a 4,732-piece set, at a cost of $209,000. They were edged in red, her favorite color. Her husband immediately made his mark on the White House by tearing out Carter's solar hot-water heater. In the seventies, the heater on the roof could be seen as contemporary overlay on a historic relic. In the image-conscious atmosphere of the eighties, it was a blemish of anxiety on the nation's preeminent symbol of executive authority.

The seventies were about complex surfaces, layering, and texture. The eighties were about veneer, a thin layer of luxury that delights the eye and creates the illusion that objects and buildings are more substantial than they appear.

Architect Philip Johnson heralded this trend to thin-sliced opulence in 1979 when he appeared on the cover of *Time* holding a model for the Manhattan skyscraper he designed for AT&T. Many people said it looked like an overblown Chippendale highboy, but soon after, cities were filled with stone-veneered evocations of guild halls, cathedrals, and Chrysler Buildings. Armed with new techniques that allowed them to use thin sheets of granite or marble as if they were glass, architects built a generation of stone-veneered buildings that seemed as substantial as

cardboard models. While the seventies had cultivated an appreciation of the old, the eighties evoked tradition as an affectation of unearned status.

The return to classic styles in architecture was mirrored in clothing. Ralph Lauren, whose outfits for *Annie Hall* had evoked a WASP girl trying to be bohemian, began to create a fantasy world in which everyone appeared to come from old money. Women in the workplace stopped trying to find a businesslike femininity and began wearing men's styles, not ironically as some had in the seventies, but in earnest. Men wore red power ties like the ones Reagan wore, along with ostentatiously conservative suits. Everyone was playing a role; it was essential to dress the part. Life was becoming ever more competitive; ambition was back in vogue.

The baby boomers were getting older. One reason for the return to formality and tailoring at that moment was the boomers' discovery that middle-aged bodies look better in suits. As people get older and begin to

Dynasty, the television program that epitomized eighties power style, debuted eight days before Reagan's inauguration, though its most memorable character, Alexis, played by Joan Collins, left, didn't appear until the second season. John Forsythe and Linda Evans were the other leads.

FREDDIE JAMES

GET UP AND BOOGIE

feel their youthful powers wane, they seek out settings and accessories that assert the power of maturity. They also realize that there is nothing quite so foolish as an old person vainly trying to appear young. The next best thing is to change the definitions of style and age: Forty became the new thirty, full cuts replaced Lycra, and personal trainers supplanted jogging trails.

On television, the dominant programs were *Dallas* and *Dynasty*, melodramatic sagas of the rich and the ruthless. Unlike the sitcoms that had dominated the previous decade,

Disco performer Freddie James on the cover of his 1979 record *Get Up and Boogie.* Boom boxes, which allow individuals to impose their music on everyone around, were supplanted by the Walkman, a libertarian appliance that allowed each person to groove to his or her own drummer.

they did not so much reflect social reality as provide imagery for dreams of affluence and power. In both cases, their most compelling figures were their villains, *Dallas*'s J. R. Ewing, played by Larry Hagman, and *Dynasty*'s Alexis Carrington, played by Joan Collins. Both embodied a relentless lust for control and styles that bordered on parody. Audiences recognized the characters' absurdity, yet they still signaled that they were living in a no-more-Mr.-Nice-Guy world.

Seventies culture had encouraged people to express their differences, often very loudly. Young people, and especially young black men, had taken to carrying huge boom boxes, from which their preferred music, or at least its pulsing rhythms, permeated whole neighborhoods. The boom box was seen as an instrument of aggression, a test of tolerance, or yet another symptom of the general deterioration of urban life. In 1979, Sony introduced the Walkman, the first portable tape

player. It permitted each person to walk around in his own sonic world, protected from the tastes of others. Gradually, boom boxes became less prevalent, as Walkmans became close to universal. Each person had his own music, but at least others weren't being bothered. The result wasn't quite the same thing as social harmony, but to many, it seemed a real improvement over the cacophony of the recent past.

The change in styles between the seventies and the eighties was dramatic and impossible to miss. But even a style that depends so much on illusion must have some substance behind it. How could Americans move so abruptly from a style of anxiety and improvisation to one of confidence and at least the image of solidity?

One reason was that just as people in the eighties tended to understate society's problems and failures, people in the seventies tended to dwell on them. Following stagflation and Watergate, people bought into a narrative of hidden evil and national incompetence. Despair at the failure of old ways of doing things gave license to try new things. Sometimes people sought the license even when there was no real reason to despair. Things in the seventies weren't always as bad as people began to feel they were.

"Just say no" was the slogan of Nancy Reagan's antidrug campaign, but it was widely understood as a condemnation of the liberties people had taken during the seventies.

The changes of the seventies gave the eighties something to build on. The maturation of the baby boom generation and the entry of unprecedented numbers of women in the workforce had given the economy a shock. The U.S. labor force—those who had work or wanted it—grew by nearly thirty million during the decade, an increase of nearly 40 percent. About 42 percent of women were working or seeking jobs in 1970, while 52 percent were in 1980. For much of the decade, the economy could not produce enough jobs for all who wanted them, but a tremendous amount of new employment was

SILENCE=DEATH

"Silence = Death" was the slogan of gay AIDS activists, who condemned the Reagan administration's failure to respond to the deadly epidemic. Most of the early victims were homosexuals and drug abusers. The disease devastated the gay community, but it also made them visible as never before.

created, and by 1980 a slightly higher percentage of Americans were working than at its beginning. The economy managed, with difficulty, to adjust itself to the numbers and values of the baby boom.

Moreover, Volcker's monetary policies took hold, dropping inflation from 13.5 percent in 1981 to 3.5 percent in 1983. Stable prices stabilized people's emotions as well.

The seventies had brought other successes in the form of more efficient cars, better insulated buildings, and a host of industrial improvements that squeezed greater economic productivity out of each barrel of oil. Energy was still an issue, and the United States kept making energy-related decisions it would later regret, its support for Iraqi dictator Saddam Hussein, for one. But people had taken action that had made the problems less urgent.

The simple fact was that America was, as it had been since World War II, the world's most prosperous and powerful nation. It had suffered a loss of confidence following Vietnam, Watergate, and the eco-

nomic upheavals of the seventies. But it was ridiculous for Americans not to recognize their nation's power and try to assume the responsibilities it implies.

The eighties did bring one true catastrophe, the AIDS epidemic. It emerged suddenly. The first cases were seen in 1979, it was officially identified in 1981, and within a year or two, many were dying. Although it has since spread into other populations, the first large group of victims consisted of homosexual men residing in large cities. This in itself had an impact on the look and feel of the times, since so many early victims worked in the design and style industries and had helped create the architecture, interiors, magazines, art, and cultural life of the seventies. Those critical of seventies hedonism saw the disease, whose spread was no doubt accelerated by the promiscuous, anonymous sex practiced in gay bars and bathhouses, as punishment for sexual excess. Whatever the merits of that argument, there is little doubt that seventies-style wide-open sex, both gay and straight, disappeared from public view. Pornography, too, became less public, though with the proliferation of videocassette recorders, it moved from the theater to the privacy of the home and grew into an even bigger industry.

"Just say no" was Nancy Reagan's famous antidrug message. In the wake of AIDS, and in the hangover from the excesses of the seventies, Americans did say no, at least in public.

The AIDS epidemic did not, however, force gays back into the closet. It killed a number of prominent people who had never acknowledged their homosexuality, and it encouraged many others to step forward and reveal themselves as they fought for their lives and those of their friends. "Silence = Death" was one of the most succinct and powerful slogans ever. Gays who made noise during the eighties forced others to recognize just how large a minority was living in their midst.

Almost as soon as they were over, the seventies supplanted the thirties as the decade Americans wanted to forget. It's easy to see why. It seems too bad, though, that people went from worrying too much to barely thinking at all. Global warming, for example, caused concern in the seventies but was dismissed as alarmist nonsense afterward. Now, with the North Pole thawing and mountain glaciers melting, it's clear that smug denial, however satisfying, is not really a strategy. As hurricanes become increasingly severe and flooding looms as a

greater problem for all our coasts, this time it might really be too late, baby.

As the years have gone by, we have largely undone all the little things that helped make our lives more energy efficient and gradually drifted into such habits as driving vehicles so large and greedy for gas that they make the 1975 Cadillac Eldorado seem almost modest by comparison. Most of the Noahs who were trying to save mankind started to seem like cranks once the price of oil went down, but now, in the wake of two wars in the Middle East, the issue with energy seems to be not price but autonomy. Some of what the Noahs were proposing seems to make sense again.

Some who hate the seventies lament that its mistrust of authority has never been overcome and that Americans will never achieve national unity again. Still, the argument can be made, especially in the wake of the events of September 11, 2001, that Americans have been a bit too quick to believe what their leaders have told them, and a bit too willing to forgive their blunders. Seventies disrespect was a healthy and much warranted reaction to serious mistakes and misconduct. This disrespect led in many directions, some of them admirable, others dumb or dangerous. But the experimentation of the seventies seems in retrospect to have been a mark of resiliency, not decadence. The country needed to evolve, and lots of people ignored the experts and found their own ways, some of which remain important in the twenty-first century.

Others bemoan the consciousness politics that arose in the seventies, saying that it has encouraged members of the electorate to view themselves primarily as victims. It seems likely, though, that the loss of national consensus has been driven primarily by marketers, who have divided the population into ever more, and ever smaller, consuming and voting units. Minorities used to have grievances. Now they have cable channels.

Meanwhile, we have tended to ignore those things that really did start to go wrong in the seventies, the most obvious of which was the stagnation of workers' income that continues in the present. The ability to work reasonable hours and support a family began to disappear in the seventies. Ever since, Americans have worked longer hours and acquired more possessions, displayed in larger houses where nobody is home. "Family values" became a political buzzword, but family life suffered.

Was there a time when your father's hair was bigger than you were? If so, it was during that decade of personal and social exploration, liberation, and reinvention that was the seventies.

This is not a plea to be nostalgic about the seventies, because that's not a very useful activity. Those who were young in that time might miss the sex, the dancing, or the danger, but such people are mourning their lost youth, not the seventies per se. Nostalgia for the seventies seems particularly inappropriate because nostalgia seems to require a belief in lost innocence. It's impossible to look at the seventies and see anything innocent about them. They knew failure. They knew sin. To live in the seventies was to live in a fallen world, one of promises broken and trust betrayed. It was to live with whatever comes after progress.

Still, though those who lived in the seventies were beyond innocence, they did know hope. They understood that the failure of old formulas created an atmosphere of freedom, a sense of possibility that produced everything from the personal computer to the discotheque. That freedom wasn't a mistake; it was simply exhausting. That's why, in 1981, Americans reached back in time to old, simple messages and pretended to believe them.

So instead of indulging in nostalgia, we might, in the spirit of the seventies, sift through the wreckage of the past and find things that are useful in our own time. We might look for ideas and artifacts that embody

views of the world and of life that might serve us better than those we now take for granted. We might learn again to appreciate how the failure of the purportedly wise opens the door for the freedom of the many. We might feel exhilarated at living in a world that's full of problems that, maybe, we can solve. We might be dissatisfied. And we might do something about it, right now.

Acknowledgments

E ver since *Populuxe* was published twenty-one years ago, fans of that book, editors, and friends have been asking me when I was going to do a follow-up.

Barney Karpfinger, my agent then and now, deserves my thanks for two reasons. He stopped me from doing so until we were both sure that what I had to offer was a statement in itself, not just a sequel. And when the time came, he worked effectively to make it happen.

Iris Weinstein, who designed *Populuxe* and probably should have known better than to get into another messy project, has once again used typefaces, proportions, and telling details to make the book into a compelling artifact. As the author of a work on packaging, I know that books are judged by their covers, so I give thanks to Susan Mitchell, who designed this one.

Sarah Crichton is an extraordinary editor. After working with me closely to sharpen the text, she then drew on her magazine-editor past to challenge me to find fresh and memorable images that tell a story of their own. Like the period the book discusses, this was a project that seemed often on the verge of flying apart into countless little pieces. Assistant editor Rose Lichter-Marck managed to keep it pulled together, and Stacey Linnartz did a heroic job of getting everything finished. FSG's managing editor, Debra Helfand, and design director, Abby Kagan, helped support and nurture this difficult and atypical project.

Special thanks go to those who created the images used in this book. There are eleven photographs by Allan Tannenbaum, whose work provides the essential visual chronicle of New York nightlife and culture during this period, and five by Peter Simon, whose work provides an essential, Arcadian counterpoint. Photographs taken for the old *Philadel-*

phia Evening and Sunday Bulletin form the core of the Temple University Urban Archive, from which I have drawn many images. I spent the decade working for *The Philadelphia Inquirer*, the competition, but I am grateful for the professionalism and creativity of the *Bulletin's* photographers, to Temple for keeping and cataloguing the material, and to the archivist John Pettit. I have also drawn on the enormous wealth of photos, documenting everything from urban street styles and houses made out of beer cans to inaugural balls and moon missions, made for various federal agencies and available to all through the National Archives. Several people went out of their way to find images for the book and get them in printable form. These include Rick Stroud of the International Association of Administrative Professionals, Megan Moholt of the Weyerhaeuser Company, Stephen Grande of the Houston Astros, Earle Barnhart of the Green Center, Chip Lord of Ant Farm, Dwayne Cox of Auburn University, Ilona D. Williamson, Dorothy Delina Porter, Howard Gribble, Steven Stengel, Paul W. Drew, Charlotte Strick, Jeff Williams, and Bob Lash (whose recollections of the Homebrew Computer Club can be found at www.bambi.net/bob/homebrew.html).

David G. De Long, Jim Shulman, Jim Ashbrook, and Howard S. Shapiro all read the completed manuscript and made suggestions that improved the book. Thanks go also to Arlene Love and Robert Iorillo, who shared their collections of seventies imagery, and to countless others who shared memories of their Great Funk–era wardrobes, homes, and consciousness.

INDEX

Page numbers in *italics* refer to illustrations.

Flintkote, 169
flokati rugs, *162*, 176
Flynt, Larry, 110, 123
Fonda, Jane, *108*, 111
Ford, Gerald, 3–4, *3*, 7, 23,
 216
Ford Mustang, 191
Ford Pinto, 38–39, *38–39*
Ford Torino, *39*, 50
Forsythe, John, *218*
Fortune, 188–89
Foxy Lady, 127
Fraser, Kennedy, 84, 126, 135
Freire, Paulo, 75
Fuller, Buckminster, 28, 29, 52–53, 54
funk, 14
Funkadelic, 149, *149*
Fuqua, Gwen, *84*

Trump, Donald, 156
"Twinkie defense," 9, *19*
2001: A Space Odyssey, 89

U

uniform dressing, 143–44, *143*
unisex clothes, *139*
unitards, 137
United Auto Workers, 201
unmarried mothers, 121, 193–94
urban renewal, 16

V

Vanderbilt, Gloria, 143
Vega, 200–201
Venturi, Robert, 119, 181
Vietnam War, 3, 7, 17, 23, 31, 46,
 97–98, 163–64, 189, 190, 193, 200,
 222
Village People, *117*, 119
Virginia Slims, *74*, 169
Vogue, 126, 150
Volcker, Paul, 15, 199, 215, 221
von Däniken, Erich, 49, 54
Vonnegut, Kurt, 90

W

wages, 26, 197, 216, 224
Waiting for Mr. Goodbar (Rossner),
 116
Walkman, *219*, 219–20
Wall Street Journal, 96
Warhol, Andy, 24, 98, *106*, 177
Washington Post, 50

Watergate scandal, 3, 7, *8*, 9, 11, 23, 24,
 25, 46, 50–51, 106, 207, 220,
 222
Waters, Alice, 20
Waters, John, 151
Wells, Malcolm, 59
Weyerhaeuser Company, *202*
White, Dan, 17
Whole Earth Catalog, 209
Wilkes, Paul, 165, 168
Wilson, Brian, 187
Wines, James, 20
Wolfe, Tom, 18, 19
women:
 in labor force, *186*, 188, 193–94,
 196–97, *196*, *198*, *199*, 200, 204,
 205, 218–19
 in sports, 79–80, *79*
 on television, 77–80, *79*
 see also feminism; motherhood
Wonder, Stevie, 23
Woodstock music festival, 15, 174, 191
Woodward, Bob, 50, 56, 106
Woolf, Virginia, 157, 169
World War II, 188, 216
Wozniak, Steve, 208, 210–211

Y

Yorkin, Bud, 70

Z

Zen and the Art of Motorcycle Mainte-
 nance (Pirsig), 68, *71*
Zero Population Growth, 48
Ziggy Stardust, 148
zoot suits, 147

ILLUSTRATION CREDITS

vii National Archives.

2 Courtesy of Ant Farm, photo by John F. Turner.

3 Courtesy of Gerald R. Ford Presidential Library.

4 (*top*) Photo copyright Allan Tannenbaum; (*bottom left*) Courtesy of Todd Franklin.

5 (*bottom left*) Temple University Libraries, Urban Archives, Philadelphia, PA; (*bottom right*) Photo copyright Dorothy Delina Porter.

6 and **7** All photos National Archives, White House Photo Office Collection.

8 (*center and lower left*) National Archives, White House Photo Office Collection.

9 National Archives.

12 and **13** Temple University Libraries, Urban Archives, Philadelphia, PA.

15 Courtesy the Roth Family.

18 Photo copyright Larry Red Rocker.

20 Courtesy SITE.

21 (*top right*) Temple University Libraries, Urban Archives, Philadelphia, PA; (*bottom*) National Archives.

22 (*bottom*) Courtesy Jimmy Carter Library.

26 Photo copyright Peter Simon.

28 NASA.

29 Copyright Martin Hendriks, Istockphoto.com.

31 National Archives.

32 National Archives.

33 (*top right*) National Archives; (*bottom*) Temple University Libraries, Urban Archives, Philadelphia, PA.

36 (*left center*) National Archives.

36 and **37** (*top and bottom*) Photo copyright Henry Chalfant.

37 Temple University Libraries, Urban Archives, Philadelphia, PA.

43 Temple University Libraries, Urban Archives, Philadelphia, PA.

49 (*top and bottom*) Temple University Libraries, Urban Archives, Philadelphia, PA.

51 National Archives.

52 (*top and bottom*) National Archives.

53 (*top*) National Archives; (*bottom*) Photo copyright Larry Red Rocker.

54 Courtesy The Green Center Inc., Falmouth, MA, drawing by Paul Sun.

55 Courtesy William Morgan Architects.

57 (*top and bottom*) Courtesy Douglas Kelbaugh.

58 NASA.

60 Temple University Libraries, Urban Archives, Philadelphia, PA.

62 and **63** Photo copyright Peter Simon.

65 National Archives.

66 and **67** All photos copyright Peter Simon.

74 (*top left*) Temple University

Libraries, Urban Archives, Philadelphia, PA.

75 (*top right*) Library of Congress, *U.S. News and World Report* Magazine Photograph Collection, Warren K. Leffler, photographer.

76 Photo copyright Ian Dickson/Redferns/MUSICPICTURES.com

79 Wide World Photos.

80 Wide World Photos.

84 *Los Angeles Times* Photographic Archive, Department of Special Collections, Charles E. Young Research Library, UCLA, photo by Harry Chase.

86 National Archives.

88 Photo copyright Allan Tannenbaum.

90 National Archives.

92 National Archives.

93 Temple University Libraries, Urban Archives, Philadelphia, PA.

94 and **97** NASA.

99 Photo copyright Dan Doughtie.

102 (*bottom*) National Archives.

103 (*top right*) Photo by Ginocchio.

108 (*top right*) National Archives; (*bottom left*) Photo copyright Peter Simon.

109 (*top left*) Library of Congress, *U.S. News and World Report* Magazine Photograph Collection, Warren K. Leffler, photographer; (*bottom center*) National Archives.

111 Photo copyright Allan Tannenbaum.

112 (*bottom*) Photo copyright Allan Tannenbaum.

114 Photo copyright Allan Tannenbaum.

115 San Francisco History Center, San Francisco Public Library, photo by Harvey Milk.

117 (*bottom left*) Photo copyright Louie M. Stewart.

124 Photo copyright Neal Barr.

125 Temple University Libraries, Urban Archives, Philadelphia, PA.

131 (*bottom left*) Temple University

Libraries, Urban Archives, Philadelphia, PA.

138 (*top left*) Courtesy John J. Ronald.

139 Photo copyright Allan Tannenbaum.

140 (*top right*) Courtesy Paul W. Drew; (*bottom left*) Courtesy Howard Gribble.

143 (*top right*) Temple University Libraries, Urban Archives, Philadelphia, PA; (*bottom right*) Copyright Houston Astros, used by permission.

145 National Archives.

146 Temple University Libraries, Urban Archives, Philadelphia, PA.

147 Chris Walter/Photofeatures.

151 (*top left*) Everett Collection; (*bottom right*) Photo by Tom Arma.

152 and **153** Photo copyright Allan Tannenbaum.

154 (*bottom left*) Photo copyright Allan Tannenbaum.

155 Both photos copyright Allan Tannenbaum.

157 Photo by Fred Jewel/Wide World Photos.

158 Temple University Libraries, Urban Archives, Philadelphia, PA.

165 Temple University Libraries, Urban Archives, Philadelphia, PA.

171 Temple University Libraries, Urban Archives, Philadelphia, PA.

180 (*top left and right*) Photos by Thomas Hine.

180 and **181** National Archives.

181 (*top left and right*) Photos by Thomas Hine.

185 Photo copyright Jeff Williams.

186 Courtesy International Association of Administrative Professionals.

192 Photo copyright Allan Tannenbaum.

195 National Archives.

198 National Archives.

199 (*top and bottom*) Temple University Libraries, Urban Archives, Philadelphia, PA.

200 Special Collections, Tutt Library, Colorado College, Colorado Springs, CO.

202 Weyerhaeuser Company, used by permission.

205 Collection of Intel Museum, Santa Clara, CA, used by permission.

207 Courtesy of Bob Lash.

209 Photo copyright Steven Stengel.

212 Courtesy Ronald Reagan Library.

213 Courtesy Ronald Reagan Library.

215 (*top*) Courtesy Jimmy Carter Library; (*bottom right*) ABC News Archives.

216 The White House.

217 Photo copyright Richard Payne.

220 Courtesy Ronald Reagan Library.

224 Photo copyright Al Vandenberg.

A NOTE ABOUT THE AUTHOR

Thomas Hine is the author of five previous books on American culture and design, including *Populuxe*, *The Total Package*, and *The Rise and Fall of the American Teenager*. He writes frequently for national and regional magazines and newspapers. He has also served as an adviser or consulting curator for museum exhibitions in Los Angeles, New York, Denver, and Miami. He was architecture and design critic for *The Philadelphia Inquirer* from 1973 to 1996. He lives in Philadelphia.